Akram Khan

New World Choreographies

Series Editors: Rachel Fensham and **Peter M. Boenisch**

Editorial Assistant: Alexandra Heller-Nicholas

Editorial Advisory Board: Ric Allsop, Falmouth University, UK; Susan Leigh Foster, UCLA, USA; Lena Hammergren, University of Stockholm, Sweden; Gabriele Klein, University of Hamburg, Germany; Andre Lepecki, NYU, USA; Avanthi Meduri, Roehampton University, UK

New World Choreographies presents advanced yet accessible studies of a rich field of new choreographic work which is embedded in the global, transnational and intermedial context. It introduces artists, companies and scholars who contribute to the conceptual and technological rethinking of what constitutes movement, blurring old boundaries between dance, theatre and performance.

The series considers new aesthetics and new contexts of production and presentation, and discusses the multi-sensory, collaborative and transformative potential of these new world choreographies.

Gretchen Schiller & Sarah Rubidge (*editors*)
CHOREOGRAPHIC DWELLINGS

Prarthana Purkayastha
INDIAN MODERN DANCE, FEMINISM AND TRANSNATIONALISM

Forthcoming titles include:

Pil Hansen & Darcey Callison (*editors*)
DANCE DRAMATURGY

Cristina Rosa
BRAZILIAN BODIES AND THEIR CHOREOGRAPHIES OF IDENTIFICATION

New World Choreographies
Series Standing Order ISBN 978–1–137–35986–5 (hardback)
(*outside North America only*)

You can receive future titles in this series as they are published by placing a standing order. Please contact your bookseller or, in case of difficulty, write to us at the address below with your name and address, the title of the series and the ISBN quoted above.

Customer Services Department, Macmillan Distribution Ltd, Houndmills, Basingstoke, Hampshire RG21 6XS, England

Akram Khan

Dancing New Interculturalism

Royona Mitra
Brunel University London, UK

First published 2015 by
PALGRAVE MACMILLAN

Palgrave Macmillan in the UK is an imprint of Macmillan Publishers Limited, registered in England, company number 785998, of Houndmills, Basingstoke, Hampshire RG21 6XS.

Palgrave Macmillan in the US is a division of St Martins Press LLC, 175 Fifth Avenue, New York, NY 10010.

Palgrave Macmillan is the global academic imprint of the above companies and has companies and representatives throughout the world.

Palgrave® and Macmillan® are registered trademarks in the United States, the United Kingdom, Europe and other countries.

ISBN 978–1–137–39365–4

This book is printed on paper suitable for recycling and made from fully managed and sustained forest sources. Logging, pulping and manufacturing processes are expected to conform to the environmental regulations of the country of origin.

A catalogue record for this book is available from the British Library.

A catalogue record for this book is available from the Library of Congress.

Typeset by MPS Limited, Chennai, India.

To Heera
My Sparkling Diamond

Contents

List of Images

Series Editors' Preface

Choreography in the global context of the twenty-first century involves performance practices that are often fluid, mediated, interdisciplinary, collaborative and interactive. Choreographic projects and choreographic thinking circulate rapidly within the transnational flows of contemporary performance, prompting new aesthetics and stretching the disciplinary boundaries of established dance studies. Crossing the borders of arts disciplines, histories and cultures, these new world choreographies utilise dance techniques and methods to new critical ends in the body's interaction with the senses, the adoption of technology, the response to history as well as present-day conditions of political and social transformation, or in the constitution of spectator communities.

As a result, well-rehearsed approaches to understanding choreography through dance lineages, canonical structures, or as the product of individual artists give way to new modes of production and representation and an ever extending notion of what constitutes dance in performance. Choreographic practice as well as research on choreography draws on new methods of improvisation, (auto-)biography, collective creation and immersion in ways which challenge established (Western) notions of subjectivity, of the artist as creator, or which unsettle the objective distance between the critic and the work. The post-national, inter-medial and interdisciplinary contexts of digital and social media, festival circuits, rapidly changing political economies, and global world politics call for further critical attention.

With an openness to these new worlds in which dance so adeptly manoeuvres, this book series aims to provide critical and historicised perspectives on the artists, concepts and cultures shaping this creative field of new world choreographies. The series will provide a platform for fresh ways to understand and reflect upon what choreography means to its various audiences, and to the wider field of international dance and performance studies. Additionally, it will also provide a forum for new scholars to expand upon their ideas and to map out new knowledge paradigms that introduce this diverse and exciting field of choreographic practice to dance, theatre and performance studies.

Rachel Fensham, University of Melbourne
Peter M. Boenisch, University of Kent
Alexandra Heller-Nicholas, Series Administration

We gratefully acknowledge the support of this publication by the faculty of arts at the University of Melbourne.

www.newworldchoreographies.com

Preface

In the summer of 1998 Akram Khan, a British-Bangladeshi man, graduated from the Northern School of Contemporary Dance in Leeds with an outstanding honours degree. The previous year, I, an Indian woman, arrived in Britain to pursue a degree in contemporary performance practices at the University of Plymouth. Both Bengalis, both trained in the South Asian dance form of *kathak* from the north of India, and both seeking performance languages beyond our classical repertoire, Khan and I shared much in common. In the same year Britain witnessed a momentous shift in politics as Labour returned to power after eighteen years. Over the next decade, in very different contexts, the career trajectories of both Khan and myself were fuelled by Labour's policies on multiculturalism and immigration. When we finally met in 2008, Khan was already a successful and influential artist in the field of British contemporary dance, and I was a scholar vested in analysing this field through the lens of cultural studies.[1]

Through this preface I wish to chronicle how Khan's path crossed my own in this British terrain leading to the birth of my doctoral thesis and ultimately this book. This monograph is a significant development of my PhD research, which I completed in 2011 at Royal Holloway (University of London). I therefore believe my readers will value an insight into the journey that led me to undertake my doctorate, and for this a brief overview of my own performance training in India and Britain is vital.

Between 1984 and 1995 while still living in Calcutta, I undertook training in *kathak* under the tutelage of three *gurus*: Rani Karna, Amita Dutta and Bandana Sen. Alongside my classical training I also performed *rabindrik* dance, a conglomerate expression that brings together elements of South Asian classical and folk dances, conceived and popularised in Bengal by the Nobel Laureate and visionary Rabindranath Tagore. In 1995 I experienced a dance event that transformed my vision of performance forever. The late Ranjabati Sircar, already an influential force in the emerging field of contemporary South Asian dance, performed her evocative solo *Cassandra* – based on the myth of the Greek princess who was able to foresee the future. In this performance Sircar rejected elaborate costumes, jewellery and other paraphernalia

associated with classical dance recitals. All she retained was her dynamic and vulnerable physicality. What I witnessed that evening was an embodied performer, making decisions in the very moments of praxis and bringing to her role her lived reality. She was stripped of all codifications that mould South Asian classical dancers, and instead evoked the Grotowskian philosophy of the sacrificial holy actor in the poor theatre. And it was her ability to make an offering of herself through her art that left an indelible mark on me. The intercultural corporeal translation of a Greek woman's story told through an Indian woman's body also left me intrigued.

Following this encounter I started contemporary dance training in the *navanritya* style that was being developed by Sircar and her mother, the late Manjusri Chaki-Sircar, at their organisation Dancers' Guild in Calcutta. Alongside embracing South Asian classical and folk movement vocabularies, *navanritya* drew on South Asian martial art forms like *kalaripayattu* as well as Western Graham technique, and was thus emerging as a culturally syncretic movement system. During this period I also briefly trained in *bharatanatyam*, the classical dance from the south of India. I soon began to discover that my *kathak* and *bharatanatyam* training were entering into conflict with my *navanritya* training vis-à-vis their approaches to basic movement principles. The composite language of *navanritya* allowed my body to engage in a more dynamic and complex relationship between my spine and the floor and was at variance with the anti-gravity verticality of my classical training. Likewise *navanritya*'s ability to communicate ideas through movement seemed to also draw on stylised everyday gestures, instead of relying solely on the strictly codified languages of *kathak* and *bharatanatyam*. I recognised that what was happening within my body was distinctive.

My body thus began to simultaneously process the classical codes of *kathak* and *bharatanatyam* and the emergent codes of the *navanritya* language, and triggered in me a need to extend my performance training beyond India. In 1997 I arrived in Britain to undertake a degree in theatre and performance at the University of Plymouth. Here my body encountered the movement languages of release technique, contact improvisation, capoeira and, perhaps most memorably, the embodied aesthetic of the hybrid genre of physical theatre, with its interdisciplinary allegiances in European avant-garde theatre and dance.[2] I chose to specialise with an MA in physical theatre at Royal Holloway in 2000. Here my multilayered corporeal training continued, not as a virtuoso dancer, but as an embodied physical performer. During this time my body found instinctive ways to compartmentalise the idiosyncrasies of

each language it was encountering, so they could co-exist but rarely in communication with each other.

While at the level of form I was struck by the creative possibilities of a multi-corporeally trained body, at an intellectual level I was drawn to artists who sought to not only blur the boundaries between classical and contemporary idioms, but in the process also politicised their own bodies. The idea of the body as a site of political intervention was for me a vital aspect of the physical theatre genre. It is through this lens that I first witnessed Khan in his high-profile *kathak* solo *Polaroid Feet* (2001) at the Royal Festival Hall in London.[3] Like Sircar in *Cassandra*, Khan's rejection of classical paraphernalia in favour of a minimalist pair of linen trousers and a fitted tunic made compelling viewing. While he performed a stylised language of a culturally specific past, unlike other South Asian classical dancers I had encountered before Khan's presentation was a simultaneous reminder that he belonged to the present milieu. In *Polaroid Feet*, through a humble and eloquent direct address to his largely Western audience, Khan deconstructed the key characteristics of *kathak* and drew us into the heart of his practice. He explained the mathematical principles behind *tatkar* (complex footwork), the physics behind the form's incessant *chakkars* (pirouettes), the intricate codes of *abhinaya* (emotional expressivity), and talked at length about the improvisatory dialogue between his accompanying musicians and himself. In removing the fourth wall that seals the space between audience and performer in proscenium-arch environments, Khan de-exoticised himself and his art. However, through *Polaroid Feet* Khan achieved more than tutoring his audiences about the nuances of *kathak*. By demystifying his art and dismantling his audience's Orientalist notions about his South Asianness, Khan placed his diasporic identity-politics at the heart of British culture and entered into socio-political dialogue with it.

As my MA drew to an end I struggled to initiate creative dialogue between the different movement languages that my body had acquired over time, and its tendency to segregate these different languages frustrated and intrigued me in equal measure. What if these languages could talk to each other productively? Would they create a hybridised aesthetic? Would this language be classified as Western or non-Western? At a physiological level, during my subsequent teaching of physical theatre as a lecturer at the University of Wolverhampton (2001–13), I began to notice that in shifting between one language and another, my spine was suffering from negotiating the different demands of my performance training. The creative tensions that surfaced in moving

smoothly between different embodiments of my body's central axis, different relationships to verticality and horizontality, and most importantly different explorations of the relationship between gravity and my body weight, were gradually manifesting as physiological tensions at the base of my spine. Even though I was advised to discontinue working with multiple corporeal languages, an intellectual reading of my physiological condition instigated interesting questions about the role of the spine in such intercultural negotiations. With this auto-ethnographic vision began my doctoral studies in 2006. To situate my corporeality against parallel contexts, I began to search for other performers who had also undertaken multi-corporeal performance training particularly between South Asia and Britain. What I discovered changed the course of my research significantly.

In the British context the most visible artists renowned for generating unique aesthetics through their multi-corporealities were Shobana Jeyasingh and Akram Khan. As a choreographer Jeyasingh's hybridised experimentations were concerned with the form of a new language that can emerge between *bharatanatyam,* classical ballet and contemporary dance. Committed to deconstructing *nritta,* the technical element of *bharatanatyam,* Jeyasingh experimented with its physical repertoire and was not as concerned with rewriting *nritya,* the expressive modalities of the dance form. Her practice situates itself comfortably in the formalist strand of British contemporary dance and has made Jeyasingh influential in this field.

In contrast Khan's syncretic aesthetic seemed concerned with the communication of personal identity-politics through a language that emerged at the interstices between *kathak* and the eclectic idioms of contemporary dance, theatre, music, visual arts, literature, digital arts and film. It thus appeared to be fundamentally multidisciplinary and driven by his lived reality. Khan seemed keen to translocate *abhinaya,* the codified and mimetic gestural language of his *kathak* training, onto his emerging contemporary dance vocabularies in order to politicise the exoticisation of his postcolonial body. His performance-training trajectory parallelled my own, and his vision to communicate personal politics through a corporeal language coincided with my own idea of the body as an interventionist site. His second-generation Bengali identity in Britain also resonated with my own (albeit first-generation) roots, and through his artistic articulations of diasporic identity, I began to recognise my own experiences of relocation and growth as an Indian now living in Britain. In the French philosopher Jacques Rancière's

terms, Khan and his art enabled my emergence as an emancipated spectator, and I felt the need to use my nuanced spectatorship to theorise this art.

Having found such a suitable case study of someone who was emerging as an explosive force in British and global contemporary dance, I realised that Khan's artistic trajectory was too complex and vast to merely support my own auto-ethnographic enquiries. Instead it deserved to become the primary focus of my doctoral studies. I acknowledged that it was vital to theorise and document the trajectory of an artist whose South Asian aesthetic and identity-fuelled contributions to the field of British and global contemporary dance were altering its landscape in significant ways. Finally I accepted that my own ability to straddle the multiple spaces between academia, South Asian dance training, physical theatre practice and the embodiment of diasporic identity-politics lent me a suitably multilayered lens through which I would be able to theorise Khan's practice in productive ways. This renewed vision for the thesis enabled me to shift the perceptions surrounding his art beyond its limiting and exotic South Asianness. Instead I examine it much more significantly as an emerging intercultural intervention within the field of contemporary dance.

During the time it has taken for my doctoral thesis to fuel the voice of this monograph, one further parallel has emerged between Khan and me that has fundamentally changed how we perceive the world around us. We are both now parents to children who embody multi-racial heritages and to whom we owe access to their rich cultural legacies. Consequently now, more than ever before, the political has become the personal and the personal, for each of us, is articulated in and through our politics. For Khan this manifests in his art, while I voice it through my scholarship. This book is a site where I have attempted to bring together both the personal and the political, art and scholarship. Through it the answers I sought as a young postgraduate student about the complex nature of the relationship between one's identity and one's art have found productive articulations. I am hopeful that my thoughts will resonate with future artists and dance/performance studies scholars in the years to come.

Acknowledgements

This book would not have come to fruition without the goodwill, support and patience of several people.

Perhaps the most significant person on this list is Akram Khan, whose honesty, generosity and eloquence in his art and in his communications with me over the years have been inspiring and humbling.

I am indebted to Palgrave Macmillan's series editors, Professors Rachel Fensham and Peter Boenisch, commissioning editor Paula Kennedy, assistant editor Peter Cary and my anonymous readers for believing in this book and its readership. I want to also thank my copy editor Anne Hudson whose meticulous attention to detail has brought clarity to this book.

I am grateful to Tamara Rojo, artistic director of English National Ballet, for the time she dedicated in interview to offer critical insights into Khan's impact on the world of classical ballet. Anwara Khan, mother to Akram Khan, was equally generous and open in sharing her memories of migrating to Britain in the 1970s, the challenges of keeping the Bengali culture alive in their relocated existence, and details of Khan's childhood – all of which has informed Chapter 1. I owe my thanks to Sonal and Dinesh Jeram, parents of Reiss Jeram, for nuancing my understanding of his role in *Abide with Me* (2012), Khan's choreography for the London Olympics Opening Ceremony.

I am grateful to Farooq Chaudhry, producer to Akram Khan Company, for enabling me to understand the company's vision through generous interviews and email exchanges over the years. I also thank JiaXuan Hon, Mashitah Omar, Celine Gaubert and Jan Hart at Akram Khan Company, and Lia Buddle at English National Ballet for always providing prompt and open access to the company's resources, responses to my endless questions, recordings of performances, and helping me source photographs and collate their permissions. You have all been invaluable. I am particularly grateful to the AKCT board of trustees for awarding me a grant of £1,400 towards procuring copyright permissions and meeting the printing costs for the stunning coloured photographs that accompany this monograph.

I want to thank the following photographers and agencies who have generously allowed me to use their evocative images to accompany my case studies: *The Times*, News Syndication (Olympics), Philip van

Dotegem (*Gnosis*), Tristram Kenton (*Zero Degrees*), Richard Haughton (*Desh*), Liu Yang (*Bahok*), Jean-Louis Fernandez (*iTMOi*) and Jane Hobson (*Dust*). Their images will undoubtedly add the much needed visual depth and richness to my analysis. I also thank the dancers at Akram Khan Company, English National Ballet, Akram Khan, Tamara Rojo and Sidi Larbi Cherkaoui for permitting the use of their photographs in the book. Thank you to Sylwia Dobkowska for designing the beautiful cover image to this book.

I am grateful to Naveen Kishore, commissioning editor of Seagull Press Ltd India and Marie Kasongo of Cambridge Scholars Press for granting me permission to include sections of two previously published book chapters from edited volumes published by them. Chapter 4 draws on my previous piece entitled 'Dancing Embodiment, Theorising Space: Exploring the Third Space in Akram Khan's *Zero Degrees*', published in *Planes of Composition* by Seagull Press (2010), and Chapter 5 is a significant development of my piece entitled 'Embodiment of Memory and the Diasporic Agent in Akram Khan's *Bahok*', published in *Performance, Embodiment and Cultural Memory* by Cambridge Scholars Press (2009).

This book would not have taken shape without the inspiring and meticulous guidance of my PhD supervisory and advisory team at Royal Holloway, University of London: Professors Matthew Cohen and Helen Gilbert and Dr Libby Worth. The insightful comments from my examiners Professors Andrée Grau and John Hutnyk were invaluable for the development of my doctoral thesis into this monograph, and I thank them for this.

There are many critical friends, mentors and colleagues whose scholarly brilliance, helpful feedback and unwavering belief in me have fuelled the completion of this book: Roberta Mock, Gilli Bush-Bailey, Priya Srinivasan, Janet O'Shea, Ananya Chatterjea, Pallabi Chakravorty, Melissa Blanco Borelli, Prarthana Purkayastha, Hari Krishnan, Stacey Prickett, Ann David, Lise Uytterhoeven, Clare Parfitt-Brown, Padmini Ray Murray and Nesreen Hussein – thank you. Sylwia Dobkowska, Gavin Thatcher and Claire Hampton – thank you for imbibing my passion for this field and for contributing to it in exciting and inspiring ways. I have so much to learn from you all.

I am grateful to my colleagues in the theatre department at Brunel University for their infectious critical rigour and for nurturing an environment that supports cutting-edge thinking. I am particularly grateful to Grant Peterson and Broderick Chow who read and provided invaluable comments on my book proposal and Introduction respectively.

To my family who have supported me through this project with endless love and encouragement, particularly my parents, Sukla and Syamal Mitra, who gave me the courage to dream, my parents-in-laws, Alison and Don Harris, who enabled my dreams to become a reality, and my daughter, Heera, for whom I dream – thank you.

Finally, my gratitude for my partner Colin knows no bounds; his endless patience, positivity and wisdom grounded me in those many moments when I wavered the most. For keeping me ever-nourished with your love and support, I shall never be able to thank you enough.

Introduction
London Olympics: A Signature Performance

Akram Khan's choreography for the Opening Ceremony of the London 2012 Olympics is an exciting starting point for a book that analyses his choreographic oeuvre through the lens of new interculturalism. Haunting public memory with images of intergenerational legacy and hope in multi-ethnic communities, *Abide with Me* provides critical insights into how the personal and the political collide in Khan's aesthetic. More importantly, however, if the Olympic Games has come to signify 'globalism's signature performance', then performing and choreographing in its Opening Ceremony is symbolic of Khan's seminal position in the contemporary British cultural milieu (Schechner, *Performance Studies* 292). As the first book-length study of Khan's art this monograph is both timely and vital in critically examining the new interculturalism that drives Khan's aesthetic, and a discussion of *Abide with Me* provides an accessible way into the heart of this discourse.

The Opening Ceremony of London 2012 took place on Friday 27 July in the Olympic Stadium in East London. As per the Olympic Charter, the event consisted of compulsory formal segments such as welcome speeches, Parade of the Athletes and lighting the Olympic cauldron alongside more 'interpretive cultural performances' that embodied the host-nation's cultural narrative and were directed by the British filmmaker Danny Boyle (Hogan 102). Writing in anticipation of the ceremony, the British dance critic Judith Mackrell endorsed Boyle's decision to invite Khan to participate in the event and predicted that Khan's contribution would 'command the Olympic stadium':

No wonder Danny Boyle chose this talented British-Bangladeshi artist, who straddles the worlds of Kathak and contemporary dance, to dance at the Olympic opening ceremony. [...] As well as being an

1

embodiment of modern, multicultural Britain, he's one of our most talented artists. (Mackrell, 'MoveTube')

Khan and his fifty-one performers did indeed command the Olympic Stadium: they used the medium of dance to convey a powerful and provocative political message of multi-ethnic intergenerational legacy, a principle that was at the heart of London's original bid to host the Games (Thornley 206). British sociologist Michael Silk claimed that, in line with all Olympic Games, London 2012 would become a 'commodity spectacle that will emphasize gleaming aesthetics, a (sporting) city and nation collapsed into (simple) tourist images, and the presentation of a particular expression of self within the logics of the global market' (Silk 733). Khan's piece for the Olympics interrupted this commodity spectacle by using dance as a political medium of communication in a populist environment. This lent the ceremony more reflexive depth than the regular virtuosic displays associated with such events.

It is important to note that Khan's choreography on the theme of mortality was broadly considered a tribute to the fifty-two victims of the 7 July 2005 London bombings that took place the morning after London won its bid to host the Olympics. During the Opening Ceremony, as a prelude to his piece, a sombre and reflective ambience was generated by a female commentator who reminded audiences of the event. This announcement framed Khan's choreography as an homage to the victims of 7/7 and a celebration of the resilience of humanity. Furthermore it meaningfully punctuated the politics of a Muslim man's commemorative choreography to mark the lives lost in the attacks by home-grown British Muslim Al-Qaeda terrorists. *Abide with Me* thus became a demonstration of Boyle's politicised narrative of a complex, pluralised Britishness that permeated his broader Opening Ceremony entitled 'Isles of Wonder'.

Boyle's journey through the British nation consisted of a segment on the Industrial Revolution, a tribute to the National Health Service, a celebration of Britain's rich literary heritage and a journey through British popular music and culture. Central to the tone of the 'Isles of Wonder' was British irony and self-deprecating humour channelled through institutionalised icons of Britishness such as the Queen, David Beckham, James Bond (played by Daniel Craig) and the comedian Rowan Atkinson. And at the heart of this Opening Ceremony was the abundant youthful energy emanating from the presence of children and young people, yet again referencing London's original bid to inspire future generations.

Khan's tribute was strategically placed between Boyle's satirical and performative historicisation of the nation's past and the ritualistic Parade of the Athletes. This placement also metaphorically signalled Britain's complex relationship to its contentious past as well as its role in negotiating global futures. Changing the tone of the Opening Ceremony from fun, frivolity and jubilation to one of reflection and resilience, Khan's choreography enabled the audience to acknowledge and remember those people who were absent from the celebrations but ever-present in the nation's collective memory. Reflecting on the making of the piece a year later, Khan shared his initial doubts about tackling such a profound theme in a global and popular context:

> Danny Boyle gave me a single word: mortality. I thought that was really courageous. For an Olympic Opening Ceremony in front of the world to take on a subject about life and death was really interesting and really challenging. One word to just remind us that life is powerful and fragile at the same time. (Ak. Khan, *Telegraph*)

This powerful fragility of the theme was captured in the accompanying haunting rendition of the Christian hymn *Abide with Me* by the Scottish singer of Zambian-English heritage Emeli Sandé. Layered against lyrics that clearly referenced faith, Khan's choreography was far more than an impressive display of virtuosic skill as previously evidenced in the use of dance in Beijing's (2008) and Athens' (2004) Olympic Opening Ceremonies. It was instead an emotionally charged piece that evoked profound themes related to mortality such as life, death, spirituality, intergenerational bonds and transmissions of hope and love between parent and child within a multicultural society.

Abide with Me[1]

A montage of photographs of deceased friends and relatives of those in the stadium lights up the 'Wall of Remembrance' screen as a female commentator explains that the morning after London won its bid to host the 2012 Olympic Games, Al-Qaeda terrorists bombed London's transport system during the morning rush-hour on 7 July 2005 and claimed fifty-two lives.[2] The montage gradually fades to reveal a big, vibrant and yellow sun, signalling the promise of a brighter future, with a triangular mass of bodies standing beneath and before it. Staring resolutely at the stage their hands are fisted in a sign of resilience while their drooping shoulders and spines simultaneously signal a sense

of resignation to their victimised conditions. As anticipation builds, enhanced by an eerie silence that descends through the stadium, the performers release a cloud of dust into the air from their fisted hands, and a soundscape of a beating heart infiltrates the space. Whether cremated or buried, the dust is reminiscent of what human bodies are reduced to in death, juxtaposed poignantly against the heartbeat, the sound of life itself. The collective momentarily part to enable a young South Asian boy to escape from the centre of their cluster.[3]

The Boy appears to emerge from the sun and runs through the stage with the chaotic vitality of youth, optimism and aspiration. His freedom is juxtaposed against the constrained and synchronised movements of the collective, captured in their relentless repetition of earthy and visceral gestures that embody anger, violence and despair. The chorus cannot escape their limbo-esque existence and their restlessness is emphasised by the never-ending rhythm of the accompanying beating heart; as though in death, they are reminded of the life that was taken away from them. The Boy on the other hand runs free, stands still, and weaves in and out of their choral formations at his own whim. At a certain point he runs past Khan who visibly responds to his presence by slowing down to absorb his youthful energy. As the restlessness amongst the collective body grows, Emeli Sandé's rich and mellow voice filters through the space like a call to prayer to calm their agitated souls. The more peaceful the message of the hymn, the more violent, tortuous, animalistic and angular become the group's movements; almost as though they reject the lyrics' call for divine intervention at difficult times. This juxtaposition is disturbing and complex to accept yet makes a powerful statement on the role of faith and the widespread cynicism towards it in an increasingly multicultural and secular society that has come to be threatened by Islamophobia. Against this backdrop Khan walks slowly to the Boy, acknowledging in his youthful and untainted presence the power of the future. Twirling his hands as though they contain an imaginary legacy that he wants to pass on to the Boy who is the symbol of the next generation, Khan hypnotises him into wanting to claim this legacy but is not ready to part with it yet. Khan's restlessness is finally interrupted as the Boy envelops him in a sudden and soulful embrace. In that moment, time stands still – Khan is overwhelmed by the therapeutic power of this simple gesture and in his initial inability to respond, he remains rigid with his arms suspended mid-air by his side. Finally, when he is able to reciprocate by embracing the Boy back, Khan's physicality acquires a calm and softness that he absorbs from the Boy and through their physical contact they share past, present and

future interactions between two generations. The power of the human contact between Khan and the Boy ripples through the space and transforms the spirit of the collective. Khan walks across the stadium while holding the Boy in a tight embrace and places him at the centre of the collective who lift him towards the sun, thereby heralding a new dawn.[4]

The Boy

Embodying Khan's spirit of new interculturalism, the Boy represents both the political and the aesthetic in Khan's choreography. On a political level the Boy can be read as Khan's artistic and intellectual response to the British theatre director Peter Brook and his trademark, neo-imperialist intercultural theatre practice, most famously epitomised in *The Mahabharata* (1985, 1989). Khan's choreographic placement of the Boy at the centre of this piece on intergenerational legacy echoes another Boy, the role he himself performed as a thirteen-year-old in Brook's controversial theatre adaptation of this Indian epic which toured the world. In the subsequent film adaptation of the epic, deemed too old to revive his original role, Khan played the role of Ekalavya.[5] Through the character of the Boy, Brook created a simple narrative device in order to make the epic's complex themes and structures accessible to his mostly white and Western audiences. The Boy became symbolic of each audience member and the history of his ancestors, as narrated to him by the sage Vyasa, became the history of human civilisation. In Brook's theatre production the Boy was thus a symbol of universalism and a sign-posting narrative device that enabled easy points of access to those unfamiliar with the epic.

In *Abide with Me* the Boy was, however, as much a universal symbol of the future of multicultural Britain and its expanding diasporic communities as he was an embodiment of Khan's personal musings on the tensions and values of intergenerational and intercultural legacies.[6] More importantly, whereas the Boy in Brook's production functioned as a narrative device and lacked agency, the Boy in Khan's choreography for the Opening Ceremony was very much the agent who mobilised his people from the grasp of collective disillusionment and stagnancy towards negotiating their own legacies and futures. Khan's Boy was an agent responsible for writing his own (and the nation's) narrative and legacy. In contrast, Brook's Boy, incapable of writing his own history, passively received the story of his ancestors from sage Vyasa and Lord Ganesha, played by two white Western actors, Robert Langdon Lloyd and Bruce Myers respectively. This submissive acceptance of his own

non-white history from white co-actors was disturbingly reminiscent of what has been and remains an Orientalist tendency of the Western world to speak on behalf of non-Western people and their experiences.

On an aesthetic plane the Boy is also the very element that enables Khan to shift public perceptions of contemporary dance from the realm of a formalist visual spectacle into an emotive, theatrical and political experience that can move masses. The Boy is what humanises Khan's choreography and enables billions of people worldwide to connect to the piece's powerful themes of intergenerational legacy, hope and love between parent and child. Amidst the immaculately choreographed precision of abstract and stylised movement that captures the restlessness of the collective, the Boy walks and runs and dodges and hides and stands still and breathes and gazes and then embraces Khan as a last resort to calm him down. It is the very power of his everyday gestures that lends meaning to the abstract movements of the collective. In addition, Khan's placement of these everyday gestures alongside the stylised movement language is a deconstructive use of the South Asian principle of *abhinaya*, the codified hand and facial gestures in *kathak* (and other South Asian classical dance forms) through which human emotions, behaviours and narrative-significations are abstracted and communicated. Instead of using the established codified language of *abhinaya*, which would be lost on audience members with no understanding of South Asian dance, Khan replaces them with familiar everyday gestures of human behaviour from the contemporary milieu and they become signposts through which meaning is communicated. It is also these everyday gestures that allow the audience to imagine and connect to the Boy and Khan at a deeply personal level, simultaneously evoking in the audience both empathy and critical-distance in the form of *rasa*, the philosophy and aesthetic principle that lies at the heart of South Asian art-reception theory.

The Boy's presence and physicality shifts Khan's aesthetic into the landscape of physical theatre: the interdisciplinary and identity-politics-driven genre that shares double allegiances with avant-garde dance and theatre experimentations of the early twentieth century (Sánchez-Colberg, 'Altered States' 21). However, more importantly, the evocation and layering of the South Asian principles of *abhinaya* and *rasa* onto the landscape of contemporary dance changes it in fundamentally intercultural ways. Khan's transposition and unique treatment of *abhinaya* and *rasa* as embodied in the Boy drives his new interculturalism, and the mechanisms through which he achieves these aesthetic manoeuvres will be addressed in detail as this study develops. For now, though, it

suffices to say that the Boy in *Abide with Me* embodies two of the fundamental principles of Khan's new interculturalism – the political and the aesthetic – and signals that it is impossible to consider one as distinct from the other.

Khan's politicised aesthetic: critiquing contemporary *kathak*

As a second-generation British Muslim man of Bangladeshi descent Khan is the first man from his community to acquire a significant position in contemporary dance practice and discourse. His rise to stardom within the fields of British and global contemporary dance has been unprecedented. A success story of this nature merits close scholarly attention, not only to trace the artistic journey but to acknowledge Khan's identity as a male Muslim dancer from the British-Bangladeshi diaspora.[7] Khan's aesthetic is therefore fundamentally entwined with his diasporic identity-politics. Yet, to date most dance critics and scholars have been quick to categorise his work in more simplistic terms. They tend to emphasise its South Asianness because of Khan's *kathak* training from the age of seven at the National Academy of Indian Dance (NAID) in London under the tutelage of the *kathak* maestro Sri Pratap Pawar (Sanders *Rush*, L. Smith, Liu). More problematic is the claim that Khan is contemporising *kathak* by amalgamating aspects of his multiple movement training in *kathak* with 'classical ballet, Graham, Cunningham, Alexander, release-based techniques, contact improvisation and physical theatre' (Sanders, 'Akram'). To critique this simplistic framing of Khan's art as contemporising *kathak*, a brief historical and descriptive overview of *kathak* would be helpful here.

Scholarship on *kathak*, the north Indian classical dance form as we know it today, remains contested and divergent.[8] While Reginald Massey claims its roots in the Hindu oral tradition of the *kathakars* (storytellers) who performed tales from the two Indian epics *Ramayana* and *Mahabharata*, Margaret Walker asserts that the emergence of *kathak* points to a story that is 'as syncretic and multifaceted as the dance itself, and calls the widely accepted unlinear story of an ancient temple dance into question' (Walker 296). Pallabi Chakravorty also challenges this populist claim that *kathak* derives from the Hindu word *katha*, meaning story, and argues that perpetuation of such narratives 'tells you more about the power of discourses than actual history' of the form (Chakravorty, 'Clarification'). The discourse as per Massey reinforces that this Hindu storytelling art developed a wider repertoire that

included secular, 'imperial, social and contemporary themes' under the patronage of Muslim rulers who invaded north India from the eighth century AD (Massey 22). While *kathak*'s dual heritage in both Hindu and Islamic performance traditions has been acknowledged by scholars, Walker notes that its leading male Hindu dancers are still perceived to be its key authoritative figures (Walker 280). Despite this attempted Hinduisation of the form during the classicisation of Indian dance as part of India's nationalist project, Chakravorty asserts that *kathak*'s 'Persian influences [...] while often unacknowledged, are undeniable' (Chakravorty, *Bells* 26).

This cultural and formal syncretism lends *kathak* a form that is distinct from other Indian classical dances. It is primarily danced as a solo in which 'the spinal column of the *kathak* dancer is upright and the use of the extended arms marks out a very clear personal space which is never invaded' (Mitra, 'Cerebrality' 170). The form engages in subtle interplay between stillness and speed, and is rendered through emotional expressivities that narrate stories, as well as technical virtuosity. Complex footwork of mathematical precision known as *tatkar*, extreme speed in motion and controlled and successive pirouettes of the torso called *chakkars* are characteristic features of *kathak*. Sudden punctuated stops in both *tatkar* and *chakkars* emphasise the significance the form lays on the relationship between stillness and speed. A *kathak* dancer's lower body remains rooted to the ground through mobile but firmly placed feet that create an isosceles triangle by appearing to touch at the heels while facing away from each other at the toes. The rhythmic pounding of different parts of the feet uses the floor as a percussive instrument and creates rich and varied soundscapes through this contact. The musicality of this footwork is emphasised by *ghungroos*, the bells that the dancers wear around each ankle, and the *tabla*, the north Indian percussive instrument that accompanies *kathak*. One of the most prominent features of *kathak* recitals is the open improvisation sequences between *tabla* players and the dancers who compete by echoing calls and responses of incredibly complex rhythms that are played out through the *tabla* and the feet respectively. These sections are often accompanied by the dancer vocalising mnemonic syllables or *bols* that replicate the rhythms of the *tabla* and the feet. Sound and musicality is thus fundamental to *kathak* performances. The upper body of the *kathak* dancer uses the rootedness of the lower body to explore highly complex and virtuosic movements through the arms, wrists, neck and spine. The mercurial and circular nature of these extended arm movements always returns to the centre, the solar plexus, from which the movements seem

to emanate, and the journeys undertaken by the arms are always traced by the dancer's shifting eye focus and head. In its more expressive modalities *kathak* dancers narrate stories and impersonate characters from Indian epics. As it is primarily a solo form, *kathak* dancers shift seamlessly between different characters and emotions by embodying clearly defined and codified gestures of *abhinaya* that pertain to the characters and themes that they perform.

Kathak was only codified and formalised as an Indian classical dance form during the mid twentieth century. During this time the dance form was institutionalised as per the models of classicisation that applied the dramaturgical principles of the *Natyashastra*, the ancient book of Indian dramaturgy, to the other classical dance forms of *bharatanatyam* and *odissi*.[9] Prior to this point one of the many elements that distinguished *kathak* from other Indian classical dance forms was its largely uncodified and improvisatory movement vocabulary. However, as Chakravorty notes, even post-institutionalised codification, *kathak* to this day remains more fluid and improvisatory in its form than *bharatanatyam* and *odissi* (Chakravorty, 'Clarification').

The above discussion historicises the contested, subversive and fluid nature of *kathak*. It further signals the need to problematise the label 'contemporary *kathak*', which was generated and endorsed by critics and scholars alike and refers to the unique movement lexicon born of Khan's bodily negotiations between *kathak* and Western contemporary dance (Sanders, Piccirillo). On the one hand, this label suggested that in order to be contemporary an art form must first be westernised, revealing a problematic equation between contemporisation and westernisation in Western dance discourse. On the other hand, the label revealed a naïve homogenisation of both Western contemporary dance and *kathak*, without acknowledging them as complex, contested and heterogeneous practices in and of themselves.

Although early on in his career Khan himself used the label as a 'reference point for the audience', he admitted that he had not gone 'deep enough into the work yet to know what to call it' (Ak. Khan qtd in Sanders, *Rush* 7). He did, however, reject the term fusion, which to him implied the application of a forced 'formula on an intellectual level' instead of the open-ended and exploratory nature of his aesthetic (Ak. Khan qtd in Burt, '*Kaash*' 104). Khan very soon rejected all associations with the label 'contemporary *kathak*' and started to speak of his emergent language as a 'confusion' that was being generated in his body. In 2008, Sanders reconsidered the efficacy of the label and stated that 'Contemporary Kathak [...] provides difficulties because its complexity

is not explicable as fusion. Khan's own rejection of the term as inappropriate to his work can be supported in that it suggests an over-simplistic response. To understand Khan's embracing of what he calls the confusion [...] requires a shift in critical and historical perspectives' (Sanders, *'ma'* 55). She therefore questioned the formalist spirit of the label and acknowledged the hybridity inherent in both *kathak* as an amalgamation of Islamic and Hindu performance traditions and the eclectic practices that come under the remit of Western contemporary dance.

A more persuasive view from dance scholar Ramsay Burt suggests that Khan's aesthetic does not so much enter into dialogue between *kathak* and contemporary dance as it requires an analysis of the 'subject of these dialogues and the new kinds of cultural meanings which they have enabled' (Burt, *'Kaash'* 93). Burt asserts that these new cultural significations contribute to 'the richness and diversity of contemporary culture in Britain' (Burt, *'Kaash'* 100).[10] In this book I extend Burt's observation by claiming that contrary to popular belief Khan is not contemporising *kathak*, but is in fact transforming the landscape of British and global contemporary dance through his own embodied approach to new interculturalism. By layering South Asian dramaturgical principles of *abhinaya* and *rasa* onto Western contemporary dance practices Khan is transforming the latter in fundamentally intercultural ways, while simultaneously reframing the contexts and modalities through which *abhinaya* and *rasa* have been traditionally performed and received. Such an analysis of Khan's aesthetic complicates the perception of Khan as a contemporary South Asian dancer. More importantly, Khan's art enables a reframing of interculturalism in the arts beyond its historic associations of one-way borrowings of non-Western people, traditions and texts by mostly white Western practitioners. As a non-white British artist with an embodied diasporic reality, with training in multiple movement traditions and knowledge of multicultural dramaturgical conventions, Khan interrupts this one-way flow by placing his embodied and interventionist approach to new interculturalism at the heart of his aesthetic experimentations and artistic enquiry.

My study therefore examines the relationship between Khan's complex identity-positions and his art through the lens of new interculturalism. Khan's new interculturalism emerges at the intersection of his two mutually linked embodied realities: his political and philosophical negotiations of multiple identity-positions as a second-generation British-Bangladeshi, and his performance training in varied movement languages, with a particular emphasis on his embodiment of the South Asian dramaturgical principles of *abhinaya* and *rasa*. This embodied

nature of the enquiry distinguishes Khan's new interculturalism from the intercultural theatre of the 1980s. Driven by the lived experience of diasporic realities, which necessitates subjects having to simultaneously negotiate multiple cultures, new interculturalism is a life-condition as much as an aesthetic and political intervention. Unlike the intercultural theatre-makers of the 1980s Khan's embodied new interculturalism manifests itself in his practice as both a dancer *and* a choreographer, shaping both the aesthetic and the content of his art. It is this embodied reality that I want to emphasise in theorising new interculturalism as I delineate it from the intellect-driven spirit that fuelled intercultural theatre of the 1980s.

Intercultural theatre and Peter Brook's *The Mahabharata*

Theatre scholar Erika Fischer-Lichte reminds us that the term intercultural theatre was introduced relatively recently to theatre studies around the 1980s (Fischer-Lichte 1). It refers to a specific set of 'taxonomic "masterpieces" of the late twentieth century' represented by the works of mostly Western theatre-makers like Peter Brook, Ariane Mnouchkine, Eugenio Barba and others who interacted with non-Western people, texts, traditions and artefacts in their desire to create theatrical dialogues with other cultures (Holledge and Tompkins 113).[11] Criticised for cultural appropriation, Orientalist depictions of non-Western cultures and neo-imperialist tendencies to silence or at the least suppress the marginal voice(s) in favour of Western perspectives, intercultural theatre has frequently come under attack by postcolonial scholars and their critiques are prolifically documented. For comprehensive debates on intercultural theatre please see *Theatre at the Crossroads of Culture* by Patrice Pavis, *By Means of Performance: Intercultural Studies of Theatre and Ritual* edited by Richard Schechner and Willa Appel, *Theatre and Interculturalism* by Ric Knowles and the journal article 'Toward a Topography of Cross-Cultural Theatre Praxis' by Jacqueline Lo and Helen Gilbert amongst other studies on the subject. For insightful postcolonial criticisms of intercultural theatre practice please see *Theatre and the World: Performance and the Politics of Culture* by Rustom Bharucha, *Post-colonial Drama: Theory, Practice, Politics* by Helen Gilbert and Joanne Tompkins and the journal article 'Beyond a "Taxonomic Theater": Interculturalism after Postcolonialism and Globalization' by Una Chaudhuri.

For the purpose of contextualising Khan's response to this brand of intercultural theatre a summary of the scholarly responses to Brook's

controversial adaptation of *The Mahabharata* is helpful. Condemned or acclaimed, Brook is a seminal figure in the field of intercultural theatre and the criticisms waged against *The Mahabharata* are in many ways representative of critiques against the Western project of intercultural theatre as a whole. When we consider Khan's own childhood experience of working with Brook on *The Mahabharata*, Khan's new interculturalism can be read as an artistic and critical response to Brook's intercultural theatre. Khan acknowledges the debt he owes to Brook for informing his future artistic vision of performance-making and the importance of distillation and minimalism in the art of storytelling. However, he simultaneously states that there is very little in common between his own aesthetic and Brook's as it is impossible for two people to experience or tell the same story in the same way because they see it through intrinsically different lenses that have been shaped by their own specific lived realities:

> While I owe a huge debt to Brook, my own aesthetic has developed in fundamentally different ways to his, despite our shared drive and desire to tell the most complex stories in the most minimalist ways. (Ak. Khan, Interview 2)

To understand Khan's response to Brook we need to first engage with Brook's approach to intercultural theatre as exemplified in his production of the epic.

Brook's *The Mahabharata* has attracted the most critical attention in its 'blatant (and accomplished) appropriations of Indian culture in recent years' (Bharucha, *Theatre and the World* 68). However, David Williams observes that several postcolonial critics accuse Brook of being a 'self-appointed representative of a "universal culture"' in light of his similar-veined projects with Iranian, African and Native American myths (D. Williams, 'Theatre of Innocence' 24). Amongst them the voice of Rustom Bharucha remains a cornerstone. Bharucha's seminal essay on Brook's *The Mahabharata* counters celebratory claims by mostly Western critics and provides an Indian perspective on Brook's tactless borrowing of the Hindu epic of *Mahabharata*, India's *itihasa*, her living 'history in all its detail and density' (Bharucha, *Theatre* 69).[12] He goes on to observe:

> At one level, there is not much one can do about stopping such productions. After all, there is no copyright on the *Mahabharata* (does it belong to India alone? or is it an Indian text that belongs to the

world?). I am not for a moment suggesting that westerners should be banned from touching our sacred texts. [...] All I wish to assert is that the *Mahabharata* must be seen on as many levels as possible within the Indian context, so that its meaning (or rather, multiple levels of meaning) can have some bearing on the lives of the Indian people for whom the *Mahabharata* was written, and who continue to derive their strength from it. (Bharucha, *Theatre* 69–70)[13]

Bharucha's critique extends beyond the use of the source text itself and includes Brook's borrowings from Indian performance traditions and cultural artefacts, 'converting them into raw material for his own intellectual experiments' (Bharucha, 'Peter Brook's *Mahabharata*' 1642).

Less inflammatory in tone, other scholars articulate similar points of concern with Brook's production. Gautam Dasgupta reiterates the complex significance that the epic holds in the lives of Indians as 'a revelatory injunction, ethical and theological in purpose, that determines and defines the social and personal interactions of millions of Indians' (G. Dasgupta 10). Brook's interpretation, in his desire to 'chisel free a viable narrative spine from this sprawling material', fails to capture these complex levels at which the epic operates in India (D. Williams, 'Theatre of Innocence' 22). Acknowledging Brook as an important Western performance maker who has experienced the inevitable challenges and pitfalls of intercultural dialogue, several Western scholars like Robert Gordon, Marvin Carlson and Phillip Zarrilli note, however, that Brook's creolised version of the epic was 'a trendy western performance that consciously and unconsciously misses the point of the original, creating a palatable Asian culture acceptable to Western viewers' (Gordon 331).

A more sympathetic view comes from Maria Shevtsova who endorses Brook's search for a universal human condition through theatre and argues that artists possess the creative licence to exercise individual interpretations when creating art (Shevtsova 99–100). Una Chaudhuri identifies in Brook's work evocations not of the universal but of multicultural diasporic spaces of the global times (Chaudhuri qtd in D. Williams, 'Assembling' 242). The most supportive view from India comes from the late Bengali filmmaker and film historian Chidananda Dasgupta who critiques the spirit of 'nation-state chauvinism' that perpetuates the idea that cultural traditions and artefacts are born in and owned by a nation alone (C. Dasgupta 1). Referring to Brook's outsider identity to the Indian nation he cynically questions whether cultures should be 'hermetically sealed off except where the outsider can become an insider through a lifelong effort?' (C. Dasgupta 1).

Central to the above critiques are the following issues. Firstly, as Gautam Dasgupta observes, Brook's unwieldy handling of the source text revealed his lack of consideration of its significance to the Indian people. Secondly his borrowings of performance traditions and cultural artefacts from India and their use out of context disturbed Bharucha who championed a more sensitive and nuanced handling of these cultural resources. Thirdly, as noted by Zarrilli, Carlson and Gordon, Brook's denial of the epic's cultural specificity in favour of presenting a palatable version of India to a primarily Western audience suggested a lack of respect and understanding of the epic's central drive. Fourthly, in Bharucha's opinion this flattening of the epic's Indianness reinforced the inherent imbalances that shaped power dynamics between the cultures involved in the exchange. And finally and perhaps most importantly, Bharucha emphasised Brook's outsider relationship to the source text itself, arguing that this is what fundamentally triggered his lack of understanding and sensitivity towards the other issues in the first place.

The political implication attached to an outsider status is often the central line of critique for many intercultural theatre projects which have been historically made by people who in and of themselves have approached cultural difference from their predominantly white Western monocultural perspectives. No matter how fascinated or curious they might have been about interacting with other cultures, it would be fair to conclude that their interactions have been somewhat limited by such a specific starting point. Consequently, intercultural theatre has focused on creating a very particular kind of mise en scène where diverse cultural traditions, texts, artefacts and people coexist within a predominantly Western dramaturgical framework. Stylistically, such mise en scène has taken two forms. In the first instance these diverse cultural elements have rarely interacted with each other, creating instead a superficial collage of cultural-scapes that appear to be precariously glued together like pieces of a jigsaw that do not fit. Or, in the second instance, these elements have been diluted to such an extent by the driving Western dramaturgical framework that one has to question the point of using them in the first place. Thus driven by a desire to invigorate Western theatre practice with (usually) non-Western cultural reference points, intercultural theatre has taken the form of a premeditated and intellectual exercise undertaken from an outsider's perspective.

This line of critique can be potentially interrupted and complicated when one's simultaneous insider-outsider status between and across multiple cultural and national contexts changes the power dynamics at play by dismantling historical us-them hierarchies, by simultaneously

embodying us, them and phases in-between. This has the potential to shift intercultural theatre from its historical reputation of being a primarily one-way Western (white) imperative that appropriates non-Western otherness, to be replaced by a relentless back-and-forth lived reality that permanently negotiates multiple othernesses from the perspective of an other. In the latter instance new interculturalism becomes an interventionist aesthetic and an embodied, political and philosophical way of thinking and being within oneself and ultimately shapes interactions with others.

New interculturalism, British multiculturalism and hybridity

Before identifying the newness in Khan's interculturalism, it is vital to delineate between the noun interculturalism and its adjectival form, intercultural. The adjective, specifically when linked to theatre, refers to 'a genre, a particular way of doing theatre' that was popularised in the 1970s and 80s by Western theatre-makers like Brook and others, as discussed above. The noun refers to an individual's philosophical and political principles that nuance the way in which the person perceives and interacts with people, artefacts, politics and traditions from cultures other than their own (Bharucha, 'Dialogue'). Interculturalism thus represents a conceptual, processual, embodied lived condition driven by one's own multiple affiliations to cultures, nations and faiths.

This distinction is captured in Khan's own recognition of his aesthetic as generated out of confusion, signalling an open-minded and embodied aesthetic as opposed to the intellectually imposed and formulaic nature of fusion that necessitates fixed outcomes (Burt, '*Kaash*' 104). Khan's rejection of fusion in favour of a more organic and embodied interaction with (all kinds of) otherness is politicised in Bharucha's passionate call for the need to distinguish between interculturalism and its state-sanctioned, safer avatar of multiculturalism:

> I would argue that we need the term 'interculturalism' because it is politically necessary for us artists, as citizens, to find ways of countering the dominance of official state-determined 'multiculturalism'. (Bharucha, 'Dialogue' 10)

This state-determined spirit of British multiculturalism as a strategy to deal with immigration-driven cultural diversity within the nation-state bears strong resemblances to intercultural theatre's historical tendency

to essentialise and emphasise cultural differences. It is therefore vital to understand how Khan's new interculturalism negotiates the wider socio-political forces of British multiculturalism that shape the nation's arts and that have framed his velocious rise to stardom, in order to understand the innate differences between them.

The emergence of Khan's unique, hybridised aesthetic fortuitously coincided with a strategic era in late twentieth and early twenty-first century British politics under the Labour government, when cultural diversity was encouraged and celebrated as part of a new 'cool Britannia' agenda of rebranding Britishness. Joanna Fomina observes that the initiatives fostered by the newly elected Labour government towards cultural diversification of Britain's work force included a 'well-developed anti-discrimination policy' which 'enabled some people with ethnic backgrounds to occupy high positions in the media [...], politics, business and arts' (Fomina 414). Khan was fortunate to graduate from university in 1998, the year after Labour regained power, circulating this inclusive vision of Britain as One Nation where 'every colour is a good colour [...] every member of every part of society is able to fulfil their potential [...] racism is unacceptable and counteracted [...] racial diversity is celebrated' (Home Office qtd in Runnymede Trust Report). He was amongst Britain's young and ethnically diverse citizens who were identified by Chris Smith, the Secretary of State for Culture, Media and Sport at the time, as subjects who would be nurtured and transformed into the nation's assets.

Multicultural policies under the British Labour government (1997–2010) oscillated between the desire to increase visibility of ethnic minorities in public spaces in the early years and the need to protect the white British population from experiencing a diluted sense of national identity, jointly brought about by large-scale immigration and the threat of Muslim fundamentalist-extremism in post 9/11 and 7/7 contexts. Black, Keith, et al. remind us that 'in the immediate aftermath of its massive election victory in May 1997, New Labour was keen to present a commitment to modernising Britain, embracing diversity and valuing cultural mix' while promoting Britain's young and ethnically diverse citizens as the nation's assets (Black, Keith, et al. 2). They continue to note, however, that after Labour's second-term victory in June 2001 their policies on multiculturalism changed tone somewhat. Home Secretary David Blunkett announced the introduction of a new citizenship test, the requirement for immigrants to learn English, the banning of female genital mutilation and forced marriages and a regulation that arranged marriages were permissible only between

South Asian residents in Britain. Werner Menski identifies a further contradiction in the Labour government's multicultural promotion of visibility of ethnic identities and how this manifested itself within the public domain:

> Members of an 'ethnic minority' in Britain today who emphasize that fact too visibly, are going to face difficulties, because the pressures of assimilation remain so very strong. At the same time, making oneself invisible is not really a viable option for non-white immigrants and their descendants. (Menski 12)

Examining this issue of visibility in the context of the contemporary British (and international) art world, Kobena Mercer echoes Menski's concerns in noting that 'although cultural difference is now more visible than ever before, the unspoken rule is that you would look a bit dumb if you made a big issue out of it' (Mercer, 'Ethnicity' 193). Mercer's and Menski's observations about this oscillating nature of making difference visible in both the British and the international domain raise interesting questions about what constitutes too much visibility and what is visible enough, and indeed who judges this sliding scale. While the Labour government nurtured and encouraged culturally diverse British men and women so that they gained more visibility, it is the way in which this visibility was managed and circulated that influenced how the public viewed them. I would argue that at the heart of this management of visibility is the role of the arts.

This management of visibility in the public domain of British culture was implemented by the Labour government's strategic renaming of the Department of National Heritage as the Department for Culture, Media and Sport:

> The renaming [...] intended [...] to signal a shift of focus away from support for the 'traditional' high arts, with their association with the protection of the values of some golden age, towards the creatively new (often associated with young, trendy and 'cool'). (Garnham 27)

Arts Council England (ACE) echoed this philosophy of innovation in order to nurture arts that could reflect Britain's contemporary, culturally diverse landscape. However, reconciling between tradition and innovation became a tricky terrain for ACE vis-à-vis meeting the needs of Britain's culturally diverse populations. On one hand ACE had to find 'a way to preserve discrete ethnic identities' and their culturally specific

art forms from disappearing in the new landscape (Kivisto qtd in Netto 48). On the other it had to find ways to encourage the growth of new art forms born of the dialogue between mainstream Britishness and 'a countervailing identity that unites the disparate groups within a polity' (Kivisto qtd in Netto 48). The need to ensure preservation on the one hand and encourage innovation on the other resulted in a mixed set of priorities that implemented itself differently at the local (margin) and national (centre) levels.

At local community levels traditional arts continued to thrive and diverse cultural heritages were preserved in museums and galleries through their educational initiatives fostering cultural diversity (Lopez y Royo, 'South Asian Dances'). However, in the national mainstream, hybridity and innovation gripped the public imagination as these qualities became 'prime site for studying the construction and mediation of identity in public space' (Netto 48). The importance of hybridity as a marker for successful integration of immigrant identities continues to be reinforced by the current coalition government's approach to managing cultural diversity. Its reinforcement perhaps signals a more worrying trend in contemporary Western governments vis-à-vis their move towards an assimilation model in managing cultural diversity. In their attempts to enable social cohesion and control immigration, David Cameron, representing the Conservative Party, and Nick Clegg, representing the Liberal Democrats (2010–), not only reinforce hybridity as integral to their cultural diversity management policies but also imply a privileging of the middle and upper classes by claiming that they want to attract 'the brightest and the best immigrants to Britain' (Cameron qtd in Bagchi and Sinha). This conflation between the conditions of hybridity and social and economic privilege is well documented in cultural studies.

Hybridity as a socio-cultural, political and philosophical concept has been as celebrated as it has been critiqued by scholars. Championed by cultural studies giants such as Homi Bhabha, Stuart Hall and Paul Gilroy, the postcolonial and diasporic condition of hybridity is believed to signal an 'interstitial passage between fixed identifications' that 'opens up the possibility of a cultural hybridity that entertains difference without an assumed or imposed hierarchy' (Bhabha, *Location* 5). Bhabha, Hall and Gilroy have celebrated hybridity as an anti-essentialist critique of cultural identity. They have advocated hybridity as a powerful interventionist tool that harbours agency for a diasporic subject's identity-formations. They further argue that hybridity lends its subjects self-critical distancing from a singular source of identity. This can enable

them to reflect simultaneously upon their place of origin and their place(s) of settlement.

The concept of hybridity has also been criticised for becoming an elitist trope that empowers a small section of an already privileged and mobile global diaspora. Annie E. Coombes and Avtar Brah raise issue with celebrations of hybridity in diasporic arts (as endorsed by British multicultural policies) and observe that at times the concept has been responsible for 'an uncritical celebration of the traces of cultural syncretism which assumes a symbiotic relationship without paying adequate attention to economic, political and social inequalities' (Coombes and Brah 1). Sanjay Sharma, John Hutnyk and Ashwani Sharma attribute the current proliferation of South Asian diasporic arts in Britain to the fact that 'Ethnicity is in. Cultural difference is in. Marginality is in. Consumption of the Other is all the rage of late capitalism' (Sharma, Hutnyk, and Sharma 1). This leads them to question whether 'being hybrid is all there is to being subversive' (Sharma, Hutnyk, and Sharma 3). Alessandra Lopez y Royo similarly notes the association between hybridity and progressiveness in contemporary South Asian dance in Britain:

> South Asian dancers are expected to engage with a western dance aesthetics – constantly pushing boundaries in terms of presentation, stagecraft, music, the unfolding and development of the theme, and doing so in a fashion recognisably informed by western performance standards. The imposed goal is to create new, different, never-seen-before work, to experiment with hybridity, to break boundaries, bowing to western modernist and postmodernist aesthetics that seem to reign unchallenged. (Lopez y Royo, 'Dance')

There is a perception that the hybrid works of celebrated South Asian artists like writers Salman Rushdie and Hanif Kureishi, musicians Talvin Singh and Nitin Sawhney, artist Anish Kapoor and dancer/choreographers Shobana Jeyasingh and of course Khan himself respond to these expectations and strategically make use of their ethnicity 'to tap into the socio-economic grids of power that support the arts' (Purkayastha 264). In this light, writers like Rushdie have been described as a 'part of the Western literary intelligentsia' (Sharma 598) and are believed to write 'both in and for the West' (Said qtd in Sharma 598). A similar line of critique is aimed at the music of 'Asian Kool' artists like Talvin Singh and Nitin Sawhney who are believed to create a 'heavily sanitized version of a British-Asian "dissident diaspora"' (Banerjea qtd in Jazeel 234).

Pnina Werbner furthers Banerjea's sentiments by suggesting that the reason why the diasporic arts of South Asian intellectuals ultimately have no impact upon the larger South Asian diaspora is because:

> most high cultural works by South Asian intellectuals have been ultimately financed and consumed mainly by a mainstream English and a small secular South Asian elite audience. (Werbner 904)

Khan himself is quick to recognise the elitist dimension of his practice when Wendy Perron asks if his Bangladeshi community comes to watch his works:

> The Bangladeshis here like entertainment like Bollywood. Once I moved into the circle of the Western audiences, they wouldn't come to my shows because they felt my venues were too bourgeois. But eventually my generation from the Bangladeshi/Indian/Asian communities started coming – from the sculpture world, from the visual arts, theatre, film. (Ak. Khan qtd in Perron)

In his bid to defend the music of 'Asian Kool' artists Tariq Jazeel reminds us:

> That this music may be produced and consumed by both a white and non-white suburban middle class resident in Britain does not mean that this middle class does not face its own identity struggles in Britain's contemporary multiculture. (Jazeel 235)

Jazeel's defence is important not only for its relevance in the field of diasporic South Asian music but because it can be extended to the study of Khan's contributions to the field of British and global dance. While recognising the criticisms aimed at artists like Jeyasingh and Khan, Prarthana Purkayastha similarly defends the significance of their contributions to British and global contemporary dance and claims that 'to say that Khan or Jeyasingh do not engage seriously or sensitively with the politics of race or identity [..] and come up with startling innovations, would be erroneous' (Purkayastha 264–5). Thus, despite its pitfalls, hybridity, as championed by the many faces of British multiculturalism, is a helpful lens through which Khan's new interculturalism can be conceptualised and understood.

While Khan's new interculturalism embraces British state multiculturalism's call for mainstream integration through its embodied hybrid aesthetic and identity-politics-driven content, it also echoes Ted Cantle's championing of interculturalism as both a departure

point from and a more progressive alternative to its failed precursor of multiculturalism.

> Interculturalism now provides the opportunity to replace multiculturalism as a conceptual and policy framework and to develop a new positive model which will underpin cohesive communities. It will also contribute to a new vision for learning to live together in a globalised, super-diverse world. (Cantle, *Interculturalism* 2)

Cantle argues that this shift is crucial as British multiculturalism has led to a dangerous ghettoisation of multi-ethnic communities that coexist in plural monocultures but rarely interact in productive ways:

> The more diverse societies have become, and the more people have been exposed to difference and become accustomed to it, the more they seem to retreat into their own identity, embrace identity-politics and support separatist ideologies. (Cantle, *Interculturalism* 14)

In a timely study that argues for the significance of interculturalism as the much needed alternative to this failed state-project of multiculturalism, Cantle theorises interculturalism as a politically and philosophically progressive ethos within governmental politics to mediate cultural super-diversity. He distinguishes between multiculturalism and interculturalism in the following ways:

> Interculturalism provides the opportunity to address five significant issues which multiculturalism has simply ignored. These are crucial in the new context of globalisation and super-diversity and are set out below:
>
> - Identity as a dynamic concept
> - From 'race' to recognition of all other forms of difference
> - From national to global/international drivers of difference
> - New power and political structures
> - An inter-disciplinary approach. (Cantle, 'About Interculturalism')

Cantle suggests that while past models of multiculturalism have essentialised identities on the basis of race alone, thereby treating identity-positions as fixed, interculturalism considers all forms of diversity in relation to identity including gender, sexual orientation, class and faith. He further suggests that interculturalism dislodges identities as fixed and emphasises their processual nature such that identity-positions are now chosen as opposed to inherited. Most importantly, Cantle argues

that where multiculturalism has 'dramatised difference' between communities, interculturalism, by virtue of its emphasis on enabling dialogue between communities, focuses on similarities between them as a way into these interactions (Cantle, 'About Interculturalism'). Khan echoes Cantle's thoughts:

> My aesthetic is driven by a search for common threads and experiences between people, and cultures. I am not as interested in what distinguishes them. This is not at all to deny that differences exist between them, because of course these differences make them culturally unique. But I am keen to find similarities that bind people despite their differences. (Ak. Khan, Interview 2)

In neither flattening differences nor emphasising them through ghettoisation in the spirit of British multiculturalism, Khan's aesthetic feels more in line with Cantle's interculturalism. Thus, Cantle's political theorisation of interculturalism is a valuable departure point from which to start my conceptualisation of the 'new' in Khan's new interculturalism, within the context of British and global contemporary dance practice and discourse.

The new in Khan's new interculturalism

My conceptualisation of this newness is in some ways a semantic tribute to the post in postmodern in its ability to signal both an aftermath and a dialectic exchange with its predecessor. While many scholars have embraced new categories to mark a moment of departure from dominant thinking around intercultural theatre (Erika Fischer-Lichte's concept of 'interweaving cultures', Rustom Bharucha's label of 'intracultural' and, most recently, Rachel Fensham and Odette Kelada's favouring of the 'transcultural' to cite a few examples), I wish to enter into critical dialogue with the very term that remains disputed by examining how Khan's aesthetic is challenging and rewriting some of the very premises of its long-contested identity. If, as according to Una Chaudhuri, the recent turn in intercultural performance has been 'to dislodge, once and for all, the handful of works and artists that have occupied interculturalism's center stage for so long', then Khan's art can be cited as one such promising intervention (Chaudhuri 34). In his attempt to complicate the one-way traffic that has historically characterised the borrowing of non-Western people, resources and performance traditions by Western practitioners, Khan's negotiation of new interculturalism makes several

points of departure from the predominantly white, Western project of intercultural theatre in the following ways:

1. In being a simultaneous insider-outsider to multiple cultural and national realities and identity-positions Khan's understanding of and approach to cultural interaction is not an intellectual and formulaic exercise but an embodied reality and a political and philosophical stance. His art is consequently nuanced by this very insider-outsider perspective on interacting with cultural otherness, generated from his own non-white status as an other. I stress therefore that this embodied inside-outside nature of Khan's new interculturalism delineates itself from the intellectually driven and predominantly white outside imperative of intercultural theatre-makers and is an inherently non-white reality, critique and aesthetic.

2. This multistitiality between different reference points is not just true of Khan's identity-positions but is also reflected in his embodied training in multiple movement vocabularies from the South Asian dance form of *kathak* to the eclecticism of Western contemporary dance with a special emphasis on the genre of physical theatre. Embodying various movement languages has enabled Khan to negotiate within his own body the tensions and potentials of working with and through a body that is fundamentally intercultural. Khan can therefore lay claim to Western and South Asian dramaturgical principles and techniques with equal prowess. This insider-outsider position once against distinguishes Khan's new interculturalism from the intercultural theatre projects of his Western predecessors who have predominantly approached non-Western dramaturgies and texts from the outside.

3. While the Western starting point for intercultural theatre has often been to adapt non-Western texts (such as *The Mahabharata*) with a view to extrapolating their innate universalism, Khan chooses to work with personal stories (sometimes his own and sometimes others') and cultural exchanges that operate primarily at a corporeal level. In focusing on more microcosmic, personal and embodied starting points, Khan's works are ironically often more accessible and less threatening to the source culture/s.

4. While the majority of intercultural theatre projects have relied on intercultural exchanges and translations in textual terms, Khan's new interculturalism is strategic in evolving through an open-ended corporeal aesthetic that is ambivalent and ephemeral and therefore impossible to fix in its significations.

5. Where intercultural theatre projects have been predominantly medi-
 ated and consequently diluted through Western dramaturgical lenses
 for fear of exposing Western audiences to aesthetics and themes too
 unfamiliar and other, Khan's aesthetic is unapologetic in its simultane-
 ous use of multilingual soundscapes and South Asian classical codes of
 abhinaya alongside other familiar Western dramaturgical techniques.
 The effect of Khan's mise en scène must be delineated from the mise
 en scène of cultural fusion in intercultural projects where cultural
 elements remained estranged from each other. While in intercultural
 theatre the audiences are presented with a westernised version of
 non-Western readerly texts, Khan's new interculturalism offers his
 audiences the opportunity to complete his art by interacting with
 his writerly texts and bringing to their readings their own lived reali-
 ties (Barthes, *S/Z* 4). This echoes Roland Barthes' seminal proclamation
 of the death of the author which resulted in his championing of writ-
 erly texts as those that enabled the birth of the reader through inter-
 actions with the text and its galaxy of signifiers. Barthes claimed that
 this empowered the reader to become an active agent in completing
 the text itself. Khan's new interculturalism creates such writerly texts
 by enabling his audiences to interact with his art at intimate and
 visceral levels in a way that intellect-driven intercultural theatre resisted.
6. Finally and perhaps most importantly, Khan's engagement with
 otherness operates in fundamentally different ways to the appropria-
 tion of otherness in intercultural theatre. Khan's new intercultural-
 ism deploys othering as an aestheticisation process and a conscious
 dramaturgical strategy through which he and his audiences encoun-
 ter multiple versions of his self. In this it is similar to his collabora-
 tor from *Zero Degrees* (2005) Sidi Larbi Cherkaoui's postulations on
 conceiving the self as both one and many Others:

 > You are never just one thing, one character, one function but
 > rather each of us has the ability to perform many different func-
 > tions, within a project but also in life. By recognizing this mul-
 > tiplicity in oneself, you realise that 'the Other' (being the other
 > performer, the new culture you discover, or the audience even)
 > is often buried somewhere inside you too. [...] 'The Other' is
 > somewhere inside of you. It's never really detached from you, and
 > it is this bond that makes me keep looking for other links. It's a
 > never-ending search for interconnectedness, for common roots.
 > (Cherkaoui qtd in Uytterhoeven 10)

Such an engagement with otherness may at first be mistaken for the same inquisitiveness for the other that fuelled intercultural theatre's Orientalist depictions of alterities. This would, however, be a reductive interpretation of Khan's new interculturalism. What makes Khan's process of othering distinct from the banal cultural inquisitiveness of intercultural theatre-makers is that he approaches othering as a self-reflexive exercise in his attempt to locate and identify the innumerable others in his own self. In other words it is from his own position of the other that Khan engages critically and artistically with alterities in order to examine his own multiple selves more closely. This self-reflexivity through which Khan interrogates otherness in himself is what lends Khan's new interculturalism its integrity and its charge, and echoes Anthony Giddens' conceptualisation of the self in post-traditional societies as 'a reflexive project' (Giddens, *Modernity* 32).[14]

Khan is strategic in how he negotiates the fine line between seemingly conforming to while simultaneously critiquing intercultural theatre's attitude towards otherness. On the one hand it is undeniable that Khan creates a safe environment for his diverse though predominantly white audiences to gain access to his explorations of otherness in a way that makes them feel like they understand difference. One such sanitised and safe space where otherness is celebrated, engaged with and commodified, and where 'the glitter of cultural difference sells well' (Beck 41) is Sadler's Wells, 'London's Dance House', where Khan is an Associate Artist:

> Sadler's Wells is a world leader in contemporary dance presenting a vibrant year-round programme of dance of every kind – from tango to hip hop, ballet to flamenco, Bollywood to cutting-edge contemporary dance – bringing the best of international and British dance to audiences at our three theatres in London. (Sadler's Wells website)

Hailed by its artistic director Alistair Spalding as the UK's premiere venue for contemporary dance, Sadler's Wells commissions, programmes and promotes the cutting edge in international and British contemporary dance, representing the popular, the avant-garde and the highly commercial ventures. Attracting diverse though predominantly white audiences from across London, Sadler's Wells is a significant arts organisation and venue that is instrumental in bringing cultural diversity from the global contemporary dance world to the city. As the only British-Asian dancer and choreographer and one of three non-white associate artists on the list, Khan's presence in this space of celebrating, exhibiting

and consuming otherness is significant.[15] It is precisely through his influential presence and seeming conformity within such a mainstream space that Khan's new interculturalism interrupts banal representations of otherness. By grounding it in the lived realities of non-white, privileged and mobile diasporic subjects who as others themselves negotiate multiple forms of otherness, Khan articulates his own selves through encounters with alterities within mainstream British culture. Khan thus critiques the naiveté of intercultural theatre's appropriations of otherness by unapologetically representing othered realities as specific to non-white realities. This act of drawing his audiences in while simultaneously distancing them is fuelled by Khan's self-reflexivity which enables him to represent othernesses from a position of the other, and with greater nuance and integrity than the cultural appropriations of alterities characteristic of intercultural theatre. The real innovation in Khan's art thus lies in his ability to undercut his white audiences' encounters with difference by providing a parallel counter-narrative that is specific to non-white diasporic lives inaccessible to the majority of his audience members and unapologetically untranslated within his aesthetic of new interculturalism. In other words, his ability to lull the mainstream into thinking that he conforms to their whiteness makes his destabilisation of white mainstream culture from within a powerful intervention. The othering inherent in Khan's new interculturalism thus teeters strategically between resisting mainstream whiteness and pacifying it at superficial levels through the commodification of his and others' non-white otherness. This echoes Graham Huggan's concept of the postcolonial exotic.

Huggan distinguishes between postcolonialism's critique of imperialist trends and postcoloniality's 'global condition of cross-cultural symbolic exchange' (Huggan ix). He explains the dual function of exoticism within the field of postcoloniality:

> Within this field, exoticism may be understood conventionally as an aestheticising process through which the cultural other is translated, relayed back through the familiar. Yet, in a postcolonial context, exoticism is effectively repoliticised, redeployed both to unsettle metropolitan expectations of cultural otherness and to effect a grounded critique of differential relations of power. (Huggan ix–x)

Huggan thus intimates that the postcolonial exotic capitalises on the exotic value of otherness within the international market while simultaneously critiquing it, thereby rewriting the way cultural difference

is perceived by the centre. Khan's deployment of strategic exoticism that generates interplay between 'exoticist codes of representation' and familiar codes of Western dramaturgical practices manages to both conform to and subvert both sets of codes with equal prowess (Huggan 32). Moreover it redeploys them 'for the purposes of uncovering differential relations of power', thereby rewriting how his and others' othernesses, and the arts generated by them, are perceived and read by mainstream white British culture (Huggan 32).

Khan's new interculturalism is thus a politicised, non-white intervention to intercultural theatre, the predominantly white and Western intellectual theatre project of the 1970s and 80s that created works of cultural fusion through formulaic, reductive and essentialising depictions in terms of alterities. It is a processual and embodied aesthetic that is generated from his own lived, othered realities with multiple affiliations to cultures, people, nations, performance traditions and histories. The new in Khan's new interculturalism therefore signals an evolving aesthetic, a political stance and an embodied philosophy that stem from a unique set of identitarian characteristics. These are shaped by biographical details, performance training in multiple cultural practices and the wider field of diasporic British South Asian arts that collectively contribute to Khan's lived reality and his political consciousness as a second-generation British citizen of Bangladeshi heritage living in London.

I develop my theorisation of new interculturalism through seven case studies that embody this concept from Khan's extensive repertoire.[16] My analyses of these performances entwine both subjective and phenomenological descriptions of key moments and theoretical reflections on their socio-political aesthetic and content. I am aware, though, that through these case studies my theorising of Khan's new interculturalism focuses specifically on an embodied, corporeal and visual aesthetic and does not address the vital aural realm at which it plays out. I realise that the relationship between musicality, physicality and the visual is fundamental to Khan's new interculturalism and is in itself a rich and substantial field of enquiry that has not been theorised to date. This is particularly evident in his recent duet collaboration, *Torobaka* (2014), with the flamenco dancer Israel Galván. In this piece the percussive potentials in Khan and Galván's bodies and their vocalisations become extensions of and contribute to the aural soundscapes created by their accompanying musical instruments. However, I admit that I lack the necessary musicological skills to undertake this analysis and therefore hope that my corporeal theorisation of Khan's work will open up

avenues for other scholars to engage with the vital aural aspect of his new interculturalism.

Chapter 1 examines the unique circumstances that have shaped the identitarian and embodied nature of Khan's new interculturalism by tracing his biographical details, his performance training in multiple movement languages and contextualising his art within the wider landscape of British South Asian arts.

In Chapter 2, through an analysis of *Gnosis* (2010), I demonstrate how Khan's embodied approach to new interculturalism is an artistic critique of and response to Brook's controversial intercultural theatre production of *The Mahabharata* in which Khan played the Boy, and later Ekalavya. I argue that, unlike Brook, Khan's new interculturalism strategically rejects a textual engagement with the original archival text. Instead he creates a fleeting corporeal aesthetic through which he hints at the relationship between Queen Gandhari and her son Duryodhana. Through these interactions Khan finds personal resonances with his relationship with his own mother in the British-Bangladeshi diasporic context.

Chapter 3 deploys auto-ethnography to examine *Loose in Flight* (1999), a dance-film made by Khan in collaboration with the filmmaker Rachel Davies. Made at the very start of his career, while the choreography captures his emerging and unique movement aesthetic between *kathak* and contemporary dance idioms, the film situates Khan's choreography against the iconic and barren architecture of London's Docklands. It is the evocatively crafted marriage of the film and the choreography that suggests an intersection between Khan's hybridised aesthetic and his equally complex identity-politics. By locating his diasporic body within a contested landscape that has long disenfranchised the migrant communities who inhabit it, the dance-film becomes a political intervention. In the spirit of auto-ethnography through the artefact of the dance-film both the enquirer – Khan – and the subject of his enquiry – his own lived conditions – are one and the same.

In Chapter 4, using postcolonial theorist Homi Bhabha's influential concept of the third space, I conduct a comparative analysis between *Zero Degrees* (2005) and *Desh* (2010). In these pieces Bhabha's figurative third space of in-betweenness where postcolonial and diasporic identity-formations are meant to occur, finds embodied and tangible manifestations in geographical borderlands in *Zero Degrees* and within Khan's body in *Desh*. Furthermore Khan shifts Bhabha's concept of the third space as a condition of interstitiality between one's home and host nation, to an aesthetic of multistitiality that emerges at the intersections of three or more artistic disciplines.

Chapter 5 analyses the significance of mobility and flexibility as a privileged and privileging lived reality of migrants who are free to travel and relocate through both choice and finances, and are inherently malleable in their identities through examining Khan's first choreographic venture, *Bahok* (2008), in which he does not perform. In *Bahok* Khan deconstructs the idea of homelessness by powerfully evoking mobile and flexible bodies as travelling homes.

In Chapter 6, Khan's third choreographic venture, *iTMOi* (2013), created as a response to the centenary celebrations of Igor Stravinsky's seminal musical score *The Rite of Spring* (1913), is analysed as an act of queering of normativity through strategic depictions of androgyny and ambivalent sexualities. I argue that Khan's queering of his own aesthetic is an homage to and acknowledgement of the ways in which Stravinsky himself queered contemporaneous normative expectations of Western classical music through his original score.

In the Conclusion I examine *Dust* (2014), Khan's commissioned choreography for English National Ballet for the quartet-billed programme *Lest We Forget* that commemorated the centenary of the First World War. I argue that, through *Dust*, Khan's artistic journey arrives full-circle, straddling, othering and destabilising the two classical words of *kathak* and ballet simultaneously.

Each of these case studies embodies the six different features of Khan's new interculturalism even though they all permeate his aesthetic holistically. Firstly Khan's new interculturalism manifests as an embodied corporeal language with a conscious rejection of text in order to keep significations both ambivalent and ephemeral. Secondly, at the heart of most of Khan's works is an auto-ethnographic, self-referential enquiry. In other words, with each project he creates an artefact through which he tries to raise questions about himself as a dancer and choreographer, but most importantly as a human being. The third aspect of his new interculturalism is his perpetual identification with a state of in-betweenness; between cultures, between nations, between disciplines and between the different versions of his own self, with a recognition that many selves and many others coexist within him. Fourthly, his new interculturalism is engendered by Khan's privileged mobility whereby out of choice, and as a result of his financial status, he is able to travel endlessly as a world-citizen with a strong attachment to London. The fifth aspect of his new interculturalism is a queering of normative understandings and expectations of his diasporic South Asianness, of South Asian arts and of contemporary dance. The sixth and final feature of Khan's new interculturalism dismantles the concept of othering as a

process that is undertaken from the perspective of whiteness, thereby blurring categories like 'us' and 'them'. Instead Khan's approach to otherenesses from a position of the other blurs these simplistic categories and lends more integrity to representing alterities within his works. The embodied nature of each of these features is what lends Khan's new interculturalism both an aesthetic interventionist charge and a simultaneous personal humility; qualities that were arguably lacking from the intercultural theatre projects of the 1980s and that justify the reasons for his uniqueness in the fields of British and global dance. But up until now Khan's work has not been framed through the lens of new interculturalism. This book attempts to fill this lacuna.

1
Khan's Body-of-Action

As a London-based second-generation British-Bangladeshi with training in multiple performance vocabularies that permeate every aspect of his aesthetic, it would be reductive, even impossible, to engage with Khan's art without understanding the embodied reality and the socio-political contexts that catalyse it. Sondra Horton Fraleigh reminds us of the fundamental link between a dancer's lived reality and their art:

> Because dance is in essence an embodied art, the body is the lived (experiential) ground of the dance aesthetic. Both dancer and audience experience dance through its lived attributes – its kinaesthetic and existential character. Dance is the art that intentionally isolates and reveals the aesthetic qualities of the human body-of-action and its vital life. (Fraleigh xiii)

To understand the kinaesthetic qualities of Khan's art requires an engagement with his dance vocabulary drawn from *kathak* and contemporary dance idioms. Moreover his embodiment of eclectic movement languages is nuanced further by his own biographical circumstances and his interactions with the wider field of British South Asian arts. Together they generate complex affiliations to diverse traditions, cultures, nations and histories. It is this processual intersection between his biography and his art that lends Khan's vital life its charge, and infiltrates his new interculturalism with a spirit of 'self-knowledge', evoking identity not as a fixed inherited entity, but as an ongoing exploration of its incomplete and multi-layered constructions (Fraleigh xxii).

This chapter begins with a summary of Khan's early years in 1970s London as the son of first-generation Bangladeshi immigrants in an environment rife with racial tensions between the white native population

and non-white immigrant communities. It then examines his training in *kathak* with particular emphasis on his learning of the South Asian dramaturgical principles of *abhinaya* and *rasa*. A close scrutiny of Khan's training in an eclectic range of Western movement languages follows, focusing on the physiological and creative tensions these created in his body in relation to his *kathak* training. The chapter goes on to isolate Khan's interactions with the genre of physical theatre as I believe its interdisciplinarity between dance and theatre and its embodied self-referentiality has had a profound impact on shaping Khan's emerging language of 'confusion'. An analysis of this aesthetic of 'confusion' follows to examine the processes through which his body organically began to make decisions for itself, resulting in the creation of Akram Khan Company in 2000 with producer Farooq Chaudhry. And finally, I examine the links between Akram Khan Company and the wider field of British South Asian arts in order to frame Khan's new interculturalism in relation to the artistic interventions of his senior and contemporary South Asian colleagues in literature, visual arts, music and dance.

Khan's early years[1]

Akram Khan was born in 1974 in London to Bangladeshi parents Mosharaf Hossain Khan and Anwara Khan. His father came to Britain in 1969 to study cost and management accountancy, and his mother joined him in 1973 after finishing her MA in Bengali literature in Dhaka, two years after Bangladesh gained independence as a nation in 1971. Bangladesh was once the same as Bengal and a part of the land mass of eastern India. In 1905 the Partition of Bengal segregated a group of people bound by a common culture and language on the premise of religion. From this the geographical boundaries of West Bengal and East Bengal were born, becoming home to the Hindu and Muslim populations of Bengal respectively. This geographical boundary became a political one when East Bengal became East Pakistan with the Partition of India in 1947. The seat of power of the newly formed nation of Pakistan lay largely with West Pakistan (the modern-day nation of Pakistan), an area separated linguistically and geographically from East Pakistan by the nation of India in the middle. Over the next two decades East Pakistan was perceived to be exploited financially and its Bengali language and culture were seemingly marginalised by West Pakistani authorities. This gradually led to a political and cultural revolt in East Pakistan in 1971, as it declared itself as the independent state of Bangladesh. Eventually, following a war of independence in 1971, the

nation of Bangladesh was born. The Khan family's arrival into Britain very shortly after Bangladesh gained independence meant they brought with them the strong sense of Bengali cultural identity that the newly founded nation had been fighting for.[2]

Khan's parents were atypical of post-Second World War South Asian immigrants on two counts. Firstly, as per the pervasive post-war narrative, while most South Asian immigrants arrived in Britain in the 1950s as part of 'migration of labour' from Britain's ex-colonies, the Khans arrived approximately two decades later (Brah, 'Asian in Britain' 36). Secondly, and perhaps more importantly, Khan's father came to Britain not as an economic migrant but as a student. These two factors alongside Anwara Khan's postgraduate level education were influential in lending the Khan family greater social mobility within their diasporic community. However, even as Khan's parents were part of a slightly different social milieu to the immigrants of the post-war narrative, they arrived into a Britain that was rife with racial tension between the white native British and the non-white immigrant populations. It was under these hostile circumstances that the Khans began their immigrant project of creating a home away from the homeland.

The exclusion enforced upon and experienced by these first-generation South Asians ghettoised them into closed communities of their own. Anwara Khan retrospectively realises that her initial joy of joining her husband in Britain was overshadowed by the difficulties she encountered in trying to make a home in a new environment where the language barrier was what she found the most alien (An. Khan, Interview). Akram Khan recognises that in order to counter the hostilities in their host country, his parents and their other Bengali friends 'formed their own community and then they locked themselves in it through memory [...] and then they held onto this memory defiantly' (Ak. Khan, Interview 1).

To compensate for their dislocation from the homeland, the Khan family home became the space where their home culture was preserved so that the children did not lose sight of their cultural heritage. Therefore, as Khan recollects:

> there was an insistence on speaking Bengali at home, eating ethnic cuisine, and wearing traditional clothes at social functions, in order to keep the bonds with their homeland alive. (Ak. Khan, Interview 1)

This transmission of home culture became largely the project of female immigrants whose identification with the motherland and her

traditions were vital to every migrant's reality, and Anwara Khan was one of many such women (Werbner 905). Having left Bangladesh very shortly after it gained independence and long before the Bangladeshi nationalist project prioritised Islamic identity over Bengali customs, Khan's mother embraced a Bangladeshi culture that was a syncretic expression of Bengali social customs and Islamic religious practices (Kabeer 38). It is this very syncretic Bengali identity that she transmitted to her British-born children, alongside investing heavily in the value of British education. The Khans realised the upward social mobility attached to the latter and aspired to have both Khan and his sister attend private school. While his sister did achieve this, Khan admits that 'I just never got in. I tried all of them. I didn't get in' (Ak. Khan qtd in Patterson). Thus, from a young age, Khan's complex identity evolved at the intersections of British education in the public domain and Bengali culture in the private sphere.

We observe a similar openness to cultures and people in Anwara Khan's anecdotes about her son learning Bangladeshi folk dance from the age of three while being simultaneously fascinated by the choreography of the late Michael Jackson. In an obituary for the *Guardian* on the untimely demise of the influential African-American pop star, Khan reminisces:

> If Michael Jackson hadn't been there, I don't know if I would have been a dancer. He was the first person I connected with. I remember when I saw Thriller, I was terrified. I'd never seen anything so frightening in my life, but it was also incredibly exciting. It had everything – music, storytelling, dance. (Ak. Khan qtd in Saner)

Khan goes on to say that as a young boy he was bullied within his Bangladeshi community for his fascination with the effeminate discipline of dance. But once he began to render Jackson's *Thriller* routines at local discos and started winning competitions he gained kudos. In retrospect Khan acknowledges his admiration for Jackson's ability to marry popular culture and dance and proposes that this 'changed everything' by removing the stigma attached to the male dancing body (Ak. Khan qtd in Saner). He recognises that his mother was as encouraging when it came to him learning Bangladeshi folk dance as she was of his obsession with Michael Jackson. At a time when his contemporaries were struggling to do so, Khan cites his mother's openness to other cultures as the reason he was able to negotiate his own identity-politics with relative ease. Consciously diluting the politically constructed national

differences between Bangladeshi Bengali identity and Indian Bengali identity, Anwara Khan transmitted to her children a Bengali identity that drew holistically upon the shared cultural histories of these nations (An. Khan, Interview). Moreover Khan experienced trans-ethnic affiliations while growing up alongside Indian, Pakistani, Chinese and African children, which obscured 'discrete national belongings and even religious identity' within the diaspora (Werbner 900).

His curiosity for cultural dialogue was further honed when from 1985 to 1989 Khan performed as the Boy (in the theatre version) and Ekalavya (in the film version) in Brook's production of *The Mahabharata*. His early exposure to Brook's performance-making instilled in Khan a quest for the 'most distilled, simple and minimalist artistic approaches to telling the most complex stories' (Ak. Khan, Interview 2). Despite sustaining their tightly knit Bengali community life in Britain, Khan's parents were thus unique in ensuring that alongside nurturing his appreciation and understanding of Bengali culture, Khan's childhood was also immersed in engendering a respect for trans-ethnic interactions and intercultural dialogue. This was reflected in Anwara Khan's keenness for Khan to not only perform Bengali folk dance but to formalise his dance training through enrolling him in *kathak* classes. Consequently, at the age of seven a Muslim Bangladeshi Khan enrolled at the National Academy of Indian Dance (NAID) in London to train in *kathak* under the tutelage of the Hindu Indian maestro Sri Pratap Pawar. Thus, in *kathak*'s syncretic, chequered and trans-ethnic history, which merges Hindu and Islamic performance traditions (as already discussed in the Introduction), Khan's own multi-ethnic identity and intercultural perspectives were rather appropriately reflected and nurtured.

Khan's training in *kathak, abhinaya* and *rasa*

While it is true that referring to Khan's art as 'contemporary *kathak*' is indeed a reductive approach, the core dramaturgical principles of *kathak*'s emotive storytelling are pivotal to his unique aesthetic, and characterise his new interculturalism in integral ways. Therefore an understanding of these dramaturgical principles is vital here. Postclassicisation in the mid twentieth century, *kathak* has come to be governed by the three components of Indian dramaturgy: *natya* (theatricality), *nritta* (technical virtuosity) and *nritya* (sentiments and mood evoked in movement). A typical recital of *kathak* always embodies all these three components in equally adept measure. Central to its complex movement language is the emotional expressivity and narrative

drive of the *natya* and *nritya* components of the dance, delivered through the strictly codified corporeal system of signification known as *abhinaya*. This stylised and mimetic storytelling feature of *kathak*, and indeed all Indian classical dance forms, conveys characterisations, themes and narratives through a codified language that synthesises *mudras* (hand gestures) and facial expressions in order to evoke the nine universal human emotions as laid out in the *Natyashastra*. They are *sringaram* (love), *hasyam* (laughter), *raudram* (fury), *karunyam* (compassion), *bibhatsam* (disgust), *bhayankaram* (horror), *viram* (heroism), *adbhutam* (wonder) and *shantam* (peace). These primary human emotions are abstracted, codified and articulated through strictly stylised physical gestures and facial expressions to create the language of *abhinaya*, thus evoking a marriage between movement and theatricality. And it is the signification achieved through *abhinaya* that evokes in *kathak* and other Indian classical dance forms the potential of the ancient Indian philosophy and principle of *rasa*.

In the *Natyashastra*, *rasa* theory is theorised as a conceptual framework for the relationship between art (across multiple disciplines) and its reception. The word *rasa* in Sanskrit means juice, or the flavourful extract derived from ingesting a fruit or any kind of cuisine. In using the term *rasa* in the context of the reception of art, a parallel is thus evoked in the *Natyashastra*, between the consumption of food and the reception of art. The physical and emotional satisfaction that can be derived from a flavourful meal is thus compared to the 'aesthetic delight – a state of joy characterized by emotional plenitude' that can accompany an immersive encounter with a piece of art (Meduri 3). Dance scholar Kapila Vatsyayan views *rasa* as a psycho-somatic system that channels the correspondence of emotional energy between the motor and the sensory systems of performer and audience. She reminds us that the relationship between the physical and the psycho-emotional is fundamentally interactive, as 'the psychical manifests itself in the physical and the physical can evoke the psychical' (Vatsyayan 19). In the physical codifications of *rasa* theory, the nine basic emotions are abstracted and stylised through *abhinaya* into 'primary moods, sentiments, primary emotive states' (Vatsyayan 64). Vatsyayan writes that while the performer is able to depict the nine basic human emotions through being skilled in *abhinaya*, it is the audience's ability to recognise and identify these emotions that generates *rasa*, and through it an ideological transactional exchange transpires between the art, the artist and its receptor.

According to *rasa* theory, this contemplative awareness that is evoked in the audience is also an impersonal state that prevents the audience

from experiencing complete empathy with the performer and creates the *sahrdaya* or the 'initiated spectator, one of attuned heart' (Vatsyayan 155):

> The sahrdaya (sympathetic spectator) sympathises (hrdayasamvada) with the original character, and to a large degree he even identifies (tanmayıbhava) with the situation depicted. But he does not identify completely; he retains a certain *aesthetic distance*, the name for which is *rasa*. (Masson and Patwardhan qtd in Mason 76)

Rasa thus generates an emotional and spiritual state in which the audience is simultaneously critically distanced yet fundamentally connected to the performance they are experiencing. This split consciousness in the audience emphasises that *rasa* relies on channelling the emotive qualities of a performance between an art and its recipient instead of focusing on its formalist aspects alone.

Kathak's reliance on the modality of *abhinaya* therefore makes it a form that renders meaning in motion, evoking a stylised human reality on stage. Furthermore this codified theatricality is only accessible to initiated audiences who are versed in the stylised rendition of the nine human emotions and are therefore able to experience *rasa* through it. In learning the language of *kathak*, Khan therefore trained in rendering *abhinaya* and its embodied marriage between theatricality and movement. He does admit, however, that he was 'always very bad at performing *abhinaya*' (Ak. Khan, Interview 2):

> I think this is because I always felt restrained and frustrated by the codified requirements of performing a particular character and their emotions in ways that have already been predetermined. (Ak. Khan, Interview 2)

Despite feeling distanced from the codified nature of *abhinaya*, Khan embodied dance as a simultaneously kinaesthetic *and* expressive art form, and this smooth slippage between movement, theatre, dance and acting began to mature in Khan's practice from a very young age. Finally and perhaps most significantly, Khan understood the philosophy of *rasa* as a critical and aesthetic distancing device through which his audiences could attain a heightened state of contemplation without fully empathising with the subject of their art. It is important to note here that Khan's early understandings and embodiment of both *abhinaya* and *rasa* were to become influential strategies in the generation of his own aesthetic of new interculturalism, and in the following

case-study chapters and the conclusion I expand on his deconstructive deployment of these South Asian dramaturgical principles.

Khan's training in Western movement practices

Gradually Khan began to feel claustrophobic within his classical dance regime. Keen to expand his performance training beyond *kathak*, Khan reveals his desire to grow on his own terms to Wendy Perron:

> I needed change, I needed to evolve. I didn't want to become what they wanted me to become, I wanted to find out who I would become by my own consequences, not someone else's. (Ak. Khan qtd in Perron)

Yearning to discover and make life-choices of his own, in 1994 Khan 'ran away' and stepped into British higher education by enrolling onto a BA (Hons) in Performing Arts at De Montfort University in Leicester (Ak. Khan qtd in Perron). Excited by the prospect that his body could learn to express itself in languages beyond his comfort zone, Khan immersed himself in Western dance training. Two years later he transferred to the Northern School of Contemporary Dance (NSCD) in Leeds, from where he graduated with an outstanding honours degree in 1998. During these four years Khan expanded his movement repertoire beyond *kathak* to include an eclectic palette ranging from classical ballet, Graham, Cunningham, Alexander, release-based techniques and contact improvisation, to physical theatre. In retrospect Khan realises:

> My time at De Montfort allowed me to enter an exploratory marriage between my *kathak* training and the various contemporary idioms I was learning. In contrast my two years at Northern caused its painful divorce. (Ak. Khan, Interview 1)

At NSCD the emphasis on rigorous and virtuosic training placed extreme and varied demands on Khan as each movement system, characterised by its own specificities, created muscular, skeletal and sociological tensions within him.

In classical ballet Khan encountered the ethereal verticality of the spine, the strict and graceful linearity of the limbs, and the lightest sense of contact with the floor through his toes, to make the dancer appear 'fairy-like' and nimble through a graceful athleticism that appears to defy gravity (Stoneley 18). This new way of moving was, however,

layered and clouded by his *kathak* training where Khan's bo
rooted to the ground through a constant pressured connect
flat feet that allowed his lower body to appear highly secure,
ing his upper body fluid mobility. Khan's ballet training in
his relationship to gravity and balance as his centre of gra\ eu
forward and upwards. Nearly two decades later, choreographing *Dust*
(2014) for English National Ballet became a seminal moment in Khan's
artistic trajectory. In *Dust*, his early bodily tensions between *kathak* and
ballet were borne out in more sophisticated ways in other classically
trained ballet bodies in order to create an explosive aesthetic that was
as earthy and emotionally charged as ballet is ethereal and mimetic.

Through Graham technique Khan's body had to renegotiate its con-
nection with gravity as his centre shifted once again, this time to the
pelvis. Martha Graham's contraction and release system mirrored the
physical process of breathing and located the centre of life's impulse
and energy within the pelvis. This system 'hollowed out the stomach
and rounded the back' as it contracted and was followed by the release,
which 'freed the body again, straightening the spine' (Foulkes 17).
Khan's engagement with this system changed his relationship to the
floor as for the first time he could use the floor as a partner, not just to
stand on, but to yield in and out of. Furthermore, whereas in *kathak* the
floor was almost like a percussive instrument, an object even, that Khan
activated through his feet, in Graham technique Khan had to reconsider
his relationship with the floor, which became an equal in their interac-
tions and supported and rejected him with equal force. His body began
to experience dynamism in the angular and the grotesque, destabilising
his preconceptions of movement as beautiful and sensual. However,
similar to his *kathak* training but in a very different way, the Graham
technique allowed his movement to render emotion and meaning
and had a significant impact on his emerging performance language.
Tamara Rojo, artistic director of English National Ballet, notes that one
of the significant ways in which Khan challenged the physiology of the
ballet body in *Dust* was by lowering the centre of gravity into the pelvis
and rounding the spinal column into its base in a very much Graham-
esque contraction, which rarely ever released (Rojo, Interview).

Cunningham's aesthetic was premised not on being anti-ballet but
on wanting to somehow create a language 'beyond ballet' (Greskovic
73). It amalgamated 'the flexible back and changing levels of modern
dance, and the upright carriage and brilliant footwork of ballet' (Banes
qtd in Preston-Dunlop 178) and aimed for a 'synthesis of the physi-
cal and spiritual energies' of the human body (Cunningham qtd in

Preston-Dunlop 179). This anti-expressionistic language exposed Khan to experiencing movement as visual, kinaesthetic and spatial, without the duress of having to communicate meaning. In principle this shared similarities with the *nritta* segment of a *kathak* recital. However, the corporeal quality of the Cunningham technique demanded from Khan's body an ephemeral litheness with a similar uprightness to ballet that was at odds with his *kathak* training.

Khan learnt of his own ill habits and corporeal tensions through the corrective somatic practice of Alexander Technique, a system that aims to unlearn and release 'unwanted muscular tension' that the body 'has accumulated over many years of stressful living' (Brennan 10). The technique restores balance, realigns the spine and re-educates the body into healthier modes of function through appropriate use of muscular and skeletal effort. Through Alexander Technique Khan learnt how to heal his body from daily stress and the weaknesses induced by his classical *kathak* training and his Western contemporary dance training. This somatic philosophy supported Khan's training in release technique. Here he learnt to work with and emphasise the natural alignments of the body by minimising muscular tension through working with gravity, momentum and breath, creating effortless patterns of movement across the floor. By realising that 'release technique purports to assimilate gravitational flows in the body's interior space to its exteriority', Khan learnt to embrace gravity as a creative partner in his training (Martin 172).

This in turn eased him into the practice of contact improvisation and its exploration of points of intimate bodily contact between two or more people who distribute weight between themselves and the floor through interplay between balance, counter-balance and momentum. Performed mostly as a duet, 'contact improvisation uses momentum to move in concert with a partner's weight, rolling, suspending, lurching together' in harmony (Novack 8). Both release technique and contact improvisation exposed Khan to unfamiliar territories as his body began to encounter gravity and momentum beyond the verticality of *kathak* into the horizontal plane by making the floor a close ally. Moreover Khan had to negotiate the socio-corporeal tension of intimate physical contact with another body, having trained in a primarily solo performance tradition.

Khan's embodiment of physical theatre[3]

While Khan's palette of skills developed beyond *kathak*, it was his exposure to the embodied and politicised practice of British physical theatre

with its shared legacies in the European avant-garde theatre and dance experiments that had a significant impact on his future-discerning choices about choreography, not just as a dancer but more importantly as an artist. Khan encountered the genre for the first time during his auditions at De Montfort University:

> I remember going to the library because I got there early, and I saw Pina Bausch and DV8 on video. I'd never seen contemporary dance, and I was completely horrified. But at the same time I asked myself, 'Then why am I still watching it?' I didn't know you were allowed to be provocative in the arts. But I could see the poetry in it, the poetry in the violence, in the truth. (Ak. Khan qtd in Perron)

This realisation left an indelible mark on his impressionable student mind.

Ana Sánchez-Colberg theorises physical theatre as an interdisciplinary aesthetic that arises at the intersections between avant-garde dance and theatre practices of the mid to late twentieth century:

> The term itself – 'physical theatre' – denotes a hybrid character and is testimony to its double legacy in both avant-garde theatre and dance. It is precisely this double current of influences which needs to be taken into consideration in any attempt to delineate specific parameters of the new genre. (Sánchez-Colberg, 'Altered States' 21)

She traces its avant-garde dance lineage back to German Ausdrucktanz and its principle aim to 'squeeze out from the inner landscape of the artist's body (and psyche) action that actualises the self in the world (the outer landscape)', as exemplified in the art of Mary Wigman, the *tanztheater* of Pina Bausch and the volatile aesthetic of DV8 Physical Theatre (Sánchez-Colberg, 'Annotated' 4). She traces its avant-garde theatre lineage to the experimentations of Bertolt Brecht and the genre of the Theatre of the Absurd (Sánchez-Colberg, 'Annotated' 5).

Sánchez-Colberg further notes that physical theatre echoes the Artaudian philosophy of theatre-making where 'the body is the centre of the mise-en-scène' (Sánchez-Colberg, 'Altered States' 23). She clarifies the nature of this body by reminding us that:

> whilst admitting to the significance of a 'decoding' process of the body as a sign of discourse, it has also become significant to consider that the social body which is the focus of such structural analysis is also

a spatial body, which, although subject to social discourse, also has its own 'embodied' knowledge. (Sánchez-Colberg, 'Altered States' 25)

Sánchez-Colberg's observation that this body is not just a vessel through which the primary means of communication occurs, but the fundamental source and stimulus of lived experience, interpersonal politics and socio-political relations with the world and therefore inseparable from its embodied subjectivity, is the very aspect of physical theatre that appealed to Khan's complex and multi-layered corporeality.

Khan discovered that physical theatre as an art form 'is not merely about the body, but from the body', and also of the body (Csordas xi). Tracing its roots in Bausch's seminal contribution to the German expressionistic genre of *tanztheater*, Khan came to recognise it as a response 'against classical ballet which was then, as she saw it, stuck in provincialism and beauty as an end in itself' (Gradinger 25). This resonated with his own desire to renegotiate a *kathak* language that was more suited to his contemporary reality and equipped to express current concerns and socio-political realities. Khan discovered the legacy of Bausch in DV8 Physical Theatre's work where the personal and the political collapsed in provocative ways. Established by Lloyd Newson in London in 1986, DV8 wanted to evoke in dance socio-political legibility by making it 'about something' (Newson qtd in Murray and Keefe 81). In his own search for self-identity as distinct from his diasporic community in London, Khan was struck by these political dimensions of DV8's work and its strategic shift from Bausch's concern with the communal to the realm of the individual. He was also influenced by Newson's highly athletic and risky physicality that drew on both stylised movement and quotidian gestures to depict frightening images of the vulnerability and fragility of the human condition on stage.

Through physical theatre, particularly the aesthetic of Bausch and Newson, Khan came to examine how relationships emerged through corporeal exchanges and studied how the body can become a transgressive site of intervention. Thus, while through *kathak*'s codified *abhinaya* modality Khan had learnt to narrate stories of Hindu epics and mythical characters of the past, through physical theatre Khan discovered the body as an embodied reality, capable of communicating contemporary issues and concerns by becoming a subversive tool of political power and the very source of narrative itself:

My encounter with physical theatre inspired me to re-examine the relationship between the codified storytelling of *abhinaya* in *kathak*

through which I told stories from the Hindu epics, and the fragmented thematic explorations of social issues through both stylised and everyday gestures in the genre of physical theatre. (Ak. Khan, Interview 2)

Khan's confusion

As Khan began to process these multiple layers of movement languages, the rigid stylisation of *kathak* began to clash with the improvisatory nature of Western contemporary idioms. Farooq Chaudhry, producer to Akram Khan Company, summarises the nature of Khan's corporeal tensions:

So what was beginning to happen was a creative interplay between a deep understanding of a classical form and the immense skill that comes with it and the freedom and formlessness of contemporary expression. (Chaudhry, 'Keynote' 2)

At first these clashes were merely physiological but gradually they manifested in creating sociological tensions within him, as his university experience often left him feeling more fragile than confident. One tutor told him that he did not have the body for contemporary dance because he was inflexible. He claims that from that moment on he worked on making inflexibility his strength, and started to play with the speed and stillness his multiple training lent him (Ak. Khan qtd in Kennedy). He remembers another incident at university that left him feeling vulnerable, when a visiting choreographer came in to advise students on the profession:

She was invited to come in and tell us about what it's like to work in the outside world. At the end of her visit she pointed to five of us, including myself, and said that we would never make it and we should change career now. It was at such a fragile stage, just about to leave college in the hope that you're going to get some work and somebody so important says something like that. I was very upset but then I thought my whole mission in life was going to prove that I could do it. (Ak. Khan qtd in Kennedy)

True to his word, after graduating in 1998, Khan continued to experiment with his multiple corporeal languages through the solo *Loose in Flight* (1997) and the duet entitled *Duet* (1999). He cites the latter

collaboration with the British dancer and choreographer Jonathan Burrows as an influential moment in his training period (Sanders, 'Akram'). Working with Burrows offered Khan something unique and insightful about the nature of human interaction to add to his already complex performance training. Described as a 'considerable – yet quirky – choreographic talent', Burrows' work has provocatively challenged normative expectations of what constitutes dance (A. Williams). Tim Etchells, the artistic director of British experimental theatre company Forced Entertainment, identifies an important interplay between simplicity and complexity in Burrows' choreography:

> All of it messes with your senses of what's simple and what's complicated. Mostly it starts at a place you'd call simple, very simple, but then they pattern it zealously; repeating, overlaying, looping the sequences, moving in and out of phrase with each other and altering the time so that what maybe began as something you could teach to eight year olds, ends up more like Bach. (Etchells)

Burrows himself has claimed that 'choreography is about making a choice, including the choice to make no choice' (Burrows qtd in Hawksley 4). This philosophy became fundamental to Khan in his formative years when finding his idiosyncratic language meant rejecting the complex and codified choices of *kathak* by generating a new language of simple-complexity through entirely new sets of artistic choices of his own. Khan himself cites the experience of working with Burrows as 'pivotal' in understanding how he could start to generate a new language within his own body (Ak. Khan qtd in Sanders, 'Akram').

Khan also remembers the moment when the uniqueness of the language he was organically developing in his own body was recognised and commended by Gregory Nash and Vat Borne:

> Do you know what you have? Do you recognize that you're creating a movement language? [...] You have something very specific. You've broken into something that people have been trying to do for years but have never done convincingly. (Nash and Borne qtd in Perron)

In contrast to many other South Asian dance artists who were creating fusion between different dance forms where differences continued to coexist within intellectualised, premeditated and artificial configurations, Khan's body was creating an organic and syncretic language generated in and through his own corporeality.

Encouraged by the advice and feedback from his mentors and senior artists, and a fresh graduate from NSCD, Khan revealed to his parents that dance was no longer a hobby for him but his future profession. Anwara Khan states that this was a difficult time for the family as they had to face criticism from the community about letting their son pursue a career in dance. However, both his parents stood by him despite communal pressures and their own fears over his unconventional career choice. In 2000 Khan received a scholarship to study at the Performing Arts Research and Training Studios (PARTS) in Belgium as part of the X-Group project, 'a prestigious choreographic platform for young choreographers to develop their own language' (Sanders, 'Akram'). Founded in 1994 by the influential choreographer Anne Teresa De Keersmaeker, artistic director of the renowned company Rosas, and Bernard Foccroulle, director of the national opera company De Munt/La Monnaie, PARTS continues to provide an artistic and pedagogic curriculum to aspiring and talented young choreographers and dancers. It promotes itself as a creative laboratory that is fuelled by critical thinking. The philosophy that drives this influential European institution claims:

> dance is not an isolated art form; it is involved in a constant dialogue with the other performing arts – music and theatre. Both these disciplines figure prominently in the curriculum, as PARTS always works towards the actual performance, the moment when the artist engages in a dialogue with the audience – the dancer as a performer, but also as a thinking performer. (PARTS website)

Although Khan's stint at PARTS was relatively short, it would be fair to say that the institution's pedagogic, aesthetic and artistic approach as described above, particularly in its spirit of collaboration, experimentation and critical thinking towards the development of contemporary dance in Europe, had a profound impact on Khan. In future years this impact possibly drew him to work closely with artists like Sidi Larbi Cherkaoui (in *Zero Degrees*) and Eulalia Ayguade Farro (in *Bahok* and *Vertical Road*) who were themselves trained at PARTS. However, perhaps even more importantly, the time he spent at the institution enabled Khan to develop an aesthetic of his own that was more in alignment with the European contemporary dance aesthetic with its emphasis on socio-political criticality, thereby reinforcing Khan's own attraction towards the genre of physical theatre, and that was in many ways distinct from other contemporaneous British choreographers who were more driven by the formalist spirit of American contemporary dance.

In 2000, on his return from PARTS that same year, Khan and Farooq Chaudhry teamed up to establish Akram Khan Company. Thus began Khan's journey from a national artist to a global phenomenon in the field of contemporary dance.

Khan and Farooq Chaudhry

If Khan's new interculturalism was triggered by the above set of fortunate and unique biographical circumstances, it has been honed further by the 'carefully conceived business, governance and organisational frame' of Farooq Chaudhry's vision as producer to Akram Khan Company (Tyndall). To 'offer the optimum conditions for his development as an artist' Chaudhry has created a vast and unique 'web of relationships and collaborations, spreading across continents, artforms, disciplines, and sources of support, that has made Akram's journey possible' (Tyndall). A British man of Pakistani heritage, Chaudhry was a professional contemporary dancer who completed his training at the London School of Contemporary Dance in 1986. In 1988 Chaudhry received the Asian Achievement Award and in 1999 he stopped dancing to become Khan's freelance manager. Equipped with an MA in arts management from City University, in 2000 Khan and Chaudhry formalised their collaboration to create Akram Khan Company. Over the last fifteen years, under Chaudhry's strategic management, Khan has 'emerged as one of the world's outstanding performers and creators', demonstrating that, alongside his own exceptional talent, 'Farooq's collaboration with Akram has been fundamental to his success' (Tyndall). Arts Council England has also recognised Chaudhry's role in the success of Akram Khan Company in making him a 'project champion' for their Cultural Leadership Programme.

Although Chaudhry claims that in his quest to nurture the vision of Akram Khan Company he is 'a producer with no formula', it is clear that he understands the strategic relationship that must be forged between art and business (Ak. Khan qtd in Tyndall):

> Too often, there's a feeling that art and business are not good bed partners, that they are like oil and water. But actually they can mix extremely well. You're judged by the results, by the consumer, ultimately. And it's about taking risks, being under pressure, knowing when to invest in the future, good timing for your decisions, developing your ideas, and reshaping them so they remain interesting for

others, to keep yourself firmly in the market place. It's about developing the brand, expanding the audience. (Chaudhry qtd in Tyndall)

Chaudhry's creation of a brand for Akram Khan Company exercises an expansionist vision by learning 'not to rely solely on the European market place' (Chaudhry, 'Keynote' 3). He also asserts that creative opportunities for the expansion of the company must be sought relentlessly, in order to be doubled and tripled (Chaudhry qtd in Tyndall). However, he acknowledges that hard work, strategising and determination have been accompanied by an equal emphasis on choosing the right creative partnerships that allow for productive and daring collaborations (Chaudhry qtd in A. Shah). Finally, Chaudhry's positive acceptance of change as the only constant in life has fuelled Khan and the company to seek collaborations as opportunities for transformation that continue to test the parameters of their vision. These philosophical and strategic positions adopted by Chaudhry's management have collectively fuelled the company's success at the heart of which is the fundamental spirit of growth through collaboration.

Khan and the wider field of South Asian arts

In seeking dynamic and high-profile collaborations Khan and Chaudhry have been strategic in forging creative dialogue between Akram Khan Company and the wider field of South Asian arts in Britain. Thus, making sense of Khan's meteoric rise as an artist in Britain warrants an awareness of other influential British South Asian artists, whose works have long since established them as influential voices within the country's multicultural milieu. Moreover Khan's art and aesthetic have been significantly shaped by these artists' contributions to the '"black" British arts practices of the 1980s' and beyond in their demand for not only 'a more inclusive narrative but a comprehensive re-conceptualisation of the analytical tools through which the objects and materials of art historical study are examined and interpreted' (Mercer, 'Introduction' 7). Kobena Mercer signals that these artists were therefore collectively undertaking an emancipatory and political act through their contributions to the field of British arts.

To understand the collective nature of such contributions Pierre Bourdieu's theorisation of 'the field' becomes a useful framework with which to examine Khan's contributions to the contemporary British cultural milieu, not as a 'substantialist' phenomenon that foregrounds him as an influential artist working in isolation, but as an agent,

fundamentally working in a relational capacity with other similar agents in the field, past and present. In a helpful summary of Bourdieu's concept of the field, dance scholar Gay Morris writes:

> The field for Bourdieu is a dynamic space of objective relationships among positions, which can only be understood by viewing the agents occupying each position in relation to all the others. This network of relations is independent of individual control. The field is one of constant struggle in which agents vie for status and domination. To compete they draw on various forms of capital they possess which include economic, cultural, social, and symbolic capital. [...] Change is most likely to occur through struggles within the field, as agents compete with one another. (Morris 54)

Bourdieu was therefore keen to locate cultural agents within a grid of network relations, reliant upon each other's historic specificities and locations. He reminds us that the agents working in a particular field, and the field itself, have specific histories and socio-political forces that constitute them. Agents in this field must respond to these histories in an effort to either conserve or change them (Bourdieu 32). Through his own art Khan is located in and negotiates this relational field of South Asian arts, fuelled by shared histories of migration, diasporic identity formations, black British identity-politics and the desire to find a mainstream voice in Britain.

Khan's new interculturalism draws on the contributions made by his senior colleagues to the field of South Asian arts while simultaneously negotiating his own voice in relation to them. His syncretic movement aesthetic can be read as an acknowledgement of the postcolonial 'resistance literature' of writers such as Salman Rushdie and Hanif Kureishi whose unique styles emphasise an interplay between the experience of assimilation into a host culture and an innate resistance to the same (Ranasinha 10). Khan's refusal to embrace monolithic identity categories as an artist echoes Kureishi's rejection of the same:

> You know, I want to feel free to not only be an Asian writer. I am going to be a writer who is also Asian. [...] And that we are, you know, artists too. And don't have to be put into that bag. (Kureishi qtd in MacCabe 52)

The themes of ambiguity and multiple subject positions that haunt Khan's works mirror Rushdie's tendency to ruminate on the relationship

of 'an individual body with the subcontinent and a personal biography with its political history' (Kane and Rushdie 95). Both Khan and Rushdie 'allegorise national history through the metaphor of the body politic' while drawing heavily on their own experiences of relocations and multiple realities of their postcolonial conditions (Kane and Rushdie 95). However, while autobiographical perspectives colour Khan's art, these are ultimately transcended to move beyond the realm of the purely self-referential.

Sculptor and painter Anish Kapoor echoes this view in stating that while art deriving out of autobiographical experiences is interesting, it is also a 'rather minor art form' (Kapoor qtd in Dantas). Arguing in favour of art that communicates beyond auto/biographical levels, Kapoor asserts that 'if art is to endure then it must have to do with more than that' (Kapoor qtd in Dantas). Khan evokes in his work Kapoor's spirit of interculturalism, which is built upon the notion of 'building a kind of bridge [...] between one bank of a certain cultural reality and another bank of a different cultural reality', enabling new and powerful crossings into Othernesses from a starting point of the Other (Kapoor qtd in Dantas).

In Khan's search for a performance aesthetic in which singular national and cultural borders collapse in favour of multiple subject positions, he echoes musician Nitin Sawhney's claim that music is for him a 'place without barriers and without boundaries' (Sawhney qtd in Poulton and Tait). Khan and Sawhney both warn against cultural dialogue that is forced and inorganic and in this evoke another musician Talvin Singh's statement, 'This isn't fusion. You can't fuse yourself' (Singh qtd in Clayton 75).

Khan's aesthetic simultaneously acknowledges and diverges from the philosophy of his senior dance colleague Shobana Jeyasingh and her pioneering movement experimentations between *bharatanatyam*, Western ballet and contemporary dance. At first they seem to echo each other's sentiments about the relevance of classicism in contemporary Britain. However, Khan's questioning of classicism in his contemporary reality is borne out through an emphasis on generating legibility through his movement experimentations, while Jeyasingh's experimentations focus primarily on creating a hybridised formalist repertoire.[4] Both Khan and Jeyasingh are nevertheless keen to move their respective training in *kathak* and *bharatanatyam* beyond solo forms to more collaborative ensembles, exploring 'the acceptance of physical dependency and trust' in their choreographies (Jeyasingh 34). While commencing their artistic journeys from within the same parameters of

kathak, Khan's aesthetic deviates significantly from that of his contemporary Sonia Sabri whose philosophy is to counteract the tendency to present *kathak* 'in the same old way' (Sabri qtd in Khalil, 'Sonia Sabri') by bringing the form into 'new spaces and contexts [...] new audiences' and 'developing a distinctive, contemporary style which speaks to the here and now' (Sabri). Sabri suggests that this can be done by questioning 'the artistic decisions one makes within a creative *kathak* format' (Sabri qtd in Khalil, 'Sonia Sabri').[5] When asked what distinguishes her experimentations from Khan's, Sabri emphasises the personal nature of Khan's aesthetic that does not transform the *kathak* idiom but instead alters the language of British contemporary dance (Sabri qtd in Khalil, 'Sonia Sabri'). She claims that what makes her own experimentation unique is its intentional intrusion into the 'rudimentary structures of *kathak*' to deconstruct and interfere with its codifications (Khalil, 'British Space'). In this Sabri's aesthetic is closer to Jeyasingh's in its desire to deconstruct and reconstruct the form of *bharatanatyam*, and operates primarily at the level of *nritta*, whilst managing to simultaneously create a new set of signs through which signification can also be achieved.

Khan's relational dialogue with the field of British South Asian arts in Bourdieu's terms therefore evokes the wider social forces of migratory narratives and identity-politics as articulated in the works of his senior and contemporary artists. In his inheritance of this field Khan references its relational dynamics and finds himself in dialogue with it. This relational dynamic is heightened further by Khan's close collaborations with Kureishi (*Ma*, 2004), Kapoor (*Kaash*, 2002) and Sawhney (*Zero Degrees*, 2005; *Bahok*, 2008; *iTMOi*, 2013) and positions him securely in this long-established trajectory, colouring the way he has carved out his own space within it. More importantly he has been recognised by these senior colleagues as unique in his contributions to the field of diasporic arts. Kureishi recently proclaimed, 'He is very, very talented, and I wouldn't say that about many people. He's the real thing' (Kureishi qtd in 'On the Verge'). In a similar spirit of admiration Nitin Sawhney shares what in his opinion makes Khan's explorations in the field distinct:

> I think with Akram [...] it's not about the form so much as it becomes about the feeling and it becomes about the ideas you are trying to put forward. So that for me is far more interesting. (Sawhney qtd in Poulton and Tait)

However, in seeking his own voice in response to his seniors' and contemporaries' unique literary, visual and aural languages, Khan continues to contribute to the field (by virtue of his own British-Bangladeshi identity) while simultaneously moving beyond it (because of his intrinsic transformation of the Western contemporary dance world). Khan's close dialogues with these senior colleagues from the field are therefore central to his own contributions to both British contemporary dance and the wider field of British South Asian art. It is also a fundamental part of his embodied reality as an influential British-Bangladeshi artist whose unique approach to new interculturalism echoes diasporic artistic interventions of the past *and* etches exciting aesthetic possibilities of the future.

Despite his strong associations with the field of South Asian arts in Britain, the real significance of Khan's practice as a British dancer and choreographer lies in its ability to transform the British and global contemporary dance landscape in fundamentally influential and intercultural ways. I acknowledge here the challenges of theorising an artist's practice whose aesthetic and vision is ongoing. Khan's performance trajectory continues to enter new, challenging and dynamic collaborations that transform his aesthetic in form and content. While it is exciting to frame Khan's new interculturalism as it evolves, it would be naïve to suggest that this book captures the entirety of the vision that fuels Khan's performance trajectory. Farooq Chaudhry describes the unfinished nature of Khan's work as 'far from being established' (Chaudhry, 'Keynote' 5).

> I feel that we are still a new company, which has only just started. Perhaps we are at that teenager phase. A little sloppy but full of optimism. We are still finding out about ourselves. There is always the danger of the perception that success and failure can give you. Both able to send you off into a journey of disillusionment. I'm grateful that people are responding favourably to our work. That they are able to take something meaningful away. We have a lot to look forward to in the future and we are very excited about sharing them with you. (Chaudhry, 'Keynote' 5)

This monograph is therefore a starting point to fill the gap that exists in academia surrounding Khan's practice. Through a close analysis of seven of Khan's pieces, I demonstrate how his new interculturalism is borne out through an emphasis on a corporeal and visual language that briefly manifests but continues to haunt its audiences long after, precisely owing to the power of their gestural ephemerality.

2
Corporeal Gestures in
Gnosis (2010)

Gnosis in Greek means knowledge, particularly 'knowledge from experience':

> The word Gnosis does not refer to knowledge that we are told or believe in. Gnosis is conscious, experiential knowledge, not merely intellectual or conceptual knowledge, belief, or theory. [...] Personal experience is not transmissible in conceptual terms; a concept is merely an idea, and experience is far more than an idea. In other words, real Gnosis is an experience that defies conceptualization, belief, or any attempt to convey it. To understand it, one must experience it. (Gnostic Instructor)

This emphasis on knowledge derived from first-hand embodied experience rather than inherited intellect is a poignant echo of my framing of Khan's new interculturalism as an interventionist aesthetic that is driven by his unique embodied realities, as detailed in the previous chapter. It is therefore not a coincidence that *Gnosis* (2010) is the title of Khan's explorations of a minuscule and mostly disregarded aspect of the Indian epic of the *Mahabharata*: a mother-son relationship between Queen Gandhari and Prince Duryodhana. In emphasising the embodied nature of his exploration of both the epic and the theme of mother-son relationships, *Gnosis* distinguishes itself from Brook's intellectual and dis-embodied treatment of the *Mahabharata*, and is thus exemplary of Khan's new interculturalism. Consequently it is also Khan's intellectual and artistic response to Brook's brand of intercultural theatre. While Khan acknowledges that his early exposure to Brook's working methodologies affected his own future vision of performance-making in fundamental ways, he is quick to note that what distinguishes their

respective aesthetics are their own and unique lived realities (Ak. Khan, Interview 2). Khan's new interculturalism is thus shaped by a fundamental spirit of embodied knowledge derived through experience. And because it is the lived body that is at the heart of channelling, processing and consolidating such embodied knowledge, Khan's aesthetic is predominantly corporeal and entirely ephemeral, vanishing in the very moments in which it makes itself present.

In this chapter, through an analysis of *Gnosis*, I unpack the characteristics that ostensibly lend Khan's embodied approach to new interculturalism greater depth and integrity when compared to the predominantly Western, intellectual, Orientalist and neo-imperial endeavour of intercultural theatre of the 1980s. To demonstrate what distinguishes Khan's new interculturalism from Brook's intercultural theatre, I conduct a comparative analysis between *Gnosis* and *The Mahabharata*. This comparison is validated by several points of contact between the two productions, not least Khan and Brook themselves. While the source text of the Indian epic *Mahabharata* fuels both the pieces, it influences them in very different ways. Where Brook perceived the epic in universal terms and wanted to narrate its entirety through his English theatre and film renditions, claiming that 'it belongs to the world, not only to India', *Gnosis* engages with the epic at a more personal level, by examining a tiny dimension of it in the mother-son relationship between Queen Gandhari and Prince Duryodhana (Brook ctd in D. Williams, 'Theatre of Innocence' 24).[1] However, the connection between Brook and Khan, as we already know, goes beyond their engagement with the same source text because of Khan's roles in Brook's production of *The Mahabharata*. His return to the epic twenty odd years later is therefore a significant moment in his career and a strategic response to Brook's intercultural theatre. Moreover Khan's focus on this mother-son dynamic within the *Mahabharata* is nuanced by his personal meditations on the influential bond between South Asian mothers and sons, fuelled by his own relationship with his mother. This personal take on a diminutive aspect of the epic achieves two things simultaneously: firstly it attempts to rectify the charges laid upon Brook's treatment of the epic as naïve in its claims of universalism, and secondly it brings to attention an aspect of the epic which has historically been ignored.

To validate these claims, the chapter examines Khan's ambiguous insider-outsider relationship to the source text of the *Mahabharata* vis-à-vis his postcolonial British-Bangladeshi identity, and discusses how this embodied reality enables a more sensitive and nuanced handling of the epic's themes. The chapter moves on to a detailed description and

analysis of *Gnosis* with an emphasis on Khan's personal meditations on mother-son relationships in the South Asian culture, as captured in his depiction of the Gandhari and Duryodhana relationship. Finally the chapter conducts an extensive comparative analysis between Khan's new interculturalism in *Gnosis* and Brook's intercultural vision in *The Mahabharata*, by examining the primary medium of communication in each performance. To tell the story of Gandhari and Duryodhana, Khan eschews a reliance on text. Instead he opts for the embodied, impressionistic, visual and corporeal genre of physical theatre, where interactions between two bodies provide suggestive glimpses of the mother-son relationship, and the ambiguity generated through their physicality refuses to concretise their stories. This inherent fluidity not only makes *Gnosis* a performance that is open to rich and subjective interpretations, but also lends Khan's new interculturalism an instinctual, open-ended and corporeal aesthetic that is more humble in its interactions with the source text.

Khan's insider-outsider relationship with the source text

As already discussed in the Introduction, central to the critiques aimed at Brook's handling of the *Mahabharata* is Brook's outsider relationship to the source text itself, which arguably triggered the lack of understanding and sensitivity towards the other issues in the first place. If the status of Brook as a white British outsider to Indian culture underscores the criticisms of his intercultural treatment of the epic, then Khan's access to and handling of the epic begs analysis in a similar vein. Any subsequent analysis of *Gnosis* needs to be conducted in the light of Khan's simultaneous insider-outsider relationship to the source text of the *Mahabharata*, vis-à-vis his postcolonial identity as a British Muslim man of Bangladeshi heritage.

Khan's suitability as a potential insider interpreter of the epic can be questioned using Rustom Bharucha's suggestion that only an internalised understanding of the epic from within the Indian context can provide insight into its cultural specificities, in order to interpret the text with sensitivity and integrity (Bharucha, *Theatre* 70). Bharucha's Indian-centric view has in recent decades been complicated by the development of a Hindu nationalist spirit which claims the epic as a Hindu nationalist text and the cornerstone of Hindu philosophy and doctrines.[2] This would by implication deny Indian Christians, Jews, Muslims, Buddhists, Jains and Parsis (like Bharucha himself), and other

South and South East Asian Hindu cultures, a claim upon the epic as their shared cultural artefact. Sanjoy Majumdar explains this nationalist move that reifies the Hindu-ness of the nation:

> Militant Hindu nationalists insist that the essence of being an Indian is being Hindu, which they call 'Hindutva', a term coined in 1923 to construct an identification of the Hindu community with the Indian nation. (Majumdar 208)

As a second-generation British Muslim of Bangladeshi ancestry Khan is neither insider Indian as per Bharucha's view, nor Hindu as per the Hindutva spirit, and on these grounds he would appear to be an outsider to the source text. However his encounter with Indian culture through a combination of circumstances in the British-Bangladeshi context can productively counter this claim. These include tutelage in *kathak* under the Hindu Indian guru Pratap Pawar that would have required knowledge and dramatisation of stories from Hindu epics, his childhood interactions with other South Asians in London through a diasporic pan-ethnicity that helped foster a collective sense of South Asianness, his teenage engagement with the *Mahabharata* under the directorial guidance of Brook, and most importantly the Bengali identity of his Bangladeshi parents who immigrated to Britain shortly after Bangladesh attained independence in 1971.

Leaving Bangladesh very soon after the nation achieved independence, Khan's parents carried with them this indigenous and syncretic Bengali culture that embraced Islamic practices alongside Bengali language, literature and cultural practices in equal measure. In my interview with Anwara Khan it becomes evident that as she transmitted Bengali home-culture to Khan and his sister in Britain, she introduced them to Bengali (and Indian) literature like *Mahabharata*, *Ramayana* and the novels of Rabindranath Tagore, as well as Islamic religious and cultural texts. Therefore while at both Indian and Bangladeshi nationalist levels Khan may be considered an outsider to the epic, at a pan-ethnic, diasporic level, the complexity of his parents' syncretic Bengali Bangladeshi identity would have managed to counter such hegemonic perceptions by providing him access as an insider.

I propose therefore that while, as an outsider to the epic, Brook's interpretation lacks depth and insight, Khan's complex insider-outsider relationship to it lends his treatment of *Gnosis* more ambiguity, sensitivity, humility and integrity. Moreover his own pan-ethnic South Asianness in the diasporic context nuances his depictions of South

Asian mother-son relationships through referencing his relationship with his own mother. It also minimises the chances of an Orientalist representation of India, as evoked by Brook through exoticised use of colours, fabrics, costumes and ritualistic gestures that collectively aimed to create a flavour of India in *The Mahabharata*. In *Gnosis* Khan veers away from the sumptuous colours and fabrics of Brook's scenography in *The Mahabharata*. Instead Khan as Duryodhana is dressed in a black *sherwani*, an austere north Indian costume for men, comprising a long and fitted tunic with fitted trousers. The use of an understated but ominous black undercuts the stereotypical Western image of India as colourful and exotic. Alongside him Gandhari is dressed in a gathered, ankle-length black skirt, contrasted by a starkly white and fitted upper bodice. Lit in very cold steels and confined within squares and rectangles, Khan's *Gnosis* is disturbingly tangible and far from the Orientalist imagery of India that Brook conjured in his depictions of the culture.

Khan's insider-outsider access to Indian culture and the epic are thus influential in shaping his new interculturalism as embodied in *Gnosis*. Moreover Khan's own multi-layered and hybridised cultural identity lends him a presence that in itself represents an organic intercultural reality. Such organic cultural syncretism shifts the notion of intercultural performance-making from the realms of a cerebral exercise to a more embodied articulation of new interculturalism.

Gnosis: an evening of distinct halves?

Gnosis is described by the *Telegraph* reviewer Sarah Crompton as a 'programme of distinct halves' (Crompton, 'Akram'). While the thrust of this chapter is concerned with the second half of *Gnosis*, a brief holistic overview of the programme and an understanding of its interdependent layers are vital for the analysis that follows. Over the course of the evening Khan transforms from the classical *kathak* dancer of the first half (which sees him revive two earlier works, *Polaroid Feet* and *Tarana*) into the contemporary physical theatre performer of the second, in its exploration of the Gandhari-Duryodhana relationship. As Khan moves from the classical to the contemporary vocabulary, he is keen to emphasise the 'process of transformation that never entirely abandons its source' (Jaggi).

The evening begins with a revival of *Polaroid Feet*. Accompanied by a Sanskrit hymn Khan offers salutations to the *ardhanarishwar* (half-man and half-woman) form of the Hindu God Shiva and his consort, Goddess Parvati. The second piece, *Tarana*, opens with Khan sitting in an Islamic

prayer position reminiscent of the ritual of *namaz*, offering salutations to Allah before breaking into a pure rendition of technical prowess. Through *abhinaya* in *Polaroid Feet* and *nritta* in *Tarana*, Khan brings together the syncretism in *kathak* between its Hindu and Islamic roots. An *Unplugged* section follows where Khan breaks the formal presentation mode of the evening thus far and addresses the audience directly to explain the mathematical and artistic principles of *kathak*, while introducing his musicians from India, Pakistan, the UK and Japan, whose dialogue with him is vital to *Gnosis*. The first part of the evening thus ends with a rudimentary but valuable exposition of *kathak*. It lends the audience the ability to identify how some of these principles are going to be deconstructed and transformed, as Khan enters the contemporary physical theatre aesthetic of *Gnosis* after the interval.

Gandhari

The second half of *Gnosis* embodies Khan's new interculturalism in evocative ways and constitutes a humble yet profound response to Brook's intercultural theatre project. This response is crafted with sensitivity and artistic flair in a physical theatre exploration of the explosive mother-son relationship of Gandhari and Duryodhana. At the heart of this piece is the character of Queen Gandhari from the *Mahabharata*. Long valorised in Indian culture as an obedient and subservient wife for willingly blindfolding herself for life when forced to marry the blind King Dhritarashtra, Gandhari's resilient survival in a male-dominated environment through her stubborn determination to uphold righteousness at all costs in order to protect her family, is not revered in the same manner. Jayanti Alam, who sees Gandhari as a silent rebel, notes that having restricted her own sight through choice Gandhari's 'inner eyes, behind the blindfolded ones, seemed to have developed special power of seeing even that which normal eyesight could not detect' (Alam 1517). She uses her inner wisdom and knowledge, her Gnosis, to warn her husband, King Dhritarashtra, and son Duryodhana of the impending disaster threatening their clan if they continue to conduct their political affairs on the basis of personal prejudices and ambitions instead of justice and the welfare of the kingdom.

Khan recognises in Gandhari's silent resilience a feminist spirit of rebellion, and is intrigued by her resolve to remain blindfolded throughout the births, marriages and deaths of her hundred children, despite having the choice to remove the cloth at any point (Ak. Khan, '*Gnosis* Programme Notes'). He is drawn to Gandhari's determination

as it resonates with his own mother Anwara Khan's relentless efforts and resolute spirit, like many South Asian mothers in the diaspora, to withstand 'a profound tension, perhaps even a split [...] between "tradition" and "modernity", in negotiating between herself and her children within the diaspora' (Jolly 1).[3] Despite all such adversities and pressures of integration these mothers continued to transmit vital aspects of home-cultures to their British-born children, and played an active role in their children's identity formations in the diaspora. Khan hints at such personal affiliations to the Gandhari-Duryodhana myth when he acknowledges that Gandhari's character merely opens up possibilities to explore themes, 'landscapes, images, sketches from which ideas spring, and are then transformed into a more personal interpretation of the story' (Ak. Khan, 'Gnosis Programme Notes'). Moreover, just as Margaret Jolly suggests that in the colonial and postcolonial South Asian context 'the mother has been marginalized in debates about maternity', Khan acknowledges the historical marginalisation of mothers such as Gandhari from the epic by insisting 'on her centrality' in *Gnosis* (Jolly 2).

Gnosis

The evocation of Gandhari and Duryodhana begins in darkness to the sound of static. Gradually a stark, steel, cold and vertically rectangular shaft of light illuminates the centre stage. Into this light, walking impossibly slowly, appears the frame of Yoshie Sunahata.[4] Even as she appears calm and collected on the exterior, her internally heightened focus is palpable through the muscular tensions visible in her body. This image mirrors Khan's appearance in the beginning of the first half, evoked by her powerful drumming. As Sunahata reaches the centre of the pool of light she stops and holds forward a white staff horizontally in the palms of her extended hands, as though making an offering of it to the audience. After touching her forehead reverentially to the staff, she places it on the floor with great care and slowly returns to standing. This ritualistic reverence lends the staff an immediate significance and marks the beginning of the 'Ritual of Birth' sequence. Sunahata as Gandhari brings her arms to her chest and begins to slowly trace a wide circle with them, extending them first to the left, then over her head, to the right and back to the centre. As her arms reach above her head, her upper body shifts its focus to the left and her right leg extends behind her into a deep plié. Then she returns to her starting position and begins the movement all over again. The slowness of the movement demonstrates her extreme bodily control and focus. At a mesmerisingly

slow speed, this initial motif transforms into the next that mimes the beating of a drum with 'deep lunges in profile, sculptural and strong' (Anderson, 'Akram'). Sunahata continues to repeat this movement endlessly as she shifts from side to side through an exhaustingly low centre of gravity. The motif builds in frenzy and momentum while still retaining its compelling precision. Her physical exhaustion colours her facial expressions as it screws up with tension and pain. Through the most evocatively choreographed abstraction, Sunahata embodies the prolonged and painful labour of childbirth, as experienced by Gandhari in the epic where her pregnancy is believed to have lasted an unusually long time.[5] Sunahata's exhausting repetition of the motif builds to a crescendo until out of the dark emerges Khan. He appears from behind her as though generated by her energy and her very being, and begins to echo her motif in perfect synchronicity. Duryodhana is born.

Their synchronisation is flawless and creates a beautiful image of the intimate and umbilical bond between mother and child, except when in fleeting and disturbing moments Duryodhana falls out of rhythm to taste his own independence before returning to Gandhari's protective rhythm. The mother senses her son's restless attempts to break free and the faintest lines of worry crease her forehead. But she continues in her movement pattern, occasionally holding on to an imaginary sphere in-between her hands, nurturing the ball of flesh for the birth of her remaining ninety-nine children. Duryodhana mirrors this image, taking protectoral charge of his siblings. Gradually the birthing process draws to an end as Gandhari collapses on the floor, exhausted and fragile. She is disturbingly controlled like a puppet by her son's hands before he breaks out into an ominous and fearless series of *chakkars* (*kathak* spins), occupying every inch of the space and marking his territory. She seems aware of the signs of his controlling nature and senses darker energies within Duryodhana's being, yet is too weary to counter them. These tiny emotional significations from both Khan and Sunahata capture with subtlety the controversies surrounding Duryodhana's birth in the epic, the supposed omens that predicted he would bring devastation to his race, and Gandhari and Dhritarashtra's inability to abandon their first born, despite being counselled to do so for the welfare of the family.

The 'Play of Innocence' begins with Gandhari scrambling around on the floor for her white staff to symbolise her blindfolded existence. She stands up supported by the stick, raises it vertically high into the air and brings it down to hit the floor in front of her. At this same instant the lighting snaps into a yellow square, signalling a transition into the next phase. As Duryodhana lies collapsed in a heap in the back of the

square having lost control of his spins, Gandhari tries to locate him by using the stick to feel the ground around her until it touches him. Duryodhana enters a stubborn and childish game with his mother, refusing to give in to her maternal demands. He holds on to her stick and lets her drag him across the floor, and continues to repeatedly stand up and fall into a heap again. Occasionally he is distracted by hearing someone whisper his name in an alluring manner, but he cannot locate its source. In the absence of her vision, Gandhari's staff not only signifies her chosen blindness but also doubles as a disciplinarian tool for Duryodhana, as she experiences him grow up through these tactile means. Moreover if, as Margaret Trawick suggests, a mother's loving gaze upon her child is the most dangerous and tainted gaze of all, then Gandhari's chosen blindness physically prevents her from gazing lovingly at Duryodhana, and thereby contains and limits her maternal love for him (Trawick 42–3).[6]

They play games with each other. Duryodhana refuses to be entrapped by her embrace (and by implication her *dharma*) as his nimble body weaves in and out of the narrowest of spaces defined between Gandhari's body and her creative use of her staff. When his behaviour gets too stubborn Gandhari's face expresses anxiety and despair, warranting Duryodhana to alternate between picking her up in an affectionate embrace and asking for her forgiveness and blessings by placing her hands upon his head. As the playfulness continues to shift between affection and agitation, Duryodhana dodges the staff as it swings through the air while simultaneously escaping his mother's desire to touch his face. It is a remarkable feat of choreography, heightened by Khan and Sunahata's emotional commitment to their characters. Finally Duryodhana goes too far and manages to take the staff away from his mother's hands, leaving her to feel her way through the space with her arms stretched out, and her face full of fear and apprehension. He knows he has overstepped the mark and returns the staff to her. As a final act of enforcing discipline, Gandhari positions her staff at the centre of his chest and pushes him to fully suspend his body weight at that singular point of contact, as she would an opponent in a game. The act appears both tender and cruel at once. As Trawick explains, 'acts embodying the cruelty of love could also and simultaneously be acts hiding its tenderness' (Trawick 48). Thus physical affection for children is 'expressed not through caresses but roughly in the form of painful pinches, slaps and tweaks [...]' (Trawick 48).

Caught between his mother's love and discipline and his obsessive ambition, 'Greed and Power' traces Duryodhana's transformation into

the villain of the epic. The alluring whispers of his name become so frequent and compelling that he cannot resist falling prey to the darker intentions they stand for. In the epic Duryodhana is goaded by his uncle, Gandhari's brother Shakuni, into waging war against his cousins the Pandavas, and despite his mother's counsel he lets Shakuni lead him astray. In *Gnosis*, at first Duryodhana repeatedly kneels before Gandhari, head bowed in respect and hands folded in a gesture of prayer, pleading for his mother's support and understanding. Realising that he has upset her, he observes penance by lying down horizontally before Gandhari and guiding her right foot onto his chest so she can walk over him repeatedly. When this fails to appease her, through an evocatively performed *abhinaya* section Duryodhana tries to assert his voice through accompanying live Hindi lyrics. In the recital he requests that his mother listen to him (*sun meri ma soon*) and pleads with Gandhari to pray that Lord Krishna will help him in the war ahead (*Krishna meri madat kare*).

Gandhari's sorrow and sense of betrayal keep her from accepting her son's attempts at reconciliation and demonstrate that 'the emotional power of the mother in any form is dangerous: it is intense, and it can easily turn into rage' (Trawick 60). She turns her body repeatedly away from him and physically brushes off his attempts to make her bless him by placing her hands on his head. In response to Gandhari's endless rejection Duryodhana turns aggressive, and violently forces her to acknowledge him by grasping her body in his arms (reminiscent of their earlier affectionate play but this time with a more forceful intention), swinging her body around in the space before putting her down carelessly. In disobeying Gandhari's advice and his tactless handling of the most sacred and enduring of all familiar bonds between mother and son, Duryodhana puts his own interests before his mother's and fails to 'protect her from whatever disturbs her' (Haddad 66).[7] Gandhari's desperation reaches a crescendo as she wields her staff into the air and crumbles to the floor in anticipation of her son's self-destruction. In the ambiguous moment that follows, Duryodhana kneels down to support Gandhari's trembling body on his shoulders. She surrenders her staff to him and leaves, as though accepting defeat with regard to the situation she cannot prevent from unfolding.

As Duryodhana transforms from 'Man to Beast' his mother's white staff exerts upon him, both physically and metaphorically, the moralistic pressures of *dharma* and *karma*.[8] The disciplinarian tool of his childhood transforms into a weapon that judges his lack of justice and righteousness. With his back to the audience Duryodhana places the

staff and balances it horizontally across his neck, visibly caving under its force. He bends backwards, arms suspended in the air, precariously off-balance, as his body responds to its metaphoric pressure through erratic and sharp movements. Swathed in a dramatic red pool of light, Duryodhana is an image of terror and pity all at once. Realising that the staff will be a constant reminder of his mother and her path of *dharma* which he never followed, he flings it away from him and accepts he is alone in his ambitious, self-destructive vision of conquering the world.

'Mourning and Fire' depicts the devastating and tragic death of Duryodhana experienced from Gandhari's perspective, as she returns to lament his inevitable passing through the eerie sounds of a Japanese song that sounds like a haunting lullaby. What Gandhari cannot witness through her eyes is palpable within her body, intensified and magnified through her maternal instincts. As Sunahata sings, her body creases up in sorrow, anger and helplessness. She appears onstage with her arms stretched out in a longing to cradle her child and protect him from his painful end. In the epic, Duryodhana's death is long and painful, and the gradual disintegration of Khan's body over a period of about ten to twelve minutes depicts this in a very disturbing manner. His feet shuffle from side to side, 'his hands at first cradling his face, like a mother caressing a child [...] until the phenomenal happens, something almost supernatural, when his body suddenly seems to be consumed. He shakes and quivers in a horrendously vivid evocation of total physical breakdown' (I. Brown, '*Gnosis*'). During this prolonged depiction of his demise, Duryodhana's hands twitchingly revisit the same evocative gesture of holding a spherical ball of flesh as he did in his birth alongside his mother. 'In an extraordinary act of physical control, shaking and twitching [...] his body seems to vanish in a dark conflagration' that paints a truly horrific, disturbing and despairing image of death that draws *Gnosis* to an evocative end (Crompton, 'Akram Khan's *Gnosis*').

Gnosis and *The Mahabharata*: a comparative analysis

In their respective productions Brook and Khan were both dealing with the source text of *Mahabharata* and its status as cultural memory for the people of South and South East Asia. Performance studies scholar Diana Taylor distinguishes between two modes of cultural memory transmission. The first is archival memory, which includes factual memory, drawn from documents, maps, textual sources, archaeological finds and other such items that are associated with permanence (Taylor 19). As a textual source, despite existing in multiple renditions and linguistic

translations all over India and beyond, the *Mahabharata* as an epic is therefore an archive. This is what lends it magnitude, permanence and longevity. Thus Brook's attempt to interpret such a seminal textual source by translating it into English and French for Western audiences was deemed by Indian postcolonial critics as tampering with a vital archive of Indian culture.

In *Gnosis*, however, Khan does not engage directly with the archive through the use of verbal language. Drawing on Gandhari's extraordinary qualities but not wishing to narrate her story, *Gnosis* successfully moves away from factual storytelling and dwells instead on corporeal imagery and 'ideas of blindness, of vulnerability and strength' (Anderson, 'Akram'). Therefore Khan chooses to strategically depict the Gandhari-Duryodhana relationship through embodied corporealities. Taylor identifies a second kind of cultural memory which she calls repertoire, and suggests that it is a form of memory which is embodied through non-verbal, gestural, oral and corporeal means. It does not rely on the written word and is thus ephemeral and non-reproducible, since it cannot be documented via conventional archival means. Taylor advocates the value of the repertoire as an embodied system of knowledge to rectify the historical tendency that has valued memory in the form of the written word (Taylor 20). By using a tiny aspect of the epic as a point of departure, Khan engages with an embodied corporeal language which does not override the archival status of the epic. Instead Khan creates a repertoire that is ephemeral in its interpretation of the epic and exists only in its moments of performance. And it is precisely its impermanence that makes *Gnosis* less of a threat to the exalted status of the source text, and thereby a more sensitive and nuanced approach to the complex dynamics that govern intercultural exchanges.

In an insightful study on the problems inherent in translating source texts for intercultural performance practices, Patrice Pavis puts forward an important defence of Brook's treatment of the *Mahabharata*. He suggests that the scale of such translations functions beyond 'the rather limited phenomenon of the *interlingual* translation of the dramatic text' (Pavis, 'Problems' 25). Citing the importance of preverbal modes of communication alongside interlingual translation in such exchanges Pavis writes:

This preverbal element does not [...] exclude speech; rather it contains it, but as *speech* uttered within a situation of enunciation, and as one of many elements in this global situation preceding the written text. Thus the preverbal is not limited to gesture, but encompasses all the

elements of a situation of enunciation preceding the writing of the text: apart from gesture, this includes costume, the actor's manner, imagined speech, in short, all the sign systems that make up the theatrical situation of enunciation. (Pavis, 'Problems' 34)

Pavis argues that Brook successfully makes use of such preverbal modes of communication through the design of a unique mise en scène which emerges at the intersection of gesture and scenography. By drawing on cultural rituals and social gestures that are removed from where they originate, Pavis suggests that Brook's real translation of the epic occurs at an 'intergestural' realm 'which alone is capable of conveying theatrically the myth contained in the Indian text' (Pavis, 'Problems' 40). Pavis concludes by saying that through *The Mahabharata* 'Brook and Carrière tell a story that exceeds text and anecdote, and constitutes itself as myth, by way of gestural discourse – a language of the body [...]' (Pavis, 'Problems' 40).

Pavis's claim needs to be contested for two reasons. Firstly the gestural discourse that Pavis refers to uses physical motifs borrowed from culturally specific gestures that get removed from their own contexts. An example of this is the primarily, though not exclusively, Indian greeting of folding one's hands in a prayer position at the chest and bowing reverentially in acknowledgement of the divinity within every human being. Brook's use of this *namaskar* gesture to depict characters greeting each other is on the surface not problematic. It could even be deemed accurate. However, it perpetuates a stereotypical image of India within the minds of Western audiences through a particular cultural gesture which has been etched onto an Orientalist representational matrix of India. In other words, the gesture continues to circulate as a myth that represents India, and its real significance is never communicated or understood. Moreover, as Richard Schechner suggests, when a gesture such as the *namaskar* is etched onto bodies that it does not belong to it becomes once removed and appears 'foreign to their bodies' (Schechner, 'Interculturalism' 44). Similarly Rustom Bharucha and Marvin Carlson are critical of the aural confusion that is generated by the gaps between the language of the script and the lingo-phonic qualities of the performers delivering them. While Bharucha suggests that in having to speak in English the performers' voices are 'reduced to accents, almost incomprehensible at times [...]' (Bharucha, *Theatre* 81), Carlson asserts that 'a Japanese actor with a French accent, pronouncing an English transliteration of a Sanskrit name, may resemble less an instrument of pure culture-free expression, than a one-man Tower of Babel' (Carlson 54).

Secondly Pavis's defence suggests that Brook's production operates effectively without relying on the verbal dialogue between the characters that moves the narrative forward. This would be countered by the commercial availability of the Brook-Carrière script which has become a Western archival version of the epic itself. While Brook's mise en scène may have created a language where the visual and aural interacted in unique ways, the narrative spine of the epic was still communicated through the script as its primary means of storytelling. This is because Brook wanted to relay the entire epic to the Western world. In contrast Khan was only interested in exploring imagistic and corporeal glimpses of the mother-son interactions in the epic. By relying on the corporeal ephemerality of his aesthetic and relegating the text to a subsidiary position in the signification process, Khan creates an ambivalence in his treatment of the epic, leaving his interpretations unfixed and open-ended.

Khan and his postcolonial body exist 'in a complex representational matrix' (Gilbert and Tompkins 12) which when placed in the centre of theatrical signification 'can be a highly useful (and even essential) strategy for reconstructing post-colonial subjectivity' (Gilbert and Tompkins 204). Khan recognises this and sees that as well as 'being the site of knowledge-power, the body is thus also a site of *resistance*, for it exerts a recalcitrance, and always entails the possibility of a counterstrategic reinscription, for it is capable of being self-marked, self-represented in alternative ways' (Grosz 64). Having experimented extensively with the interactions between the delivery of live text and movement in a range of his works (*Zero Degrees, Sacred Monsters, In-I, Bahok*) to varying degrees of success, Khan's move away from the use of text as the primary means of storytelling in *Gnosis* is worthy of analysis. In wanting to create visual impressions of the Gandhari-Duryodhana relationship, Khan realised that a reliance on text would fix meanings too easily, and not allow space for ambiguity and multiple readings of his interpretations. Instead his choice to work primarily through embodied corporealities draws on the movement medium which articulates his own embodied new interculturalism more effectively. He understands however that to express his explorations of the Gandhari-Duryodhana myth effectually, he is 'required to move beyond the confines of self', while still retaining and evoking his own condition in his art (Fraleigh 23). Therefore, without overtly dwelling on the parallels he draws between the mythical mother-son dynamic and the influential role of his own mother, *Gnosis* becomes a meditation on Khan's musings on South Asian mother-son relationships. Khan understands the flaw in human logic that makes us 'simple minded enough to believe that if we have something to say

we would use words', and resorts to the language of the body to make his art (Cage and Cunningham qtd in Fraleigh 71). The embodied and politicised language of physical theatre through which Khan and Sunahata convey their narrative challenges the 'continuing hegemony of a theatre defined by its literary and verbal dimensions' (Murray and Keefe 6) by reversing the assumed 'hierarchy of word over body' (Murray and Keefe 7). By demoting the use of verbal language to a subsidiary and supportive role delivered live through accompanying lyrics by the exquisite vocalist Faheem Mazhar, 'a direct sign-signifier relationship is broken' and 'objects, characters, scenes and events acquire a multiple, fluctuating, fragmented identity'(Sánchez-Colberg, 'Altered States' 23).

There are two moments within *Gnosis* when signification through layered interaction between body and supporting lyrics is achieved at different levels for the audience. The first is aimed at the uninitiated audience member who is unfamiliar with the narrative of the epic, and not privy to understanding Hindi lyrics. In the 'Transformation of Man to Beast' section, through *abhinaya*, Khan enacts the narrative that underscores the accompanying Hindi lyrics to the recital of Faheem Mazhar's *sun meri ma sun* (listen to me my mother). For the audience member not able to understand the lyrics, even at a formalist level, Khan's movement creates Pavis's 'intergestural dynamic' through which Duryodhana's emotional struggle is communicated via Khan's dynamic and violent body. For the audience member who can follow the lyrics, the visual medium of Khan's body is layered upon by the aural medium of the lyrics, and a closer association with the source text is attained. However, it is in the final 'Mourning and Fire' sequence, when Sunahata's haunting Japanese song accompanies Khan's disturbing embodiment of death, that the relationship between Khan's corporeality and Sunahata's Japanese lyrics creates a whole new nexus of signification. The aesthetic of non-translation of the Japanese song limits the inter-textual signification to a very small proportion of the audience (outside of Japan) who might understand the language. In an email exchange about the significance of the song that Sunahata sings in Japanese, she reveals it is a *minyo*, a Japanese folk song which is passed down through generations as an oral tradition and pertains to a specific region of Japan. She translates the song into English as follows:

> Iwate is rural, but in the east and in the west, it has a lot of mountain mines.
> When you come next time, please bring the leaves of the nagi tree from beyond the mountains. (Sunahata)

The dramaturgical choice to include this Japanese song in the context of Duryodhana's demise within *Gnosis* is just as obscure for those who understand the lyrics as it is for those who do nott. However, the aural soundscape created by the song vis-à-vis Sunahata's mourning Duryodhana's passing as his mother is more reminiscent of a comforting lullaby sung to her baby at his darkest hour of need. The complexity of the soundscape also evokes Khan's ex-collaborator Sidi Larbi Cherkaoui's artistic strategy of non-translation to create an obscured dramaturgy within otherwise familiar semiotic frameworks (Uytterhoeven 11). Therefore those who do not understand the meaning of the Japanese lyrics that accompany Khan's evocation of death respond instinctively to the aural qualities of the haunting lullaby-like song that communicate a mother's mourning of her son's passing, without any reliance on the lyrics.

Through *Gnosis*, Khan and Sunahata's respective embodiments of Duryodhana and Gandhari and their mutual interactions become 'elusive and ephemeral' in their refusal to be tied down to definitive significations (Albright 5). It is precisely this deliberate 'semiotic vacuum, outside of language and meaning' in which *Gnosis* exists that makes its transmission of cultural memory of the epic through a repertoire more sensitive to postcolonial critiques of intercultural theatre practices (Albright 5). However, it is able to exist in this semiotic vacuum because it does not aim to become an exercise in dramatisation of the entire epic.

The function of a central narrative is therefore a significant point of departure between Brook and Khan's approaches to the archival text. Sanjoy Majumdar suggests that 'Brook attempts to present the epic as a cultural text that is able to stand independent of any one history or social reality, as a universal tale of "all humanity"' (Majumdar 205). Brook is therefore keen to present the epic in its entirety to the Western world, made accessible through Western dramaturgical frameworks of storytelling, structure and characterisations, communicated through verbal language. Khan on the other hand moves away from the factual fidelities of storytelling and concentrates instead on exploring his personal responses to the mother-son relationship in the epic through visual and corporeal means. Khan therefore attempts to ask of himself the question that Bharucha feels is vital when borrowing from such a significant archive: 'what does this epic mean to me?' (Bharucha, *Theatre* 71).

In asking the question of himself, Khan signals a more personal and subjective interpretation of the epic's musings on mother-son relationships, and creates an ambiguous visual and physical language that

initiates multiple readings of *Gnosis* instead of anchoring a singular meaning to the epic. This ambiguity is a deliberate ploy of Khan's on two accounts: firstly it becomes a postcolonial strategy that assumes a certain level of familiarity with the source epic, and that deliberately denies explanations of the epic itself to audiences who are less familiar with the text. This complicates the way in which different audience members receive and respond to *Gnosis*, and Khan is unapologetic about not offering a fuller explanation to those whose knowledge of the Gandhari-Duryodhana dynamic is limited. Secondly, and connected to the issue of postcolonial strategising, I would argue that this ambiguity heightens the responsibility of audience members in their reception of and contribution to the eventual writing of *Gnosis* itself, through a suggestive reference to Roland Barthes' seminal framework of 'the death of the author' (Barthes, 'Death').

In a poststructuralist turn to his literary analysis of texts, Barthes signalled through his death of the author proclamation an end to the author's agency and power, and a dismantling of the hierarchy between the author and the reader. This led to the birth of the reader and, with it, openness to interpretations and multiplicity of meaning-making through a singular text. Barthes suggested that there are two kinds of texts: the readerly text through which readers are closely guided as passive consumers without being offered an entry point into the text, and the writerly text which viewed readers as active producers of textual meanings (Barthes, *S/Z* 4).Viewing the text as a 'galaxy of signifiers, not a structure of signifieds' (Barthes, *S/Z* 5), Barthes valued the writerly over the readerly text, as he believed that 'the goal of literary work (of literature as work) is to make the reader no longer a consumer, but a producer of the text' (Barthes, *S/Z* 4).

In examining the reading of an epic like the *Mahabharata* Rakesh Thakur suggests that:

> The act of reading is an encounter. Yes, indeed, the encounter with the narrative moves across two plains: the mapping of its mythical historicity [...] and at a more sublime level, the trajectory of the reading mind, as it negotiates the various themes, the contested terrain of governance, family and society. (Thakur 58)

Following Thakur's discussions on the inherent nature of the epic as a writerly text by virtue of its ability to interact with its consumers at multifarious levels, I propose that Brook's production aimed to map the epic's mythical historicity through a foreign lens. In doing so Brook

created a readerly text for his audience, who became passive consumers of his meditations on Indian culture and were not given an entry point for any subjective contributions to these readings.

In comparison, Khan and Sunahata's relegation of the verbal means of communication, their decision not to narrate the entire epic and their imagistic exploration of the Gandhari-Duryodhana relationship, created a writerly text. This writerly text became a postcolonial strategy that invited its readers to an 'active participation in the production of meanings that are infinite and inexhaustible' (Thakur 60) through a 'disciplined identification and dismantling of the sources of textual power' (Barry 66) that Brook fell victim to. Moreover, as per literary critic Wolfgang Iser's notion of gaps that are deliberately woven into a text as opportunities 'to bring into play our own faculty for establishing connections – for filling the gaps left by the text itself', Khan's deliberate use of ambiguity and gaps within *Gnosis* provided its audience with an abundance of such entry points through which to access, interpret and write their own associations of mother-son relationships, and became a fundamental postcolonial strategy for referencing the Gandhari-Duryodhana dynamic without explaining it (Iser 193).

Through the readerly text of *The Mahabharata*, Western audiences encountered a carefully manufactured and exoticised representational matrix of Brook's vision of Indian culture. Through the writerly text of *Gnosis*, Western audiences were instead provided with fleeting, abstract, imagistic glimpses of a tragic mother-son relationship that conjured up opportunities for them to make their own associations. Khan's intelligent scaling down of the scope of the project made his approach to new interculturalism more personal, humble and tangible. While Brook relied primarily on textual dialogue and narrative devices to conduct the storytelling of the epic, Khan created an embodied corporeal aesthetic that operated beyond logocentricism to evoke expressionistic suggestions of the Gandhari-Duryodhana relationship. He was not interested in narrating the entire story of the *Mahabharata* or indeed an evocation of 'India'. Instead, *Gnosis* became an offering of Khan's musings on his own relationship with his mother, loosely mediated through the characters' interactions in the epic. In Brook's production the search for a universal theatre language managed to fetishise cultural difference, while simultaneously homogenising the cultural specificities of his multinational cast. In *Gnosis*, Khan and Sunahata's equal and balanced exchange in corporeal languages and performance presence created a syncretism that drew on points of contact, despite their embodied cultural differences. This gave birth to a new, heterogeneous

semantic altogether, while not erasing their own cultural identities and performance traditions. Christopher Balme suggests that:

> Although the cultural texts in syncretic theatre [...] undergo a process of recoding, there exists a consciously sought-after creative tension between the meanings engendered by these texts in the traditional performative context and the new function within a Western drama-turgical framework. [...] In syncretic theatre [...] cultural texts retain their integrity as bearers of precisely defined cultural meaning. (Balme 5)

Khan and Sunahata dissipated this tension by using as their primary medium of translation an ambiguous and slippery aesthetic of corpo-real ephemerality over the definitive value usually afforded to text. It is precisely the ambiguity generated by Khan and Sunahata's corporeal exchanges that made their audience work harder by questioning 'who or what is speaking through the body and in what language [...]' and opened up multiple readings of the piece from their own subjective perspectives (Auslander qtd in Balme 167).

In this light this chapter has tried to provide an analysis of *Gnosis* through one such possible reading nuanced by my own postcolonial diasporic identity in Britain and my own familiarity with the source text. The chapter has also implicated the value that Khan's new inter-culturalism places on the corporeal and the gestural treatment of themes, over and beyond the importance that has been afforded to the 'narrative or theatrical plot, which is generally the first exchange between western and eastern theatre' (Holledge and Tompkins 15). Khan monopolises the ephemerality inherent in such a corporeal aesthetic, emphasising its unfixed and processual nature. By using the body as a primary means of exchange Khan has invested in and capitalised on its 'ability to move, cover up, reveal itself, and even "fracture" on stage', recognising in it the 'many possible sites for decolonisation' from the highly limiting exoticism afforded to his body and art by countless Western critics (Gilbert and Tompkins 204).

3
Auto-ethnography and *Loose in Flight* (1999)

Khan's use of the body as both a site and source of decolonisation may have reached a crystallised political aesthetic in *Gnosis*, but its presence as a strategy of artistic enquiry was evident from his earliest endeavour as a student at university. Between 1996 and 1998, during his time at Northern School of Contemporary Dance, Khan created *Loose in Flight*, a solo that began to negotiate the confusion generated through the multi-corporeal layers between his training in *kathak* and contemporary dance idioms. The innovative spirit and distinctive aesthetic of *Loose in Flight* is seminal to Khan's career trajectory for two reasons. Firstly it marks the moment when his very confusion began to generate an organic, dynamic and unique emerging aesthetic. Secondly and more significantly, the piece signals Khan's earliest approach to new interculturalism as an auto-ethnographic enquiry of his own complex embodied condition. In 1999 British television producer Rosa Rogers of Channel 4 approached Khan to adapt this solo for the screen in collaboration with filmmaker Rachel Davies, as part of a series called *Per4mance* which was designed to promote short collaborations between filmmakers and performing artists. As a dance-film *Loose in Flight* (1999) embodied the interdisciplinary and collaborative spirit that has continued to characterise Khan's trajectory. It further exploited the national televisual medium in order to dismantle native British notions of South Asian dance, identity and culture at a time when mainstream British television had already started to witness significant shifts in representations of diasporic South Asian identity.

Loose in Flight is a commentary on Khan's multilayered corporeality and its complex relationship with the marginalised history of London's Docklands and its migrant dwellers. While Khan is part of the British-Bangladeshi diaspora, his upwardly mobile, middle-class upbringing

in Wimbledon distinguishes him from the more deprived Bangladeshi migrants who live in the cramped and run-down council estates that characterise the Docklands landscape.[1] Thus Khan's body and its inside-outside relationship with Docklands becomes a metaphor for his ability to operate inside and outside several socio-cultural spaces at once, emphasising his complex but multiple belongings and non-belongings to categories such as British, Bangladeshi, Bengali, South Asian, classical, and contemporary amongst others. Deploying Valerie Briginshaw's ideas on how bodies and spaces shape each other, this chapter investigates the historic significance of the relationship between Khan's turbulent body and the derelict cityscape of London's Docklands, as captured in the dialogue between Davies' film and Khan's choreography.

Loose in Flight marks the beginning of Khan's career trajectory and through it he carves out a visible space and presence for his minority self. This visibility retrospectively acquires even more symbolism when, thirteen years later, Khan and his performers take centre stage at the London Olympics Opening Ceremony in the Queen Elizabeth Olympic Park, purpose-built for the London 2012 Olympic Games through a regeneration project in Stratford, also in the East End of London. Over a period of thirteen years Khan's complex relationship to East London and the Bangladeshi communities residing in the region thus journeys from his own embodied confused isolation as captured in the solo of *Loose in Flight*, to his commanding and integrated mainstream presence in his mass ensemble choreography of *Abide with Me* at the London Olympics Opening Ceremony.

Loose in Flight is thus as much an assertion of Khan's visibility as a British-Bangladeshi as it is Khan's auto-ethnographic enquiry into this very embodied reality. We witness through the piece a collapse between the enquiry and the enquirer, such that Khan embodies both simultaneously. This self-reflexivity of the piece places Khan at the centre of his own enquiry. Moreover *Loose in Flight* is a commentary on the British-Bangladeshi diasporic condition as a whole, revealed as a fragmented, isolated and complex condition as seen from Khan's own embodied perspective. Its auto-ethnographic spirit infiltrates Khan's earliest manifestations of new interculturalism as an exploration of his own organically developing condition, which was being borne out corporeally, instinctually and physiologically, as a reflection of his own complex identity-politics.

Khan's confusion and *Loose in Flight*

At an aesthetic level *Loose in Flight* marked Khan's initial explorations between *kathak* and multiple Western movement systems, and

articulated the confusions that were surfacing within his body. It was also the piece of work that generated the problematic label 'contemporary *kathak*' which was later going to be applied to *Rush* (2000), *Fix* (2000) and other of Khan's early works. As noted in the Introduction, contemporary *kathak* implies a limiting encounter between classical *kathak* and Western contemporary dance training, where the only possible (and desirable) outcome is a contemporisation (and westernisation) of the non-Western classical dance form. By equating his confusion with contemporisation, the label problematically dilutes and dissipates the deconstructionist possibilities inherent in the condition of confusion. Contemporary *kathak* further implies that because Khan's training started in *kathak*, his emerging aesthetic would have to be tied into his classical training in fairly explicit ways. *Loose in Flight* was thus received by audiences as an effort on Khan's part to contemporise *kathak* and Khan was categorised as a contemporary British South Asian dancer.

In reality Khan's confusion was generating something far more profound than a contemporisation of *kathak*. Alongside working through his own corporeal tensions in an organic and instinctual manner, Khan was also transposing the principle of *abhinaya* from its codified avatar in *kathak* to an everyday contemporary performance language. On the contrary then, rather than seeing *Loose in Flight* as an example of contemporary British South Asian dance, I would like to propose that it embodies Khan's early explorations of new interculturalism and begins to transform British contemporary dance in intercultural ways.

At the heart of Khan's confusion were physiological and creative tensions between his training in *kathak* and contemporary dance idioms. The verticality of his *kathak* training, accentuated by a mobile upper torso and a grounded lower torso through unlocked knees, straight legs and flat feet, began to clash with the pro-gravity horizontality of his contemporary movement training, particularly as embodied in release technique. Equally jarring were the strict codifications of the *kathak* language on the one hand and the improvisatory nature of contemporary dance on the other. Khan admits that the most unnerving and exciting of these tensions was the clash between the *known* nature of his classical repertoire and the *unknown* nature of contemporary dance. He further notes:

In those early days I had no pre-established map to refer to, so I realised that I would need to create my own map by exploring and discovering the potentials that lay latent in my own lived realities. Other South Asian dancers who had ventured into this field of inbetweenness, were yet to find an aesthetic that was embodied and that

spoke of embodied realities. And that is what I was looking for.
(Ak. Khan, Interview 2)

In emphasising the embodied nature of his explorations, Khan gradu-
ally learnt to stop rationalising the changes that were taking place in
his body, and instead placed trust in his body's own capacity to process
information. He reflects:

> The body is a sponge. It absorbs any information that you give it and
> has a way of making decisions for itself, not necessarily consciously.
> (Ak. Khan qtd in Ellis)

This led to the emergence of a movement language that drew from his
multiple training systems, without sitting conveniently in any particu-
lar one. The syncretism in Khan's emergent movement language began
to closely mirror the syncretism in his identity, lending his aesthetic
not just artistic but also intellectual value, as his articulations of his
identity-politics appeared to be 'borne out in practice' in the spirit of
auto-ethnography (Norridge 5).

This complex and layered, fragmented and ruptured, dynamic and
volatile syncretic aesthetic became the central charge of *Loose in Flight*,
as identified by Shezad Khalil in an unpublished conference paper on
the piece:

> Khan depicts no sense of clarity between the borders of Kathak and
> contemporary. They are blurred. They are indistinct. There is no
> point in the choreography that allows the observer to identify the
> transition between western and non-western dance movements.
> They are intertwined, mingled and combined. The gates of these
> boundaries are broken. (Khalil, 'Contemporary Kathak' 18)

It is precisely this seamless fluidity between multiple movement systems
that makes the piece impossible to categorise and hence a seminal piece
of work in Khan's ever-exploratory trajectory. By becoming a point of
physiological and emotional release for the various tensions that had
accumulated in his body, *Loose in Flight* can be read as Khan's auto-
ethnographic enquiry into his multilayered existence. And in giving
voice to this, the film medium plays an indispensable role. Therefore
Khan's choreographic experimentations alone do not make this auto-
ethnography a seminal point of departure in his repertoire. *Loose in
Flight* also marks Khan's first interdisciplinary collaboration between

his own emergent movement language and the dynamic medium of film, as he strategically chooses to articulate his identity negotiations through the established genre of dance-films.

Dance-film and *Loose in Flight*

Khan's melding of film technology and dance continues a line of experimentation that can be traced to the early twentieth century, which saw the emergence of a new language in the interstices between movement and screen. As the dialogue between choreographers and film directors went 'beyond the constraints of the body' dance-films found fresh ways to 'capture human motion' (Mitoma xxxi). Judy Mitoma suggests that, apart from documenting dance, this marriage between dance and film instigated the creation of choreographies specifically for the camera, such that they could only exist in the film medium. This gave birth to the genre of dance-films whose dissemination process through mediums such as television broadcasting blurred the boundaries between their audiences' 'race, class, and geography' and was thus 'critical to the development of the field' of dance as a whole (Mitoma xxxi). Film producer Kelly Hargreaves identifies in late twentieth century European dance experimentations a desire to relocate a narrative drive, and suggests that this coincided with the search for a narrative drive in film-making. She suggests further that the film medium's ability to allow 'our imaginations to travel to actual locations' lent these dance experimentations and their desire to achieve signification the appropriate artistic language (Hargreaves 163). The consequential meeting between these two similar needs to create meaning generated the powerful interstitial aesthetic of dance-films.

Khan's adaptation of *Loose in Flight* into a dance-film followed the example of several live performances by DV8 Physical Theatre (*Enter Achilles, Strange Fish* and *The Cost of Living*) that have been sensitively adapted into dance-films and are recognised as distinct entities on their own. He exploited the film medium's capacity to emphasise interactions between real social spaces and the bodies that occupy them, such that it heightened awareness of the space itself and the performer's embodiment of that space. Khan used the dance-film medium to radically revise the architectural structures of Docklands in order to locate himself within it. It is this revisioning of the space that lent Khan 'a fleshly impact', loading his movement with context, signification and political commentaries (Billman 12). Moreover by broadcasting this dance-film on national television, Khan exploited the capacity of the mass medium

to dismantle notions of second-generation South Asianness in the public domain, and seized the moment that was already witnessing increased visibility of South Asian identity on British national television.

South Asian visibility, British television and *Loose in Flight*

Under the Labour government's new multicultural initiatives (1997–2010), British television was circulating images of second- and third-generation South Asians who were negotiating the British environment on their own terms as 'skilled cultural navigators' (Ballard):

> This is a person who switches mid-sentence from English to Hindu, Urdu or Gujarati, and now to Somali and many other languages, and can also handle a wide variety of socio-cultural situations within a personally selected, more or less broad band. So a British Muslim may go to a pub with his or her colleagues, but will probably drink orange juice instead of beer. (Menski 11)

These integrated images of British South Asians began to dismantle stereotypical ideas of this community held by the native British population, and also marked their arrival at the heart of mainstream British culture. Commenting on the relationship between late twentieth century British multicultural policies and national television programming, film studies scholar Moya Luckett reminds us that amongst Britain's terrestrial television channels, Channel 4 prioritised representing the voice of the South Asian and Afro-Caribbean diaspora and 'moved toward culturally specific minority programming' (Luckett 409). The end of the twentieth and the beginning of the twenty-first century thus witnessed a significant increase in the visibility of South Asian culture within mainstream Britain.

One key moment was the televising of the successful BBC Radio 4 (1996–8) comedy sketch series *Goodness Gracious Me* (*GGM*) by BBC2 (1998–2001), written and performed by second-generation South Asian actors Sanjeev Bhaskar, Meera Syal, Kulvinder Ghir and Nina Wadia. *GGM* marked the arrival of South Asian identity within mainstream popular culture. The series became an influential exposé on both British and South Asian identity through using a culturally hybridised sense of humour that defused cultural stereotyping and blurred the margin and the centre (Werbner 902). Thus humour became the tool through which young South Asian artists were able to voice their identity-politics

within multicultural Britain (Werbner 902). It would therefore be fair to observe that the significance of *GGM* moved beyond its seminal contributions to the tradition of British comedy as it came to

> occupy a central position in British popular culture as the series which broke boundaries in British 'race' relations in terms of their relationship and representation of the Asian community in particular. (Gillespie 105)

Khan and Davies' collaboration in *Loose in Flight* strategically capitalised on this strategic moment in British television with its increased visibility of young and integrated South Asian lives.

This dance-film was created and broadcast on British terrestrial television as part of a programme called *Per4mance*, designed to promote the work of contemporary performing artists through three-minute films that were produced and relayed by Channel 4 at approximately 19.55 hours between August and September 1999. *Loose in Flight* was broadcast on national television, programmed straight after *Channel 4 News* and before the start of prime-time entertainment.[2] Beyond this national television broadcast, the dance-film of *Loose in Flight* was subsequently screened at the Purcell Room at the Royal Festival Hall as part of a programme called *No Male Egos* in September 1999 and then at the Dance Umbrella Festival in October 2000, at the Lilian Baylis Theatre in London. Under the sponsorship of the British Council, it was then taken on a world tour between 1999 and 2002 as part of the screening of a DVD entitled *One Hundred Years of British Dance on Screen*, before being shown on *The South Bank Show* in October 2002 and on *Imagine* on BBC1 in 2008.[3]

While South Asian culture occupied a prime-time spot on national television through the late twentieth and early twenty-first centuries and generated new audiences, South Asian dance also gained visibility in mainstream community settings such as museums and heritage sites, fuelled by the multicultural policies of the Arts Council that transformed British museums from agents of preservation to agents of cultural production. British museums thus shifted from exhibiting white British heritage to promoting culturally diverse public art, and generated new opportunities for British South Asian dancers to cultivate their own artistic presence in mainstream British community spaces (Lopez y Royo, 'South Asian Dances' 2). However, while British national television was successful in dismantling stereotypical notions of South Asian identity, South Asian dance within museums and heritage sites

continued to perpetuate Orientalist imagery (Lopez y Royo, 'South Asian Dances' 1).

Loose in Flight was broadcast in British homes at a point when on the one hand *GGM* had already successfully reclaimed an integrated, intelligent and contemporary image of diasporic South Asian identity. On the other hand, however, community and museum practices of South Asian dance had in some ways reified the Orientalist stereotype of the art forms by, in some cases, constructing the dancers as exotic museum exhibits (Lopez y Royo, 'South Asian Dances' 1). Through *Loose in Flight* Khan managed to successfully de-exoticise this vision of South Asianness, in order to express the more contemporary insider-outsider reality of a diasporic artist. He also strategised the need to make South Asian culture more accessible to mainstream Britain in a similar manner to *GGM,* by bringing it into the nation's homes. The collaboration between Khan, Davies and Channel 4 thus mined the already fertile and equipped grounds offered by the televisual mass medium. It represented on screen the social and physical realities of a British South Asian artist, particularly emphasising the negotiations between his past and present, and his tradition and modernity, through corporeal and visual means. *Loose in Flight* used the dance-film medium to comment on the complex relationship between Khan's corporeality and the East London cityscape and provided a charged political commentary on the landscape's historical connection to migration and transitory identities.

Khan's strategic use of the dance-film medium is commended by Bisakha Sarker, a South Asian dancer living in Britain, who suggests that South Asian dancers in the diaspora need to discover new contexts and aesthetics for their dance practices to mirror their contemporary realities. She suggests that film offers an appropriate means to capture the changing landscapes of South Asian dance practices in the UK:

> This is because it can unambiguously place South Asian dance choreography physically against those very backdrops that are changing it [...]. (Sarker ctd in Nasar)

Sarkar refers to the dialogue between these spaces and the bodies that fill them as '"new architectures"' (Sarker ctd in Nasar). *Loose in Flight* deploys these 'new architectures' to not only capture the changing landscape of British South Asian dance, but to transform our perception of British cultural sites and practices vis-à-vis diasporic arts practices, through embodied intercultural interactions.

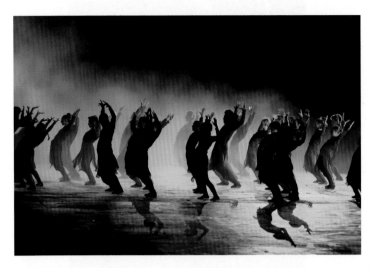

1 Akram Khan Company at the London Olympics Opening Ceremony by photographer Marc Aspland, *The Times*, with photo permission granted by News Syndication

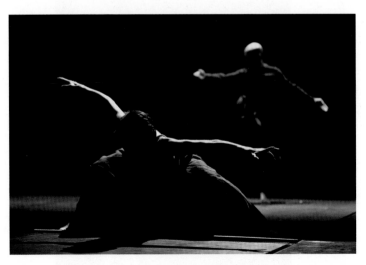

2 Akram Khan and Fang-Yi Sheu in *Gnosis* by photographer Philip van Ootegem

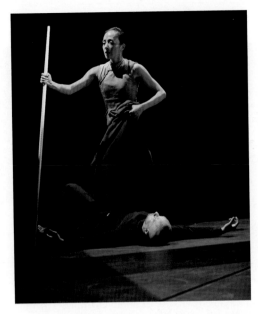

3 Akram Khan and Fang-Yi Sheu in *Gnosis* by photographer Philip van Ootegem

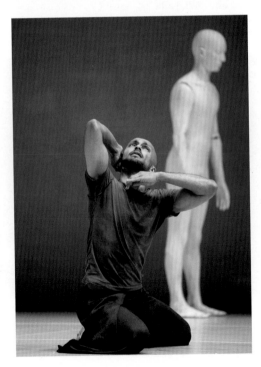

4 Akram Khan in *Zero Degrees* by photographer Tristram Kenton

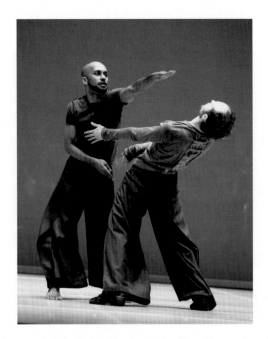

5 Akram Khan and Sidi Larbi Cherkaoui in *Zero Degrees* by photographer
Tristram Kenton

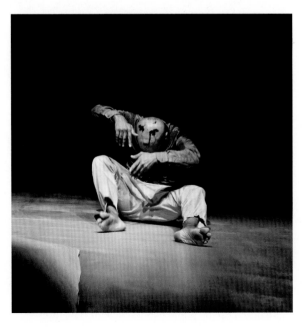

6 Akram Khan in *Desh* by photographer Richard Haughton

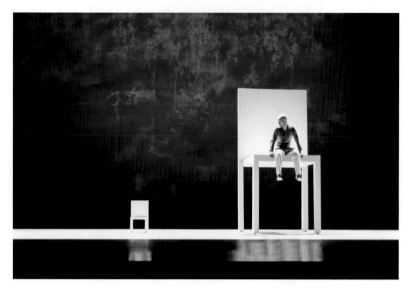

7 Akram Khan in *Desh* by photographer Richard Haughton

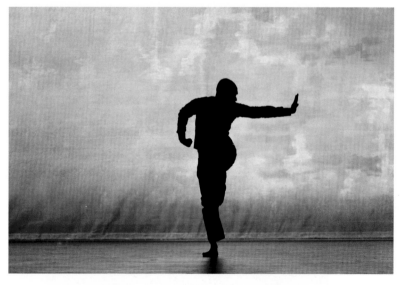

8 Akram Khan in *Desh* by photographer Richard Haughton

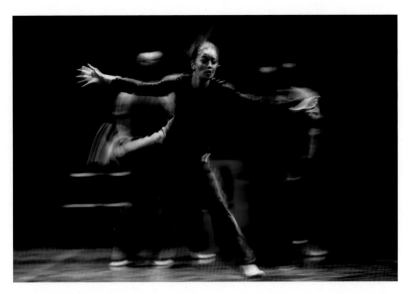

9 Shanell Winlock in *Bahok* by photographer Liu Yang

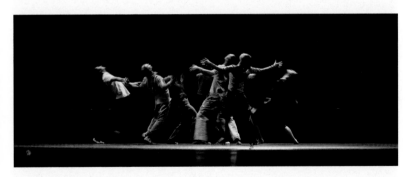

10 Akram Khan Company in *Bahok* by photographer Liu Yang

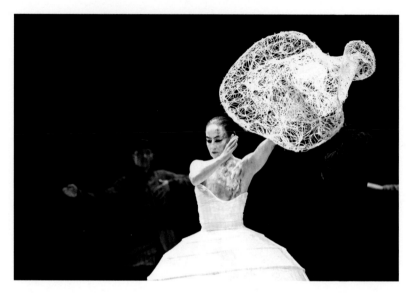

11 Catherine Schaub Abkarian and Denis Kuhnert in *iTMOi* by photographer Jean-Louis Fernandez

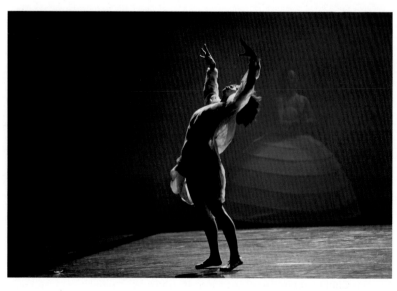

12 Ching Ying Chien in *iTMOi* by photographer Jean-Louis Fernandez

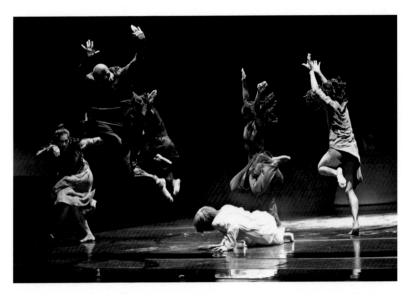

13 Akram Khan Company in *iTMOi* by photographer Jean-Louis Fernandez

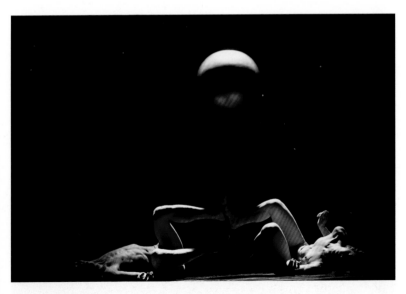

14 Yen Ching Lin and Sung Hoon Kim in *iTMOi* by photographer Jean-Louis Fernandez

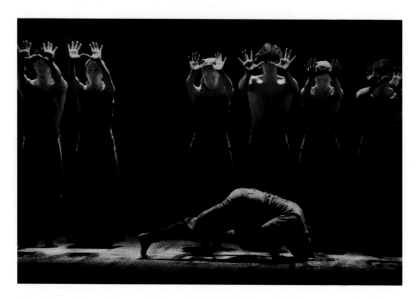

15 Akram Khan, Tamara Rojo and English National Ballet in *Dust* by photographer Jane Hobson

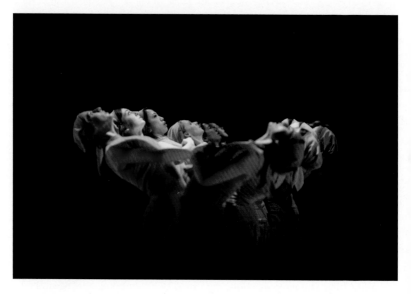

16 English National Ballet in *Dust* by photographer Jane Hobson

The film medium further offered Rachel Davies the opportunity to make a considered choice about the location that would equally influence the reading of Khan's choreography:

> I wanted somewhere with impact. Extremes of interior and exterior spaces I thought would evoke notions of tautness then release [...]. Culturally, the Docklands is recognisable as an area of London but also as a transient place in constant flux and rebuild. It creates a sense of looking to the future, encompassing 21st century multicultural Britain. I guess, subconsciously, I felt this fitted Akram's work and how he would want it to be understood out of a stage context by UK and overseas audiences [...]. (Davies qtd in Khan and Davies)

Khan himself admits that one of the advantages of translating his movement experimentations into film was taking control over the audience's field of vision:

> *You* can decide what you want the audience to see [...]. In a live version you can have five dancers on one side and one on the other side of the stage and you want the audience to watch the one dancer, but it's not necessary that the audience are going to do that. (Ak. Khan qtd in Khan and Davies)

Being able to manipulate what the audience sees and therefore interprets also became a vital tool in Khan's transposition of *abhinaya* from its codified origins in classical *kathak* to its contemporised and legible form, using everyday gestures. It is its legibility conveyed through strategic use of the camera that successfully shifted *Loose in Flight* from being another exotic spectacle of South Asian dance, to offer glimpses into the complexities of British South Asian realities.

Docklands and diasporic identity in *Loose in Flight*

Loose in Flight begins with an image of Khan's face pressed against a window screen, breathing onto the glass which creates condensation on the cold surface. His right hand is cupped gently around the edge of the right side of his face, narrowing his field of vision, as he looks out through the window to the empty and sparse landscape of London's Docklands. Khan's stare through the glass connects him to the cityscape beyond, suggesting how real and metaphoric spaces contribute to the shaping of identity positions as his awareness of this

cityscape's historic relationship to migrant bodies infiltrates his gaze (Briginshaw 4).

Through the nineties, this area of East London became '(in) famous for Canary Wharf, post-modern architecture, and gentrification' (Keith and Pile 16). Keith and Pile go on to observe that 'the Tower (1 Canada Place) – now so much the symbol of Docklands, [...] stands "proud" amidst some of the most deprived estates in one of the most deprived boroughs not just in London but in the country', and inevitably became the grounds for resentment for 'people who live in the shadow of the Tower – physically and metaphorically' (Keith and Pile 11). Thus, gradually, alongside the wealthy splendour that it stood for, two other identities of Docklands emerged: 'the Docklands belonging to the indigenous communities and the Docklands that cannot be sold for love nor money' (Keith and Pile 16).

Khan and Davies' filming of *Loose in Flight* within the heart of this conflicted cityscape was thus strategic, aiming to centralise Khan's minority identity within the landscape of Docklands that had historically marginalised migrants. Additionally, if as dance scholar Valerie Briginshaw claims space is a construct and 'cannot be explored without reference to human subjects', then the placement of Khan in the centre of this disputed landscape was deliberate, a comment on how the constructed nature of both Docklands and Khan's identity mutually shaped each other (Briginshaw 4). Briginshaw postulates further on the symbiotic relationship between the constructed nature of space and the subjectivities produced by it, especially in movement:

> How does the space in which the dance occurs affect perceptions of subjectivity? Different spaces for dance such as cities, and the buildings that constitute them, and wide open outdoor spaces [...] hold connotations and associations. They are not empty [...]. What happens when dance is set in such places? What effect does it have on the choreography?; on the spaces?; [...] How can investigations of body/space relations in dance contribute to rethinking notions of subjectivity, to opening up possibilities to previously excluded subjectivities. (Briginshaw 6–7)

The above passage is particularly relevant to the analysis of *Loose in Flight* in its depiction of Khan's body and identity as strategically connected to this London locale. As Briginshaw suggests, it is vital to understand that the landscape of Docklands is not an empty signifier as a site, but loaded with connotations that shape Khan's fleshly presence. And it

is precisely the interventionist placement of this body in a site that has historically marginalised its presence that heightens Khan's visibility within it. In this it evokes dance practitioner and scholar Carol Brown's claim that 'such a view [...] subverts historical legacies that situate the dancing body as the central organising force within a void-like space, as space itself is understood as an agent within the work' (C. Brown 59). Brown continues to state that this allows for the emergence of a new 'matrix of relationships shaped by states of flux between the body and the built [...], ephemerality and the seemingly permanent' (C. Brown 58).

To begin with Khan's relationship to Docklands is established through his outward gaze through the window pane. In yearning to escape the confines of the space that contains him, Khan peers out through the glass window and appears trapped, accentuated by a disturbing sound-scape of long and sharp intakes of breath. The camera cuts to the derelict interiors of a dingy, vast warehouse. He stands in the centre of this space, dressed in a black pair of loose trousers, a black fitted t-shirt and black socks or thin black jazz shoes. His upper body is slumped over his unlocked knees. His arms hang loose without any tension in them and appear to almost touch the floor. His feet are in the starting position of *kathak*, nearly touching at the heels, creating the tip of an isosceles tri-angle with the two feet facing away from each other. Another sharp and long inhalation of breath follows in the soundscape, which breathes life into Khan's slouched spine. He sharply unfurls it into an upright and centred position accompanied simultaneously by his arms, which take up the starting position of *kathak*. They are gently bent at the elbows and held close to his chest with the palms facing down. The tips of the middle fingers on both hands almost appear to touch. His eyes follow the momentary collapse of his right elbow into the right side of his body, and he uses his left hand to replace the right elbow into the cor-rect starting position of *kathak*. This is immediately followed by a subtle collapse of the right side of his pelvis, which forces his upper body to slump again towards the floor. Allowing his body to rest a while, he gently unfurls his spine into the *kathak* position again. An impulse in his right shoulder raises it close to his right ear and moves his right arm to take up the starting *kathak* position again. This considered moment is punctuated by a shift in the soundscape. A haunting and monotonous tune starts to filter through the space, interspersed occasionally with the sharp intakes of breath.

The camera, which has until this point been filming Khan head on, shifts to the right and starts to capture Khan's body and his shadow from an angle. Khan and his shadow seem joined at his feet, and appear

the same and yet two different bodies all at once. From the central start-
ing positions of the arms to which Khan always returns as in a *kathak*
recital, he raises his right arm diagonally across his chest and swivels
his upper body to the left to follow his arms. He then returns his arms,
body and gaze back to the centre again. However, this time the classical
starting position is ruptured by the unexpected rising of his left foot
and knee, which slightly collapses the left side of his body. His eyes
follow this unruly burst of movement from his lower body towards the
floor and back to the centre again. The same sequence is repeated twice,
before he starts to open out his arms from the folded elbow position to
a horizontal one, where both arms are fully opened out and held at the
chest level with their palms facing upwards. Khan first opens out his
right arm, pointing it to his diagonal right corner in front of him, and
his left arm to his diagonal left corner behind him. He returns his arms
to the centre starting position before going on to repeat the pattern
on the other side of his body. When his arms move, his feet and legs
remain still and appear forcibly immobile.

It therefore appears that unlike the technique-driven *nritta* compo-
nent of *kathak* where the arms and feet mostly move together, Khan's
upper and lower body are moving separately, such that when his upper
body and arms move in the modes of *kathak*, his lower body and feet
remain static.[4] And when the lower body and legs move in contempo-
rary language patterns, his upper body and arms appear uncomfortably
still. It becomes evident that the different layers of the body are expe-
riencing tensions in coexisting within his corporeality. It also seems
that different parts of Khan's body are aligning themselves to different
modes of movement training. His arms are strongly embedded in the
kathak idiom. His pelvis and knees and at times his legs display princi-
ples of release technique, and his eyes move between the *kathak* gaze
that follows his arms and the static neutral gaze of contemporary train-
ing. Shezad Khalil writes:

> Each time Khan produces a small unit of movement, he seems
> to retreat to the standard arrangement, and each time a unit of
> movement is displayed another part of Khan's body moves and/or
> several parts move, until all of his body parts are moving. (Khalil,
> 'Contemporary Kathak' 20)

However, this takes many attempts and the choreography unfolds in a
complex and layered manner to reflect Khan's own multilayered train-
ing. It seems to suggest that just as the tiniest movement motifs grow

into more complex patterns through endless repetition, Khan's own physiological and sociological struggle with his corporeality will require endless re-visitations and re-negotiations to attain eventual expressivity and impact.

Khan raises both arms above his head (similar to the stance of a fla-menco dancer), and allows his wrists to make gentle contact against each other, so his hands can swiftly and gracefully rotate on their point of contact. At first only his arms and wrists move, creating a quick and graceful circular motion above his head. Khan's eyes follow his actions, darting back and forth, leaving an aerial trace of the movement behind. Gradually he allows his upper body to become a part of the swivel such that it follows the spherical motion of his wrists, neck and shoulders, until it all falls into a rhythmic pattern. His feet start off remaining static, allowing his upper torso to trace a fluid and circular motion. But as the upper body gains momentum, he pushes his right foot back to support his torso in its explorations of his body's spherical motion. Suddenly, as if his body is taken by surprise, the rigid formulaic struc-tures of *kathak* disappear and are replaced by a lyricism that consumes his entire body. His arms weave a spell with 'their snake-like, kathak, tension exploding into a liquid eloquence all his own' (Hale). As Khan's body starts to emanate a syncretic vocabulary of his Western contem-porary dance technique, drawing particularly from release technique, the relationship between his spine, the floor and gravity dismantles his body's hitherto held verticality.

In this opening sequence *Loose in Flight* uses *kathak* as the structural base to break out into lyrical passages of contemporary physicality. Khan uses *kathak* as a starting point to his corporeal explorations and returns to it by adopting the starting position periodically. As his contemporary movement sequence starts to get more complex, computer-graphics-generated images of Docklands' urban identifiers like a bridge, a crane and a water tower flutter on the screen. These function as reminders of what lies on the outside of the derelict interior that entraps him. As the images of the urban exterior build, Khan's corporeal agitations also gain momentum and start to move fluidly, sharply and unexpectedly between the fragmentation of his contemporary corporeal language and the regal composure of *kathak*, until it reaches a point of tense and preg-nant stillness. He scurries up a few steps to stand upright and contracts his spine and upper body into his chest into a moment of stillness, as the anticipation of what is to follow heightens. This pregnant pause is full of possibilities such that the 'stillness becomes a resource for discov-ery' for Khan's body to negotiate its expressivity from the point of not

knowing what comes next, in order to allow clarity and knowledge to re-emerge (Claid 133).

As Khan takes stock of his body through stillness, the moment is both fraught with tension and calm with anticipation. Finally he begins to trace the side of his right hand slowly and vertically down his chest with his fingers facing downwards. The use of hands in his choreography is significant, drawing on everyday gestures which are loaded with meaning. In this, Khan's expressive hand motifs find a contemporary resonance with *kathak*'s codified hand gestures. His slow and deliberate gesture points towards his pelvis repeatedly, as though it contains some secret force that is awaiting release. This is significant as one of the key distinctions between the verticality of his classical training and the horizontal axis of his contemporary training is the release required of his body, from and through his pelvis to embrace gravity. The soundscape which has also built to a crescendo to accompany Khan's agile bodily expressions settles to a slow and tense tempo and nears silence. Finally Khan allows his hand to move beyond his pelvis to the floor, collapsing his upper body before rising back into the vertical in one sharp and swift movement. It is his relationship with the floor in an entirely re-evaluated capacity that is soon to become the focus of the following section. This time he does not assume his *kathak* starting position. Instead he goes into a sideways jump, where his left and right feet are touching each other and point beyond the right side of his body, high into the air. His arms are held in the *kathak* starting position and his gaze is directed at the floor towards his feet. This is the first moment when all his body parts that have so far moved as separate units start to move in unison. As his feet return to the floor the camera cuts to an outside location where Khan is seen to be completing the very same jump which his body started inside the derelict warehouse. When he lands, it is impossible to ignore that his feet are now bare, and his body more weightless, lithe and lyrical than ever before.

This move from the dark entrapment of the disused industrial warehouse to the airy and light outside location, with the unmistakable backdrop of Docklands architecture framing his presence, also brings about a significant shift in Khan's bodily expressions. At first he launches straight into a pure *kathak nritta* sequence, exemplified by his signature self-containment in space which is 'broken only by the heart-stopping speed of those, now legendary, spins that the mind can barely register' (Hale). The camera thus enables him to strategically locate his South Asian identity through its classical dance language, at the centre of the Docklands landscape. Deliberately juxtaposed against

the 'metropolis; the postmodern, the constructed, the defined and the authoritative space', Khan's body then explodes into a series of organic and lyrical movement passages that position his agile corporeality in the centre of London's Docklands (Khalil, 'Contemporary Kathak' 18). This juxtaposition reveals that there is much in common between the shifting identities of Khan and the unstable identity of Docklands, shaped by its specific historicity and geographical locale. Moreover 'the Docklands as a choice of location, with its old trade links to India, is a nod to the history behind today's cultural melange in Britain', of which Khan is a vital remnant (Nasar). Similarly Khalil argues that 'by placing himself at the centre of the composition, Khan is projecting that he is not an alien body wandering aimlessly and lost in the postmodern metropolis. In fact, he is an active individual in the construction of this domain' (Khalil, 'Contemporary Kathak' 20).

In this sociological mapping of his body the significance of Khan's bare feet deserves analysis. At a simplistic level it can be read as a reverential allusion to the memorable moment in early modern dance when, seeking freedom for the dancing body from the captivity of ballet slippers and corsets, dancers like Isadora Duncan and Loïe Fuller took to the stage barefoot (Banes 74). In the early twentieth century dancing without ballet shoes came to stand for freedom from physical restriction and aesthetic control. However, to apply the same logic to Khan's bare feet in *Loose in Flight* would be a simplistic reading of his culturally specific and complex circumstances. Dancing barefoot for Khan cannot merely stand for physical freedom. In fact it is perhaps the very reverse of it as within his *kathak* training Khan had to dance barefoot. Moreover the points in the piece where Khan dances barefoot bear little relation to the kind of movement idiom he is rendering through his body at the time. In other words, he seems as comfortable dancing contemporary movement *without* shoes as he does dancing *kathak* sequences *with* shoes on. Performing barefoot for Khan then becomes a powerful metaphor for exercising discerning choices and control over his own choreographic vision. It becomes symbolic of Khan's yearning to be recognised as both a dancer and a choreographer in equal measure.

As Khan continues to render lyrical passages of high 'muscular density' and interlaces it with *kathak* spins, the camera manipulates the viewer to follow Khan's own visual perspective (Meisner). It languidly follows the length of his left arm and gaze along the landscape and arrives at another frame by the River Thames. Here Khan completes an impressive spiral jump with his entire body and lands parallel to the ground, supported by his hands and feet on a white mat. He repeats a

variation of leaps off the ground, seemingly drawing energy from the earth as he horizontally lifts himself up into impossibly high jumps and then spirals his body in the air before returning to the ground with dynamism and grace. In this middle section of *Loose in Flight*, his relationship with the ground draws the viewer's attention to how his body changes its response to gravity, from the verticality and uprightness of *kathak* to the horizontality of release technique. He embraces the floor by yielding into it and gracefully rising out of it, playing with the boundaries of resisting gravity while graciously accepting its power for returning safely to the ground. Khan acknowledges the shifting nature of the land beneath him that he claims as his own, resonating the transient spirit of the title of Salman Rushdie's novel *The Ground Beneath Her Feet* (1999). This land is representative of London, the city that homes him in his country of birth with its history of migration and settlement. Equally, this land stands for his tenuous relationship with Bangladesh, his parents' country of origin, and its strained links with the nation of India, themes I explore in detail in the next chapter through my analysis of *Zero Degrees* and *Desh*. Claiming ownership of transient landscapes and localities signals Khan's multiple affiliations to multiple nations, histories and cultures in twentieth-century Britain. It requires him to re-negotiate the space he occupies on these lands and acknowledge the impact that these lands have on his changing identity.

The camera pans across the Docklands landscape in the distance, reminding the viewer that Khan's bodily negotiations cannot be separated from this site, and indicating an erasure of the border between his self and the city (Briginshaw 43). Glimpses of East London's council flats are interspersed with the landscape, returning the viewer from the vast industrial character of Docklands to its residential quarters that are home to many migrants. The image of the council flats and the contained space they signify directly juxtaposes the vast expanse of liberated space in which Khan moves. This implied claustrophobia abruptly cuts short Khan's lyrical and free physical expressions. It acts as a harsh reminder of his own inability to exist in that one free space, endlessly haunted by his own multilayered tensions within.

His body collapses at the waist again as he lifts his upper torso into an upright position. His feet return to the starting position of *kathak* and his agile arms visibly struggle to negotiate smoothly between the classical patterns of *kathak* and the linear modes of contemporary dance. The once effortless transition between his varied modes of corporeal training gives way to an obvious bodily resistance. A swift and fleeting frame momentarily places Khan back in the derelict warehouse and returns

him to the outside location again. However, as his agitations build he is unable to remain outdoors and we find him back in this entrapped space, caught up in a physical repetition of a sequence that he is unable to escape. In this pattern his feet are still again, almost unable to move. His upper body slumps over to the floor, and he sharpens his spine into the upright position to regain the *kathak* starting position. His right pelvis and right arm collapse from the starting position to the floor, and his left arm, held in the *kathak* position, rectifies the unruly right-hand side of his body, as if through cerebral intervention.

Familiar movement patterns from the starting section of the film start to infiltrate his fragmented body in short bursts, and what once seemed to be exciting articulations of his corporeal experiments now appear as moments in which Khan finds himself incarcerated. In returning to the physical and metaphoric space where Khan's explorations begin inside the warehouse, the film does not offer any solutions to his agitated existence. Instead it demonstrates the cyclical process that Khan's body endures in seeking articulation, thereby implying that his transient condition is unlikely to find an obvious solution. And perhaps most importantly, the corporeal experimentations that at times seem to move Khan towards a confident articulation of his negotiations, at other times are retrograde in moving him backwards into moments of amplified confusions. In this, Khan dismantles the often romanticised associations of freedom associated with Western identity and contemporary bodily expressions as both mythical and inadequate, in his own body's search for its unique intelligibility.

This inside-outside placement of Khan's body in different physical locations within the landscape of Docklands, as captured through Davies' strategic filming, editing and use of graphics, evokes dance critic Sanjoy Roy's notion of inexclusion. Arguing that the double-consciousness of diasporic subjectivities needs to be re-evaluated as more than a product of bicultural allegiances, Roy extends its meaning to include the 'paradoxical sense of being inside and outside at the same time', and terms this simultaneous sense of belonging and non-belonging as inexclusion (Roy 72). This experience of 'inexclusion' is embodied in Khan's corporeality as he negotiates his ambivalent liminality somewhere between the confines of the warehouse and the vast outdoor space by the Thames. It is not a simple negotiation however, as when inside the warehouse Khan yearns for the outdoors, and while in the liberated landscape of Docklands, framed by the city, he finds himself drawn to the interiors of the warehouse again. He experiences belonging just as much as he experiences non-belonging in both spaces equally. His

Bangladeshi heritage and the lexicon of *kathak* are as familiar to him as they are alien, just as his British identity and his contemporary movement training are both comforting and destabilising. Such 'inexclusion' can create a kind of hybridity

> in which the hybrid is not seen as a compound of separate parts, but a new form that is incompatible with the division which defines them *as* separate parts. This is a more unsettling sense, for the hybrid cannot be placed on the map of prior knowledge. (Roy 81)

This hybridity fuels Khan's new interculturalism and is generated within Khan's body and accentuated further by being mapped into and onto the Docklands landscape by Rachel Davies' film, creating an unsettling aesthetic. Khan, with Davies' help, succeeds in mapping his subjectivity into and onto a site that has historically marginalised his (and in turn other diasporic subjects') presence, and in doing so generates a contemporary reality that cannot be understood on the basis of prior knowledge and practices.

An auto-ethnographic enquiry

Loose in Flight is thus an embodied exploration of the relationship between Khan's complex identities, the Docklands landscape and his own multiple corporealities. This self-reflexivity lends the dance-film the status of an auto-ethnography, 'a genre of writing and research that connects the personal to the cultural, placing the self within a social context' (Reed-Danahay ctd in Holt 18). In *Loose in Flight*, although Khan does not write his findings in the conventional sense, he does so in corporeal terms into and onto the landscape of Docklands, enabled by and recorded permanently into the artefact of the dance-film. Khan's embodied enquiry evokes dance scholar Theresa Buckland's observations on the impact of postmodernism on dance ethnography:

> Ethnographic perspectives began to emphasise the socio-cultural construction and movement of 'the body', shifting from the objectified study of dance in a cultural context to the experiential consideration of the emergent performance of cultural identities that are non-essential, fluid and relational. (Buckland 337)

This recent turn, according to Buckland, has led to an increased reliance on the researcher's embodied and experiential role as 'body witness',

as an extension to his/her distanced and objective role as an 'eye witness' within conventional ethnographic enquiry (Buckland 340). This implies, as we observe in *Loose in Flight*, a collapse between the role of the enquirer and the enquiry itself (Buckland 340). Consequently Khan becomes the subject of his own enquiry thereby validating Annalisa Piccirillo's view of his practice as a 'rational form of research' (Piccirillo 31). As the piece endeavours to raise and work through corporeal, aesthetic and cultural conditions that are unique to Khan's specific circumstances, it is fitting that he starts to experiment with his embodied approach to new interculturalism within solo choreographic vignettes. The solo form is something Khan is comfortable with because of his prolonged training in *kathak*. As Nadine Meisner observes:

> Khan well understands how the solo form needs, like a short story, to seize its moment trenchantly and mark out a clearly defined logic. [...] Performed with his extraordinary blend of liquidity and precise geometry, blurring speed and muscular density, this is consummate choreography [...]. (Meisner)

This clearly defined logic that Nadine Meisner refers to moves beyond the mere choreographic merit of the piece. Instead and more importantly, *Loose in Flight*'s 'clearly defined logic' is situated in its ability to exploit the solo form as praxis, raising questions about Khan's own complex identity and corporeality, through generating an artefact in the form of the dance-film that continues to circulate in the public domain. However, the film is more than an artefact that documents Khan's experimentations for future peer review, and is in and of itself a cinematic artwork. Just as Khan's choreography in *Loose in Flight* breaks down the geometrical lines and precise rhythms of *kathak*'s structures, Rachel Davies seeks through her art the chance to fragment the conventional structures of commercial filmmaking. She attempts to 'explore and isolate some of the more formal qualities of film' in order to locate Khan's politicised body within the landscape and to 'create metaphors of movement in space and time' (Khan and Davies). The artefact is therefore an inseparable and visceral part of Khan's auto-ethnographic endeavour and is as much a process in itself as it is an end product.

Through the dance-film Khan's corporeal enquiries equally seek to illuminate the place of the body within the political, cultural and social conditions of the diaspora. By 'concentrating on the body as the site from which the story is generated' *Loose in Flight* emphasises the value of 'the methodological praxis of reintegrating [...] body and mind' as a

legitimate form of research (Spry 708). Auto-ethnographer Tami Spry notes the historical denial of the body as a significant and salient source of knowledge within research:

> When the body is erased in the process(ing) of scholarship, knowledge situated within the body is unavailable. Enfleshed knowledge is restricted by linguistic patterns of positivist dualism – mind/body, objective/subjective – that fix the body as an entity incapable of literacy. (Spry 724)

As an auto-ethnography *Loose in Flight* overturns this historic logocentricism, by privileging corporeally embodied knowledge. As an ethnographer who is none other than a 'socially embedded storyteller' (M. Smith 508), through the piece Khan tells his own story, the 'story of the body told through the body' (Langellier qtd in Spry 710). In doing so he significantly extends his classical training as a *kathakar*, a storyteller, adept at rendering tales of heroic adventures, mythical creatures, divine romances and human conditions, imposed upon him via the Hindu epics of the *Ramayana* and the *Mahabharata*. Instead Khan selects to narrate stories of his own embodied realities through his own gestures, rather than feeling limited by the dis-embodied, mimetic and codified conventions of *abhinaya*, while still retaining its basic principles. At first, however, *abhinaya*, or the expressive modalities of *kathak*, seem absent from *Loose in Flight* with its surface emphasis on *nritta*, the formal and technical layers of the dance form. However, the cinematic interventions of layering digitised images of iconic sites of Docklands, the ability to cut between different locations, and the privileging of camera angles to direct an audience's gaze and attention become its expressive storytelling devices. They come to replace the apparently missing elements of *abhinaya* in Khan's bodily gestures and assist integrally in the storytelling process by providing context and meaning to Khan's *nritta*-led language. Khan thus successfully transforms *abhinaya* from a codified and culturally specific performance principle to a globally recognisable, contemporary and legible performance device by transposing its narrative modalities from the language of the body to the language of film. Furthermore Khan replaces the codified gestures of classical *abhinaya* with familiar and everyday gestures such as cupping his hand over his eyes to narrow his vision as he looks out of the window onto Docklands. More importantly, by juxtaposing his physical isolation in a man-made environment, completely devoid of habitation, Khan lends the primarily solo format of *kathak* and its *abhinaya*-driven

storytelling heritage a politicised edge. His physical isolation can be interpreted as a strategic commentary on the pressure put upon migrant communities in Britain to assimilate into mainstream society without adequate support, infrastructure and cultural understanding of their diasporic conditions. Thus, through *Loose in Flight* Khan becomes a 'socially embedded storyteller', where the story he examines and narrates is his own. In acknowledging his own identity and body politics as fragmented, partial and incomplete, Khan extends and politicises his storytelling training to evoke his own volatile condition, 'not as a single, completed identity, but as multiple, incomplete and partial identities' that constitute his contemporary reality (M. Smith 501). Its auto-ethnographic lens continues to catalyse and shape Khan's approach to new interculturalism and manifests in every project Khan has entered into since, as each performance becomes yet another attempt to unravel the complex layers of his embodied existence between cultures, disciplines and artistic spaces.

4
Third Space Politics in *Zero Degrees* (2005) and *Desh* (2011)

Khan's new interculturalism is bound up in questions of the self. Through it he negotiates the tricky terrain between his inherited relationships with Bangladesh and his own embodied Britishness. This in-betweenness fuels Khan's musings on identity-politics in the diaspora and beyond, and finds profound manifestations in two critically acclaimed pieces, *Zero Degrees* (2005) and *Desh* (2011).

Zero Degrees is Khan's collaboration with the Moroccan-Flemish dancer and choreographer Sidi Larbi Cherkaoui, British sculptor Antony Gormley and British-Asian musician Nitin Sawhney. Through a complex storytelling ritual, where once again he is the story he is telling, the piece narrates Khan's memory of a border-crossing between Bangladesh and India. It is thus located in a figurative, political and geographical borderland which makes Khan acutely aware of his own British-Bangladeshi identity. This liminal space also evokes issues of citizenship, cultural heritage, belonging, exclusion and otherness, and forces him to revaluate his sense of self. His identity is destabilised further when, on the train to Calcutta, Khan encounters the body of a dead man, and is advised not to offer any help to his wailing wife. *Zero Degrees* becomes the vehicle through which Khan relives the traumatic memory of his border-crossing as he postulates on the liminal margins between life and death, belonging and non-belonging, while discovering the other in oneself.

Made six years later and meaning homeland in Bengali, *Desh* is Khan's homage to his complex and inherited relationship with Bangladesh. Interweaving autobiography, myth and history, *Desh* is an honest, painful, penetrative and 'therapeutic self-portrait'(Ak. Khan, Interview 2). It further lays bare Khan's turbulent relationship with his father as analogous to his relationship with Bangladesh. The piece moves seamlessly

between London and Bangladesh, and in both these evoked locations we witness Khan's isolation and restlessness as he relentlessly searches within for a sense of belonging. A seminal solo in Khan's career created in collaboration with the Oscar-winning visual artist Tim Yip, the poet Karthika Nair and the award-winning composer Jocelyn Pook, *Desh* is a multidisciplinary, emotive and theatrical journey through the fragile, vulnerable and volatile landscape of Khan's fragmented reality.

This chapter examines *Zero Degrees* and *Desh* through Homi Bhabha's theoretical lens of the third space, a metaphoric in-between space in which postcolonial diasporic identity-formations occur. Through these pieces Khan refutes Bhabha's third space as erudite, abstract and non-representational by finding tangible manifestations of it, while simultaneously questioning it as a space of privilege and power. While in *Zero Degrees* it is evoked in the geographical borderland between India and Bangladesh, in *Desh* the third space is articulated in and through Khan's own lived body. The pieces further shift the third space beyond its literary origins as interstitial between two cultural reference points to performative realms by embodying it as a multistitial space of aesthetic and critical enunciation between multiple artistic disciplines such as theatre, dance, animation and the visual arts. The chapter argues that Khan's negotiations of the third space emerge at the intersections between his complex identity-positions and his aesthetic negotiations between multiple artistic disciplines. And it is this embodied multistitiality that fuels his unique approach to new interculturalism.

Third Space, diaspora and Khan

The seminal postcolonial theorist Homi Bhabha conceptualises the third space as a metaphoric space in which postcolonial identity formation in the diaspora occurs. Post-national and anti-essentialist in spirit, this metaphoric third space is situated figuratively and interstitially between one's home and host nations and cultures. It is further believed to undermine the privileging of either position in the formation of diasporic identity, such that 'neither site, role, or representation holds sway' and 'one continually subverts the meaning of the other' (Routledge 400). Bhabha comments on the intangibility of this space while he recognises the ways in which it challenges fixed and homogeneous notions of culture:

> It is that Third Space, though unrepresentable in itself, which constitutes the discursive conditions of enunciation that ensure that the

meaning and symbols of culture have no primordial unity or fixity;
that even the same signs can be appropriated, translated, rehistori-
cized, and read anew. (Bhabha, *Location* 55)

He conjectures that this third space 'properly challenges our sense of
the historical identity of culture as a homogenizing, unifying force,
authenticated by the originary Past, kept alive in the national tradition
of the People' (Bhabha, *Location* 54). The third space transfers the 'bur-
den of the meaning of culture' from ritualistic national traditions to the
'"inter" [...] the *in-between*' which Bhabha suggests is where 'the cutting
edge of translation and negotiation' occurs (Bhabha, *Location* 56).

According to Bhabha diasporans occupy this third space, harbour-
ing dynamism and engendering new modes of political articulations.
Moreover he proposes that the empowerment of the space brings 'crea-
tive invention into existence', which is characterised by an inherent
hybridity that gives rise to new articulative opportunities (Bhabha,
Location 12):

> The importance of hybridity is not to be able to trace two original
> moments from which the third emerges, rather hybridity to me is
> the 'third space' which enables other positions to emerge. The third
> space displaces the histories that constitute it, and sets new structures
> of authority, new political initiatives, which are inadequately under-
> stood through received wisdom. (Bhabha qtd in Rutherford, 'Third
> Space' 211)

This third space and its hybridised articulations of identity 'bears the
traces of those feelings and practices which inform it' while simultane-
ously generating a 'new area of negotiation of meaning and represen-
tation' (Bhabha qtd in Rutherford, 'Third Space' 211). The third space
thus offers an alternative and empowering way to understand and own
one's sense of displacement, a condition associated with the diaspora.

Khan's displacement is of course neither a consequence of enforce-
ment nor choice. His condition is generated circumstantially through
his parents' choice to relocate from Bangladesh to Britain. Subsequently
Khan's multiple affiliations to nations and cultures need to be under-
stood as distinct and more complex than his parents' sense of simulta-
neous belonging to both Bangladesh and Britain. The first-generation
South Asian diaspora in Britain often experienced a condition of collec-
tive nostalgia and a yearning for the homeland through experiencing
a sense of displacement and a subsequent 'boundary-maintenance'

Brubaker 5). In contrast, Khan's second-generation identity and its negotiation between his ethnicity, cultural heritage and nationality is transient and more committed to 'boundary-erosion' (Brubaker 6). Yet, his erosion does not manifest without heartache.

In *Zero Degrees* and *Desh,* from within the position of the empowering and privileging third space, Khan conjectures a more complex relationship between diaspora and homeland, and demonstrates that this relationship differs for first- and future-generation diasporans. His experience of simultaneous belonging and non-belonging to Bangladesh is explored beautifully in these pieces and suggests that for a second-generation diasporan the relationship between diaspora and homeland is as inseparable as it is demarcated, and as painful as it is nourishing. The pieces also explore how Khan's corporeality has been shaped through the burden of inheriting his parents' cultural heritage, and the disorientating schisms that are generated between multiple affiliations to nations and cultures:

> how is the body marked or inscribed by this journeying and how does the diasporic subject inscribe her/himself within/on the landscapes s/he traverses? (Grehan 229)

Even as Khan's own body did not undertake the initial journey of dispersal from Bangladesh to Britain, his inherited cultural identity continues to be marked by his parents' sojourn. *Zero Degrees* and *Desh* thus become the artistic articulations of the impact that Khan's inherited journey of dispersal has had upon his own identity formation within the third space.

Borderland, third space and *Zero Degrees*

Zero Degrees opens with a large and bleak grey-white box occupied by two white mannequins that lie horizontally on either end of the space facing the ceiling, with their heads directed towards centre stage. They are located at right angles to the stage walls, and while one is positioned backstage right, the other is positioned front stage left. As their austere inertness settles before the audience, Khan and Cherkaoui inject life into the space by appearing backstage from either end. They walk swiftly towards each other, meet at the centre and then turn to face the audience before continuing to walk down the central axis of the stage. As they reach stage front they sit down cross-legged, a stance both intimate and grounded, strangely static for a dialogue [...]' that

is to follow (Norridge 10). They place their elbows on their knees, clasp their hands, rest their chins upon them and then finally shift their eye focus away from the audience to the down-stage right corner. The act of looking down and to the right is one of pensive recollection and suggests a recall of an experience and an emotional state, lasting about fifteen seconds (Catley). In this perfect stillness the audience become aware of Khan and Cherkaoui's synchronised breathing, the tiniest rise and fall of their shoulders and the fluttering of eyelids. Finally, after what seems like an eternity, they break their meditative silence and with their focus still on the down-stage right-hand corner start to narrate in perfect synchronisation a memory that begins halfway through a sentence:

> And what I remember is there were these guards there,
> Who were very, very powerful. (*Zero Degrees*)

As they enunciate the word powerful they revert their eye focus back to the audience with a sharp turn of their necks. This moment signifies a clear shift from their soft internal gaze of memory recall to their sharp and caustic gaze of externalised presence before the audience. Through a carefully crafted language of 'simultaneous spoken narrative and movement synchrony' that interlaces everyday gestures, pauses, hesitations, shifts in eye focus and delivery of text, Khan and Cherkaoui relocate the audience to a border checkpoint between Bangladesh and India (Norridge 1). The initial ambiguity of the blank canvas of the space transforms into the physical location of this borderland immigration control, through the mention of words like guards, security, queue and passports. As they continue their impeccably synchronised delivery, the story turns to the unnerving moment of callous handling of passports, as they are passed endlessly between several guards:

> Suddenly I realised just how vulnerable I felt. Because if that passport disappears, where is my proof of identity? They could just say I'm a Bangladeshi, I'm a bandit. It's amazing how much a passport holds, how much power a passport holds. A passport holds between a good life and a bad life. Between life and death. I mean it holds everything. It's just a piece of paper. And it was incredible just how much I wanted to hold onto it. (*Zero Degrees*)

As the guards pile up passports before stamping them, Khan and Cherkaoui's synchronised delivery reveals more about the inherent

differences between the surface of passports and their implied power imbalances:

> And my passport was different because it was red [...]. But the other passports were Bangladeshi, because predominantly... the predominant... erm... erm... nationality of the people who were congregated there were Bangladeshis, so they had green ones. (*Zero Degrees*)

The opening scene of *Zero Degrees* raises the following issues: firstly, although the audience is not told whose memory is being recalled, their prior knowledge of Khan's British-Bangladeshi identity and/or his visible South Asian ethnicity implies it probably belongs to Khan. It thus opens up 'an intriguing space to examine audience assumptions' (Norridge 10). Secondly this implied ambiguity of identity is further heightened through the process of doubling that is performed by Khan and Cherkaoui in synchrony. Thirdly, in contrast, however, the explicit mention of identity, British passport and Bangladeshi nationality are direct references to the issues of citizenship, belonging, exclusion, self and other that permeate the opening of the piece. These issues collectively indicate that *Zero Degrees* confronts the challenges inherent in the embodiment and questioning of identity as experienced particularly at border zones.

In an interview about the making of *Zero Degrees* Khan reveals what is arguably the fundamental premise of the piece:

> I realise how Bangladeshi I am here and when I am in Bangladesh I realise how British I am. I am never complete in one place. (Ak. Khan qtd in *Zero Degrees* DVD Interview)

Through *Zero Degrees* Khan confronts the very moment when, at the border of Bangladesh and India, travelling on his British passport, he feels like an alien amongst the people from the country of his cultural heritage. It is significant that it is in a borderland, where his passport is the only means of identification, that Khan becomes most aware of his non-belonging to his parents' homeland because his red (British) passport separates him visibly and legally from the people of his shared cultural heritage and their green (Bangladeshi) ones. This is communicated in the hesitant delivery of the word 'nationality' as he acknowledges that most people gathered at the checkpoint are Bangladeshis, suggesting that while he can claim Bangladeshi cultural heritage through his parents, he will always be excluded from having

a legal status in his parents' homeland. Gupta and Ferguson remind us that:

> If [...] it is acknowledged that cultural difference is produced and maintained in a field of power relations in a world always already spatially interconnected, then the restriction of immigration becomes visible as one of the main means through which the disempowered are kept that way. (Gupta and Ferguson 17)

However, his relationship to Bangladeshi identity is chequered. Just as quickly as Khan mourns his lack of legal identity as a Bangladeshi, he also acknowledges the power and privilege shared by particular nationalities over others. In a sea of green passports Khan admits that he is fearful of losing his red one as a result of the careless handling of the documents by the guards, as his lack of legal identification might make the guards identify him as a 'Bangladeshi' or a 'bandit'. So while on one hand he feels excluded from the sea of green passports because of his red one, on the other he does not want to lose the privileges attached to his British citizenship, and is fearful of the perceptions attached to owning a Bangladeshi passport. This makes Zoe Norridge question 'why is "Bangladeshi" placed next to "bandit"? Which is the greater fear?' (Norridge 11).

Zero Degrees then is as much about 'a discrete identity, symbolised by the passport' as it is about 'the precariousness of such an identity, about the ways in which it may collapse and be appropriated by others' (Norridge 10). This constant shift between these two positions of Khan's identity and the simultaneous undermining of both by both is indicative of a third space politics which 'displaces the histories that constitute it, and sets up new structures of authority, new political initiatives' that 'enables other positions to emerge' (Bhabha qtd in Rutherford, 'Third Space' 211). However, Khan is quick to point out that his other positions are able to emerge in the first place because of the mobility attached to his British passport. In this representation of third space as a physical borderland, Khan thus critiques Bhabha's idealistic position, which suggests that both histories that constitute diasporic identities are equally displaced. Instead he clarifies that his negotiation of the third space is only made possible by slightly privileging his British nationality and the mobility and power attached to it to negotiate new positions, which then in turn destabilise notions of Britishness.

In *Zero Degrees* Khan is not alone in his embodied diasporic status and is accompanied by Cherkaoui's identity as a Moroccan-Flemish Belgian

national. Therefore the decision to perform in synchrony in the opening section not only creates a unique aesthetic, but also layers a political charge through the doubling of identities. According to Zoe Norridge:

> A related disconnect is found between what appears to be a deeply personal, subjective account and its delivery – through two speakers, two 'Is', two remembering subjects. (Norridge 10)

This theme of the doubling of identity resonates all the way through the piece where Khan and Cherkaoui perform a constant interplay between being themselves and each other. At times this is achieved through intricate mirroring of a complex set of fluid hand movements which seem to permeate into each other. In other moments it is signified through simple but effective interactions with each other's larger than life shadows on the cyclorama. This complicates the process by which the audience can read 'the presence of the subject from or about whom the discourse springs' (Norridge 13). Because there are constantly two human referents, the ambiguity created around the visibility of the subject deliberately heightens the issues pertaining to 'boundary-erosion' in third space identity-formations (Brubaker 6). Reflecting on the significance of the title *Zero Degrees* Cherkaoui suggests that it is the 'point where one thing becomes another [...] when Akram becomes me and I become Akram. [...] For us zero degrees was the point of transformation' (Cherkaoui qtd in *Zero Degrees* DVD Interview).

Cherkaoui's description should not be taken to imply a one-way transformation as he seems to suggest, because in *Zero Degrees* transformations (particularly between identities) are performed endlessly, back and forth, such that boundaries between self and other are erased and 'the politics of polarity' are evaded in order to emerge anew as others of their own selves (Bhabha, 'Commitment' 22). It is important to realise that Khan and Cherkaoui do not ever become one and the same person, but always negotiate this contradictory and ambivalent position that encourages a 'split-space of enunciation' to emerge (Bhabha, 'Commitment' 22). This splitting makes them conscious of simultaneously belonging and not-belonging to their cultural heritages, their nationalities and their ethnicities in order to create a new sense of self. It also suggests that the act of boundary-erosion between their different identity-markers involves the recognition of those boundaries in the first place, before they can be erased.

Khan and Cherkaoui intersperse their storytelling with fluid and symbolic corporeal exchanges that extend their identity doubling beyond

the realm of concrete text and into the field of abstract imagery. The energy of their movement exchanges ranges from mutuality, to fragility, to coercion, to control, to manipulation, to volatility, to acceptance, as they explode into the whole space. However, every time they revert to the narrative, they signal this return through adopting their initial contained physicality of memory recall and occupy centre stage. As if the frustration of experiencing exclusion during immigration checks at border-control is not enough to destabilise his sense of identity in this border zone, the story moves forward to its most disturbing moment. This time Cherkaoui lies on the floor facing the ceiling with his knees up and Khan sits on these knees as they create a three-dimensional illusion of mirrored doubles. They continue to deliver their hand gestures and text in perfect synchronisation, reaching towards each other to sustain the illusion exactly as in a mirror reflection. However, because Khan's position is deliberately prioritised in the visual, there is a heavier insinuation that the memory is his.

In the confessional that follows Khan and Cherkaoui narrate the memory of witnessing a dead man on the train to Calcutta and his wailing wife who repeatedly asks for assistance in vain. Against his will Khan is advised by his cousin not to assist the helpless woman for fear of bureaucratic hassle and even accusations of murder. The memory of his own inhuman act of betrayal stays with him as Khan contemplates the cruelty of the world that he finds himself in in the borderland:

> When you come to a country you submit or leave behind your world, your rules. Because it's their rules and you have to play by them. (*Zero Degrees*)

And as Khan tries to deal with the disturbing polarities he has experienced on his border-crossing, between life and death, belonging and non-belonging, exclusion and inclusion, he cannot help but admit that, to put all of this to rest, he 'just can't wait to get to the hotel' (*Zero Degrees*) in Calcutta, where 'conveniences' such as hot showers and MTV await him. In this instance Calcutta, despite its complex relationship to the history of Bangladesh and the complexities of Bengali identity, becomes Khan's physical third space of enunciation. As an interstitial city it signals a move away from the borderland and into a national space that has no immediate impact upon Khan's identity, and in which he is able to negotiate his British nationality and Bangladeshi cultural heritage simultaneously. However, once again, he is able to articulate these alternative positions of identity only once he

has gained access to the privileged conveniences associated with his British identity.

Khan's evocations of the third space of border-identity politics in *Zero Degrees* is thus significant as he finds physical and geographical manifestations for Bhabha's abstract concept. Furthermore he simultaneously critiques the notion that this space allows its subjects to discover new subject positions by privileging neither of the cultural histories that constitute it. On the contrary, *Zero Degrees* suggests that only through a slight privileging of his British identity is Khan able to marshal the power and mobility this lends him, in order to negotiate new subject positions for himself.

Khan's body, third space and *Desh*

If *Zero Degrees* critiques the metaphoric nature of Bhabha's third space by physicalising and locating it in the geographical borderland between Bangladesh and India, then six years later *Desh* furthers this critique by articulating the third space within Khan's body. This not only offers a further tangible manifestation of a concept that has remained largely figurative within postcolonial studies, but more importantly prioritises the role of the body and its lived reality at the heart of diasporic identity-negotiations. *Desh* therefore suggests that Khan's body does not just occupy the third space, but that it is in fact one and the same as the third space. This phenomenological approach to Bhabha's metaphoric concept rewrites the third space as an embodied and lived condition, and collapses the conceptual segregation of space and body as distinct entities.

As Sondra Horton Fraleigh reminds us, '[p]henomenology is first of all a method that, as its point of beginning, attempts to view any experience from the inside rather than at a distance' (Fraleigh xiv). In *Desh* Khan draws on his inside reality and uses his own body to demonstrate how these tensions play out within and upon his body, as opposed to in a space distinct to and distanced from his own embodied reality. Khan's body is thus not located in a figurative space of transformation, but is itself a catalyst for transformation from within itself. In this instance the third space thus takes on a tangible, lived and fleshly form and the space and the body become inseparable from each other.

Transformation lies at the heart of *Desh* both as an aesthetic choice as Khan moves seamlessly between different characterisations, and as a political commentary on the lived reality of diasporans. As an epic solo performance in which Khan can only interact with different versions

of himself, he shifts between his moody teenage British self, his resilient and proud Bangladeshi father, his nuanced and reflexive adult self interacting with his third-generation British-Bangladeshi niece, Ishita, and Shonu the little boy from the Bengali myth of Bon Bibi, which is a metaphoric fulcrum of the piece. The ultimate transformation occurs at the end of the piece when Khan becomes his father, thereby suggesting that the cycle begins all over again. What is of course common to all his incarnations is Khan and his own embodied reality. It is through his body that he is able to not only give life to these myriad characters, but also access the reality of being them.

Desh begins with a minimalist set accentuated by what looks like a Muslim burial mound situated front centre stage. Khan walks in with a lit *lonthhon*, a lantern that is typical of rural Bangladesh, and places it with great deliberation next to the grave. He kneels down, goes onto all fours, then swiftly stands up and looks at his hands. He rubs his hands over his face as if to calm and ground himself as the lights snap to a blackout. In the darkness begins the sound of a sledgehammer hitting a hard surface. The lights come up on Khan repeatedly hammering the mound, dressed in a *dhoti*-like pair of trousers and a shirt.[1] The stylised hammering builds in tempo as though to desperately release from within the mound what forever lies beneath. He suddenly stops and then looks stage left as a soundscape of Dhaka (but what could just as easily be London) starts to infiltrate the space. Khan's body responds to this changing aural landscape as he shifts into a movement solo that captures restlessness from being out of place in the environment, evoked by the sounds of a chaotic cityscape that he does not belong to. He interacts with the beeping horns and rickshaws by recklessly crossing an imaginary road. He squats on his feet and gestures with his upturned open right hand as a beggar, to imaginary people walking by. He momentarily bursts into a tiny fleeting motif of a Bangladeshi fishermen's folk dance and then seamlessly becomes something else. Khan conjures up Bangladesh in his body with as much familiarity as he others these images as belonging in a space outside his body. It is through these oscillating tensions between familiarity and otherness and belonging and non-belonging that Khan's body becomes the fleshly third space of enunciation of identity-politics. Through all these transformations, he keeps returning to or looking back at the mound of earth, as though it is the fulcrum that triggers and controls his actions.

He suddenly and deliberately walks over to the mound, drops to the floor, holds and covers his face with both his hands and reveals

the top of his shaved head which has been marked by a black felt-tip pen to evoke eyes, nose and mouth. This very moment transforms Khan into what we come to realise is his father. He speaks a mixture of Bangal, Bengali spoken with a Bangladeshi dialect, and heavily accented English:

> Aami purushmanush – o aami ranna kori (I am a man and I cook)
> Cook for my village – 200 people.
> Ekhane, my own restaurant England-e. (Here, my own restaurant in England). (*Desh*)

What follows is an intricate and evocative movement solo by this elderly cook who chops his vegetables and churns his pans and woks with great clarity of gestures, making his character come alive with utmost intention. We learn that Khan's father is a cook and a restaurant owner in England and that he takes great pride in his business. Towards the end of his solo, as the elderly cook fades and Khan gradually reappears, he wipes the felt-tip markers off his head with his hands with deliberation and stares at them before wiping them meticulously. It is as though we witness a flickering realisation that his father is enmeshed into his very being, and removing the felt-tip marks from the skin's surface is a superficial and pointless attempt to distinguish himself organically from his father. This is the central premise of *Desh* as at the 'centre is a child in crisis' who is trying to establish his own sense of identity, as distinct from his father's, and un-burdened by his inherited Bangladeshi identity and culture (Ak. Khan qtd in Crabb).

The opening sections of *Desh* weave reality and fiction as they evocatively capture Khan's relationship with his father and, through him, his relationship with Bangladesh. As the piece unfolds it becomes clearer that perhaps the burial mound is Khan's father's grave. It is through a return to this grave that Khan looks back upon and unravels the relationship he shares with his father and Bangladesh. In a recent television interview on *Parkinson: Masterclass* Khan confirms that the grave is indeed his father's (although his father is very much alive), and becomes a metaphor for the need to kill off his relationship with his father in order to find his own voice and identity as a second-generation British-Bangladeshi (Ak. Khan qtd in Parkinson). Towards the end of *Desh* Khan takes off his Western shirt and puts on his father's *kurta* (a long tunic worn by Bengali men), which he retrieves from the grave. He in essence becomes his father. Khan admits in the same interview that no matter how much a son does not want to become his father, as soon as he himself has a child, he finds himself transforming into

the very person he rejected all associations with. He explains that he spent most of his teenage years disassociating himself from his father's staunch identification with Bangladesh because he believed that his father's values were not his own. However, he explains further that now, as father to a British daughter of Bangladeshi and Japanese mixed heritage, he is organically reassessing his relationship with his own Bangladeshi heritage in order to ascertain what aspects of his own inherited culture he can pass down to his child.

In *Desh* Khan explores this complicated relationship to Bangladesh vis-à-vis the next generation through the imaginary character, Ishita, who is evoked through voiceovers as Khan's fictional niece. Ishita is a third-generation child born and brought up in London to her parents who are themselves second-generation British-Bangladeshis. Khan's interactions with Ishita in *Desh* involve transmitting to her Bangladeshi oral traditions of myths like Bon Bibi which is as imaginary as it is politicised in providing metaphoric glimpses into the turbulent history of Bangladesh's war of independence from Pakistan. As Ishita wants to know more of the story, Khan insists on her learning the password in Bengali, stressing the importance of retaining a link to one's inherited culture through its language. Just in case this transformation in Khan from the moody teenager who wanted to have nothing to do with Bangladesh, to realising the importance of transmitting inherited cultural values to the next generation seems too simplistic, we are transported back to a frictional exchange between the teenager Khan and his proud Bangladeshi father, where Khan once again embodies both characters.

Swathed in a dreamlike square of blue light, Khan dances out his tensions and vibrations between his *kathak* training and his contemporary dance vocabularies in what is evoked as the sanctity of his own bedroom. We see resonances of motifs from *Loose in Flight* in fleeting moments. His frenetic movement work is interrupted by a harsh return to reality in white lights as we hear his father's voice shout, 'Akram, niche asho' (Akram, come downstairs). Khan retorts impatiently in English, 'I'm practising.' What develops very quickly is a heated exchange where Khan's father demands his son give up his dancing to work in his restaurant kitchen, and Khan expresses determination to carve out his own future, disassociated from his father and what he stands for. Khan's father asks in exasperation, 'Why do you move all the time?' to which Akram rudely and harshly replies, 'Go back to your own country and fuck off and leave me alone.' This exchange poignantly captures that for Khan movement is a powerful and phenomenological

medium through which he negotiates his turbulent and complex identity-politics, because it reflects his own reality as lived in his own body, distinct from his parents. In movement Khan finds solace, comfort, and escapism. And ultimately by being immersed in movement he desires to be left alone in order to discover his own sense of self, by navigating his own embodied third space on his own terms.

At the very end of *Desh*, as Khan stands over his father's grave now dressed in his *kurta*, a voicemail message from his father infiltrates the space, perhaps the final message Khan received before his father's passing, which he ignored at the time. In this message his father calls from Bangladesh and requests that Khan join him in his country of origin in order to buy a plot of land in their ancestral village, expressing how happy this would make him. This sequence captures beautifully the complexity of the title to the piece, *Desh*, as it reveals that *desh* means more than just a metaphoric notion of a homeland or a land of belonging. It also signifies a tangible and physical ownership of a plot of land that ties one to one's place of belonging. This final sequence further symbolises the significance the Bangladeshi culture places upon owning *jomi* or land in order to access identification to the land and all associations of belonging that come with it. Khan's father's request for his son to buy a plot of land in their ancestral village in Bangladesh is perhaps his final attempt to connect Khan physically to his cultural heritage. It is hinted that the grave Khan stands upon and tries to permeate with the sledgehammer is situated in the heart of this *jomi*.

In *Desh* Khan embodies the third space as a condition of critical enunciation just as much as he captures it as a reality that is permeated by tension and confusion. But this sense of confusion must be understood as distinct from the confusion experienced by first-generation diasporic subjects, whose nostalgic yearning for the homeland generates a different kind of schism in their identity-formations than that experienced by future generations. For the latter group of diasporans there is no nostalgia as the homeland they are expected to embrace is not their own, but inherited from their parents. Instead their destabilising confusion is about embodying a permanent state of transience and volatility that is not just a figurative experience but a fleshly lived reality. In this, Khan questions Bhabha's optimism in conceptualising the third space as a metaphoric and forward-thinking space that empowers diasporic subjects to make choices that destabilise existing historic power structures. Instead Khan's embodiment of the third space is an honest and fragile reality that can be as empowering as it can be repressive.

Multidisciplinarity and the third space

In *Zero Degrees* the aesthetic tools that enable Khan and Cherkaoui's performative articulation of third space identity-negotiations consist of text and pedestrian gestures from theatre, technique and stylised movement from dance, and interactions with life-size mannequins from visual arts. Khan and Cherkaoui exploit the possibilities of significations that lie dormant in the multistices between these three disciplines and create a syncretic language that blurs the boundaries between them. Similarly *Desh* develops an efficacious language that is generated at the intersections between theatricalised storytelling, stylised and demanding dance movements, intricate gestural language of puppetry and the epic visual dimensions offered by live interaction with digital animation. These pieces challenge Bhabha's conceptualisation of the third space as a liminal space of enunciation between *two* points of reference by demonstrating that *multiple* points of reference can enter into dialogue to generate a syncretic aesthetic whose emancipation lies in in-betweenness. At the heart of *Zero Degrees* and *Desh* then is the desire to narrate Khan's autobiographical embodiment of multistitiality through aesthetic strategies which are in and of themselves multistitial.

Khan states that the starting point of *Zero Degrees* is anchored in this very spirit as Cherkaoui 'starts from theatre and moves towards dance', while he starts 'from dance and moves towards theatre', in order to 'meet in the middle' (Ak. Khan qtd in Sanders, 'I Just Can't Wait'). However, he recognises that the multidisciplinarity in *Zero Degrees* also explores the points where the visual arts end and performance begins. This, he says, is captured in the moments where text is introduced because movement is no longer able to communicate adequately, and the mannequins are interacted with because text and movement fail to convey the desired significations (Ak. Khan qtd in *Zero Degrees* DVD Interview). A very similar approach permeates the aesthetic of *Desh*. Through an intelligently crafted integration of dance, theatre, puppetry and digital animation, Khan creates a performance language between these different disciplines that is multilayered and collaborative. He is able to sustain *Desh* as a ninety-minute storytelling solo because of his collaboration with these multiple disciplines that conjure myriad characters who convincingly occupy the theatrical space alongside Khan, without actually being present in the flesh.

The creative process of *Zero Degrees* and the consequent aesthetic that emerges from it rests on the principle of collaborative exchange, both between disciplines and between artists. Khan recognises that through

their artistic choice to interlace text with movement in the opening section of *Zero Degrees*, he and Cherkaoui created a syncretic performance language where his autobiographical memory was translated through Cherkaoui's gestural 'system of synchronisation' (Ak. Khan qtd in *Zero Degrees* DVD Interview). Therefore, even though it is Khan's narrative that unfolds, it is Cherkaoui's corporeal placement in the splitting and sharing of this narrative that emphasises the issues of difference, sameness, dichotomy and multiplicity that fuel the narrative itself.

As the opening text is delivered in perfect synchrony by Khan and Cherkaoui, its pauses, hesitations and intonations experienced in the movement of the text, its rhythm and musicality, appear simultaneously the same and different, just as the borderland they speak from which simultaneously joins and separates Bangladesh and India. A similar ambivalent split can be witnessed in the apparently perfect synchronicity of movement gestures that accompanies the text. Performed with impeccable timing the actual details in the gestures are invested with their respective corporealities. Cherkaoui speaks of the significance of our pedestrian gestures in everyday communication and reminds us of the subliminal messages they convey:

> When we talk we don't pay attention to the way we gesture [...] we do a lot of gestures and there's a lot of positions with the hand at the mouth, at the eyes, at the ear, at the nose, at the skin, you go to your neck, sometimes you have to scratch. And all these things mean something, they mean something beyond the words. (Cherkaoui qtd in *Zero Degrees* DVD Interview)

Erving Goffman echoes Cherkaoui's view in suggesting that the study of human behaviour is at its richest when the materials examined are 'the glances, gestures, positionings, and verbal statements that people continuously feed into the situation, whether intended or not' (Goffman 1). These quotidian gestures act as signposts and become the aesthetic tools through which signification is achieved in *Zero Degrees*, revealing both literal and subliminal messages through carefully crafted choreography and impeccable delivery.

The use of everyday gestural behaviour in the opening scene of *Zero Degrees* also allows the audience to receive the memory of the border-crossing beyond its textual narration. At one level the hand gestures visually reinforce the aural storytelling; for example, the movement of the passport between guards is demonstrated by repeatedly miming the passing of an invisible document from the left palm with their right

hand and following the action with their eyes. On another level the use of detailed hand gestures reveals something beyond the words; for example, their vocal hesitation over the word 'nationality' is captured physically, as they repeatedly appear to wipe clean their upward-facing left palm with their right hand, until they are able to articulate the word they are looking for. Similarly their mental frustration and nervousness at having their passport taken away and passed around endlessly between guards is embodied in a subtle scratching of their upper right arm with their left index finger. And on a third level, because the gestures used in the performance are learnt and performed by Cherkaoui and Khan from replicating to exactitude the gestures Khan used when telling the story for the first time in their rehearsal process, the gestures are twice removed from Cherkaoui in his replication of Khan's body language, and once removed from Khan himself in his replication of his own body language as caught on film.

This replication or restoration of Khan's original and spontaneous gestures, as captured on film into a heightened and stylised theatricality where the gestures are embodied and performed by Khan and Cherkaoui simultaneously, evokes Richard Schechner's notion of restored behaviour or twice-behaved behaviour. Schechner conceptualises the 'habits, rituals, and routines of life' as restored behaviour, when these regular behaviour patterns 'can be rearranged or reconstructed' and performed by a body different to the one from which it originates (Schechner, *Performance Studies* 34). He compares this performance of original behaviour patterns through other bodies to the splitting of a self into many selves, suggesting that the 'fact that there are multiple "me's"' in every person is not a sign of derangement but the way things are' (Schechner, *Performance Studies* 34). In *Zero Degrees* the splitting of Khan's self into multiple selves is achieved through the doubling, replication and restoration of his original hand gestures through his own and Cherkaoui's bodies simultaneously.

The splitting of their identities is also mirrored in the splitting of the communication that takes place between text and movement. As Khan and Cherkaoui 'play with fertile spaces of ambiguity between language and movement', their language, created in the interstices between everyday quotidian gestures and text, is completely interdependent upon its constituent parts (Norridge 2). This suggests that the signification achieved in the opening section of *Zero Degrees* is generated between the theatricality of text and everyday gestures and the choreographic quality of the synchrony that governs their impeccable delivery, suggesting that everyday communication is conducted through a form of

intricate choreography of body language that aims to generate meaning (Cherkaoui qtd in *Zero Degrees* DVD Interview). Zoe Norridge suggests that this blurring of boundaries between the disciplines of theatre and dance also challenges the understanding of the dancer as someone who has remained 'conventionally mute' (Norridge 7). By creating an inter-dependent language between movement and text, *Zero Degrees* thus assists in the 'transgression of the dancer's traditional role as physical conduit for unspoken communication' (Norridge 7). This lends Khan and Cherkaoui the power to articulate through their voices and their bodies simultaneously by 'dancing the conversation' (Norridge 14).

If *Zero Degrees* emerges in the liminal spaces between theatre and dance, its ambivalent system of signification is further heightened by its creative dialogue with the visual arts. To extend the piece's central issues of identity splitting, erasure and blurring beyond their two live bodies, Khan and Cherkaoui work with and alongside two life-size mannequins who are sculpted clones of themselves. Created by the British visual artist Antony Gormley, Khan and Cherkaoui's mannequin replicas explore the politics of borderland identity through interacting with their live counterparts.

In the interview on the making of *Zero Degrees*, Khan reveals that the mannequins are peculiarly diametrically opposite to their live selves. Thus, while the live Khan's body is grounded and dynamic in his relationship to the floor through a supple and erect spine, his mannequin is spineless and incapable of standing on its own. On the other hand, while Cherkaoui's live movements are fluid, contorted and submissive in their relationship to the floor, his mannequin stands erect on the ground and exudes a silent power. The mannequins are therefore inanimate extensions of their identity splits through which they confront their own sense of self. Moreover this dialectical alignment between Cherkaoui's mannequin and Khan's live self and Khan's mannequin and Cherkaoui's live self opens up multitudinous opportunities for dialogue between self and other. Here the other is not an unfamiliar site external to oneself, but rather a dimension and extension of oneself. This is exemplified by Khan's simultaneous affiliation to and rejection from Bangladesh by virtue of his red British passport, which separates him from the people of his shared cultural heritage and their green passports. In this moment Khan's identity-split generates a condition that makes him become his own other. Khan and Cherkaoui use these mannequins to evoke the other in themselves by extrapolating moments of confrontation with one's split self, where the self and the mannequins are intricately connected. Either this connection is demonstrated in the

way in which Cherkaoui's mannequin appears to control him, when in reality it is Cherkaoui who stands face to face with his mannequin and uses his hand to hit himself in a disturbingly abusive relationship with himself. Or it is demonstrated in the way in which Khan's body voluntarily replicates the actions his mannequin performs in response to being physically abused by Cherkaoui, such that Khan and his othered self are in harmonious existence in that moment of abuse from an external other.

This depiction of inner struggle and identity splitting through simultaneous interactions between the live bodies of Khan and Cherkaoui and their inanimate counterparts in the form of mannequins is reminiscent of the works of the Polish theatre director, painter and avant-garde stage designer Tadeusz Kantor. Like Khan, Kantor was interested in a language of art that evolved at the interstices between multidisciplinary exchanges. Through immersing himself in the visual arts he developed a language for the theatre where live actors and inanimate mannequins created a syncretic aesthetic reliant upon each other, and through this he put forward his manifesto of the 'theatre of death'.[2] Kantor recognised in an inanimate object like a mannequin an ability to artificially imitate life through a latent power that made the mannequin 'more alive' (Kantor 108) because it 'submitted easily to the abstraction of space and time' (Kantor 109) within the theatrical mise en scène. He used mannequins as 'DOUBLES of live characters, somehow endowed with a higher CONSCIOUSNESS', alongside their live companions and believed that they were 'already clearly stamped with the sign of DEATH' (Kantor 111).

In *Zero Degrees* Khan and Cherkaoui's mannequin replicas become intermediaries between life and death, and embody Kantor's belief that 'it is possible to express *life* in art only through the *absence of life*, through an appeal to DEATH, through APPEARANCES, through EMPTINESS' (Kantor 112). Their haunting presence, endowed with a charged stillness generated from the interactions they share with Khan and Cherkaoui, achieves a more profound impact on the audience than the movements of the live performers themselves. The live performers imbue their mannequin replicas with life, and in turn are charged by signification through the ways in which the mannequins come to interact with themselves. At times the mannequins symbolise Khan and Cherkaoui in a further suggested splitting of their selves. At others they take the place of people in their border-crossing narrative, both dead and living. However, perhaps most significantly, through implied but not concretised imagery at the end of the piece when they occupy the

pace on their own, they are an evocative reminder of the innumerable people who lost their lives in the border zone politics that accompanied the splitting and formation of India and Bangladesh as independent nations.

If *Zero Degrees* explores the creative potential between three disciplines, *Desh* furthers Khan's ambitious explorations of multidisciplinarity through his collaborations between dance, theatre, puppetry and digital animation. There is a further point of distinction between the two pieces, however. The multidisciplinary collaboration in *Zero Degrees* is mediated in performance by both Khan and Cherkaoui, and emphasises a close artist-to-artist collaboration. The multidisciplinary collaborative nature of *Desh* is instead exemplary of Thomas Jenson Hines' notion of collaboration between multiple art forms as opposed to artists (Hines 4). Hines acknowledges that while the arts themselves cannot be entirely separated from the artists, a composite and multidisciplinary piece of art does evoke 'the effects of the "collaboration of the arts" rather than the acts of collaboration of the artists' (Hines 4). The aesthetic of *Desh* seems to be fuelled by this same conceptual distinction and rests on an emphasis on the relationships that emerge between the artistic disciplines of theatre, dance, puppetry and digital animation, rather than Khan's collaboration with individual artists who have brought their respective disciplinary expertise to the piece. This distinction is particularly important to consider because, in *Desh*, it is the collaboration between the different disciplines that conjures up the myriad characters who occupy the stage-space alongside Khan, reinforced by Khan's interactions with them. Khan recognises the significance of this nature of collaboration between art forms:

> It has really helped me to rethink collaboration in this way and has given me confidence to deliver a full-length solo production. (Ak. Khan, Interview 2)

Desh uses Khan's comfort zone of the interstitiality between dance and theatre as a fulcrum from which other disciplinary collaborations are explored. These create moments of multistitiality that blow apart and complicate the initial syncretism of dance and theatre. In one instance the interstitiality of dance and theatre encounters the art of puppetry to give life to Khan's father within Khan's body. Instead of choosing conventional signifiers such as costume changes, Khan's body transforms into an elderly frame as his upper body suddenly droops to the floor, his chin is tucked into his chest and his shaved head, marked

with a black felt-tip pen, takes on the facial features of his father. It does not take long for the audience to forget that this body belongs to Khan as the transformation is impeccable and sustained, reinforced by gestural language borrowed from the precision of puppetry. If in *Zero Degrees* Khan performs alongside his own life-size puppet or mannequin, in *Desh* Khan's body transforms into one. The character's physicality is brought alive through dialogue that is delivered in a combination of thickly accented English and Bengali. Khan's rendition of his father as a puppet symbolises the military-like precision with which his parents' generation lived lives in the diaspora, devoted to their homelands, too utterly controlled by their value-systems to risk straying from them.

In another section, as digital animation projects silhouettes of hundreds of Bangladeshi revolutionaries onto the back wall in their fight for independence, Khan stands apart, separated from them as he watches from afar, as though to remind us that he has inherited this story through his parents, and finds it difficult to reconcile with the idea that it is somehow also his own. But gradually his inherited memory permeates his lived corporeality as his own arms start to punch the air in protest, and his own feet start to stomp the ground rhythmically like the silhouettes on the wall. As he repositions himself on the stage, Khan becomes consumed by the rhythmic and spellbinding dance of the revolutionaries and becomes one of them. Here the seamless integration of dance, theatre and digital animation creates a powerful and visceral scene of revolution on stage with only one performing body, exuding the power of the millions who rose in protest for his parents' country's independence. As this sequence intensifies, a Bengali song of great resonance and potency filters through the space and its impact is profound for those who understands its lyrics:

> Jole bhasha poddo aami (I am a mere floating lotus)
> Shudhhui pelaam jatona (And all I have got from life is anguish)
> Amaar naoito kothhao kono thhai (I have no shelter anywhere) (*Desh*)

Just as the audience have been lulled into believing that through Khan's corporeality his Bangladeshi identity and history have found their articulation, these lyrics create an important schism that reminds us that, despite his ability to perform his inherited narrative of Bangladesh as his own, ultimately he is admitting that he, like a floating lotus flower, has no home and belongs nowhere. This realisation is poignant but

again, in keeping with Khan's postcolonial strategy of non-translation, only accessible to those members of the audience who understand Bengali. The layering of the soundscape onto this richly textured multidisciplinary aesthetic of dance, theatre and digital animation enables the thematic content to crystallise in a way that is appropriate to Khan's complex relationship with Bangladesh and avoids the danger of presenting it in simplistic ways.

In the spirit of third space politics, these multidisciplinary collaborations in *Desh* recognise and exploit the artistic potency that resides at a site of multistitiality, by exercising its powers of critical enunciations and rewriting the ways in which these disciplines communicate with and impact audiences on their own. The result is an alternative aesthetic that cannot be categorised and that operates at the boundaries of each art form, blurring their individual characteristics and heightening their ability to reach out to audiences at multidimensional, emotional, cultural and sensorial levels.

Through *Zero Degrees* and *Desh* Khan's multidisciplinary experimentations between theatre, dance, visual arts, digital animation, puppetry and music generate an aesthetic that is simultaneously ambivalent and visceral in its power of storytelling. He has developed the craft to exhaust the qualities of a particular discipline before drawing on others to layer and nuance his aesthetic into a multidimensional, visual and emotive experience. What emerges in the multistitial creative spaces between these disciplines is a language that communicates in complex and multilayered ways. The liminality of Khan's aesthetic resonates in and reinforces the liminality of his precarious, fragile and volatile identity-politics at border zones in the homeland and within the diaspora, and thus becomes an efficacious aesthetic through which Khan's own identity-negotiations can be explored and articulated.

Through the extensive discussions above, this chapter has demonstrated the ways in which *Zero Degrees* and *Desh* evoke multiple and tangible manifestations of Bhabha's conceptual third space at the intersections of Khan's identity-politics and multidisciplinary experimentations. Khan's explorations of his own embodiment of the diaspora firstly depict the third space as physical and fleshly, thereby critiquing Bhabha's postulations of the third space as a figurative concept. Secondly his multidimensional aesthetic questions its postcolonial identity-politics-driven interstitiality between the two oppositional forces of one's home and one's host nation, by redeploying it instead as a multistitial aesthetic site that is generated between multiple artistic

disciplines. In these ways Khan's new interculturalism articulates the complex multistitiality of his identity-positions as a lived reality. Furthermore Khan's reframing of third space politics starts to loosen the moorings on more conventional theorisations of the diasporic condition as a localised experience in a host country to a more globalised condition of nomadism that permeates the complex lived reality of subjects who are constantly on the move between borders and nations and cultures, characterised by incessant travel as itinerants and their embodied homes.

5
Mobility and Flexibility in
Bahok (2008)

In *Zero Degrees'* and *Desh's* dismantlings of the third space, Khan's complex negotiations between his inherited roots and his chosen routes emphasise his multiple affiliations to people, places, cultures, nations and ultimately homes. His ability to move between, occupy, find resonance in and influence multiple spaces and places simultaneously points to another significant catalyst that fuels his embodied approach to new interculturalism; this is the condition of mobility and its relationship to flexibility vis-à-vis relocated subjectivities and homes.[1]

In this chapter Khan's conjectures on mobility, flexibility, relocations and homes are examined through an analysis of *Bahok* (2008). Bengali for carrier or one who carries, *Bahok* is a poignant title for a piece that explores the condition of uprootedness, while constantly being on the move and carrying home within one's body.[2] An artistic commentary on the postmodern condition of 'culture *as* travel' (Clifford, 'Traveling Cultures' 103) that has reconceptualised home as 'dwelling-in-travel' (Clifford, 'Traveling Cultures' 102), *Bahok* is an exposé on the experiences of eight multinational individuals who find themselves stuck in a 'non-place' which takes the shape of an unspecified global transit zone (Augé). Each of these individuals is a *bahok*, a carrier of their own embodied histories, experiences and memories. Caught in a global transit zone and in search of origins and destinations, their distinct and embodied cultural memories become irrelevant outside the borders of their national identities, which include Spain, Slovakia, India, South Korea, South Africa and China. In their place emerges a temporary, flexible and shared community identity that is generated in and by the time and space they occupy together. It is temporary because the community identity will change if any of its members leave, and it is flexible

because it has the ability to adapt to accommodate the departure of current members and arrival of new ones.

A collaboration between the multinational Akram Khan Company (AKC) and the National Ballet of China (NBC), *Bahok*'s ensemble cast consists of five dancers from the former and three dancers from the latter.[3] The piece also marks an important departure point in AKC's repertoire because *Bahok* is Khan's choreographic and directorial debut within the company's trajectory. This allows Khan's artistic quest for other bodies that embrace alternative forms of new interculturalism to continue to mature outside his own body. So if *Loose in Flight* was an auto-ethnography of his own identity negotiations within a national space, *Bahok* provides ethnographic glimpses of how others, similar to himself, behave when trapped in a global transit zone. Working with other bodies also enables Khan to exercise critical distance while ruminating over the significance of working with a multinational cast:

> To bring together a Company of such diverse cultures, experiences and voices is a blessing for me and to the work. It is a reflection of what I am today, which is to be in a state of 'confusion': where boundaries are broken, languages of origin are left behind and instead, individual experiences are pushed forward to create new boundaries. (Ak. Khan qtd on AKC Website)

This spirit of boundary-breaking permeates the central premise of *Bahok* in its critique of origins and roots, and its championing of processual living through distinct routes that characterise individual choices. These eight multinational individuals share neither roots nor routes as they find themselves circumstantially stuck in a global transit zone. The piece suggests therefore that it would be counterproductive to homogenise the experience of these eight *bahoks*, as each individual is marked by distinct histories and embodied experiences. However, it also suggests that through their circumstantial meeting and subsequent interactions they are forced to generate a communal language with which to communicate with each other based on their shared experience of a momentary entrapment. And in these shared moments they operate as a 'community of circumstance' (Fraser).

A global transit zone

Bahok opens onto an urban, cold and dark environment defined by nine utilitarian wooden chairs that face the audience. Two of these

are located front stage right, while the rest are lined up backstage in twos and threes. A large rectangular digital noticeboard similar to those found at airport lounges and train stations hangs centre stage. All these signifiers come together to evoke an unspecified global transit zone. An electric drone starts to infiltrate the space as the light gradually dims into complete darkness. The sound continues to build to a crescendo through the darkness and creates an unsettling ambience that puts the audience on edge. It cuts out abruptly as the darkness snaps into a still image of seven individuals who now occupy the formerly empty chairs, washed by a stark white light. The physicalities of these four women and three men are reminiscent of travellers who are tired and bored of waiting in this departure lounge. They appear to be dressed in regular everyday urban Western clothes and clutch suitcases, rucksacks and bags.

There is another man who appears to be more active in his stillness as he stands downstage left and faces downstage right with a suitcase in his hand, as though ready to move at the first given opportunity. The image is held still for what seems like ages, giving the audience time to examine tiny details about each individual, what they are carrying and exactly how each body etches into the space. Downstage left the man slowly puts down his suitcase, leaving it upright, and then sits down on it before allowing the stillness to continue. He then gradually stands up, purposefully walks to the digital noticeboard with his back to the audience and stares at it in anticipation, as if willing it to change. Nothing happens for a long time and then suddenly the digital noticeboard shifts into action. It takes a long time for its letters to keep scrolling through before displaying the message 'PLEASE WAIT'. The new instruction on the noticeboard stirs life into the travellers as they reposition themselves in the space and respond despondently to their further prolonged wait.

A fragmented conversation ensues between an East Asian woman and a European woman who sit downstage right, in languages that neither can understand. One speaks in Chinese while the other responds in heavily accented English. They intersperse their verbal exchange with frantic physical gestures to find out where each person comes from. We find out that the English speaker is twenty-eight-year-old Lali from Spain who claims 'everyone needs to know their origin' (*Bahok*). Obsessing over this notion of origin Lali discovers that her co-travellers hail from India, China, South Korea, Slovakia and South Africa. In order not to lose sight of her own origin Lali carries around with her fragmented details about her own identity written on scraps of paper that she tries to piece together as a jigsaw. She gets more and more agitated

as the pieces of the jigsaw do not fit and tries to share her anxiety with her fellow travellers who ignore her. Eventually Lali talks herself into a frenzy before exclaiming 'that's my problem. I don't know where is my home. Because people immigrate' (*Bahok*).

Lali's anxiety is a severely heightened version of that of the other travellers who have all clearly arrived from somewhere, but cannot seem to find a way out of this unspecified transit zone. They seem unsure of their destinations while simultaneously searching for their places of origin, and look weary and agitated by their journeying. Through the use of dialogue, quotidian gestures and emotive theatricality, this carefully crafted opening scene of *Bahok* brings to life eight tangible characters whose initial interactions signal three important issues: the first is the condition of uprootedness as a consequence of their relocations; the second is the group's super-diversity as embodied in their multiple nationalities and languages; and the third is the impact that this super-diversity has on their inability to communicate with each other.

Mobility and relocations

The first issue pertinent to mobility, relocations and nomadic globalised lives constitutes the heart of *Bahok* and requires theoretical attention.[4] Extending the title of the piece beyond its Bengali meaning of carrier to a conceptual framework itself, *bahok* becomes a useful construct through which two common conditions that shape these multiple manifestations of relocated subjectivities can be theorised. The first is their feeling of uprootedness due to endless travels and relocations. Closely related to this is the second shared experience, which is that their relocations are mobilised out of choice and privilege and not fuelled by political upheaval or violent uprootings. In *Bahok* we witness such upwardly mobile and privileged travellers, armed with mobile phones and state-of-the-art digital cameras, whose relocations are driven by choice and backed by finance. In order to understand the nature of the mobility embodied by these eight *bahoks*, the experience of being uprooted through forced dislocation must be delineated from the privilege attached to self-chosen relocations. It is also this very privilege that grants the *bahok* the status of a social agent in a host country, if they wish to use this influential position in generating change (Papastergiadis 55). In other words these subjects are new cosmopolitan elites, privileged, opportunity-seeking and upwardly mobile, who can become agents as citizens of the world if they so wish.

Khan is aware of the difference between mobility derived from the privilege of relocation and mobility experienced through enforced dislocation as he talks of his own mother's stories of repeated uprooting and settlement during the war for Bangladesh's independence:

> She was telling me the story where she carried one of my cousins when the war was happening between Pakistan and Bangladesh, how she had to carry him for days through fields and rivers and forests. Each time they would settle and then they would have to be uprooted and have to move somewhere else. Each time they would carry less and less. (Ak. Khan qtd in *Bahok: Lettres sur le Pont*)

He contextualises his mother's story against his uncle's, who was a freedom fighter in the war:

> He was one of the Bangladeshi people who fought for independence against Pakistan [...] He has so many amazing stories about leaving his home and travelling with strangers who became his family because these strangers were fighting for the same cause. He has some incredibly horrific stories about when he got captured by the Pakistani army and was tortured. And somehow he managed to escape but his friend didn't. (Ak. Khan qtd in *Bahok: Lettres sur le Pont*)

Khan describes the torture that was inflicted upon his uncle's friend who, on refusing to divulge information demanded by the army, had the skin removed from the soles of his feet. But his uncle reminisces that, despite the pain inflicted upon his body, his friend continued to travel onwards in search of the next settlement. Finally Khan shares his personal affiliations to mobility, relocation and carrying physical and metaphoric loads through such journeys:

> My Mum was pregnant with me in Bangladesh – so in a way she carried me over to London where I was born. So if you like I am a product of a tradition of my family who are all carriers. (Ak. Khan qtd in *Bahok: Lettres sur le Pont*)

As someone who acknowledges the privileges attached to relocating from choice, Khan's complex associations with travel, mobility and carrying permeate *Bahok* and become an implicit homage to his ancestral

history of often traumatic dislocations as evoked in Marianne Hirsch's concept of 'postmemory':

> Postmemory describes the relationship of the second generation to powerful, often traumatic, experiences that preceded their births but that were nevertheless transmitted to them so deeply as to seem to constitute memories in their own right. (Hirsch 103)

As a representative of the 'hinge generation' (Hoffman qtd in Hirsch 103) Khan evokes in *Bahok* subtle resonances of his inherited ancestral stories 'without appropriating them', while ensuring that his own generation's stories are not 'displaced by them' (Hirsch 104). Thus in *Bahok* Khan's postmemory is not 'mediated by recall but by imaginative investment, projection, and creation' through eight *bahoks*, whose mobile cosmopolitan lives are marked by a starkly different kind of privileged mobility and interventionist agency when compared to his ancestors' (Hirsch 107).

Khan's evocation of these *bahoks* is reminiscent of British-American novelist Pico Iyer's notion of global souls as 'the children of blurred boundaries and global mobility' (Iyer 24). Iyer suggests that these subjects of relocations are not exiles (who have lost their homes), or expatriates (who work abroad), or nomads (whose movements are tied to rhythmic tides of the seasons), or refugees (whose dislocations are the result of violent uprootings). In fact they themselves are aware of the differences between these different subjectivities (like Khan). A global soul is an international citizen:

> made up of fusions (and confusions) [...] this creature could be a person who had grown up in many cultures all at once – and so lived in the cracks between them – or might be one who, though rooted in background, lived and worked on a globe that propelled him from tropic to snowstorm in three hours. (Iyer 18)

Iyer's global souls, like Khan's *bahoks*, have multiple affiliations to communities and homes which they carry around 'in the ties and talismans' that accompany their relocations (Iyer 19).

Despite these commonalities that permeate the lives of these *bahoks*, their responses to their self-chosen life of global nomadism are idiosyncratic. In one we witness a complete loss of a sense of origin and a yearning for a state of settlement in a tangible home. In another we see a clear, painful legacy of what was once home with all its contested

emotions and a desire to escape from these memories through further relocations. In still others we see home being evoked through international telephone calls to their place of origin, to keep alive a sense of rootedness. The eight *bahoks* therefore demonstrate eight distinct manifestations of the impact of being global souls, and their distinct subjectivities add to the super-diversity they bring to their chance meeting place of the transit zone.

A super-diverse non-place

The second issue that the opening scene of *Bahok* conjures is the condition of super-diversity as embodied in the eight *bahoks* who represent five nations and cultural heritages between them. At a micro level Khan's evocation of their super-diversity in the unspecified transit lounge is symbolic of sociologist Steven Vertovec's postulations on the super-diversity of contemporary Britain. Vertovec notes that the shift from the 1950s patterns of immigration from Britain's ex-colonies to more recent migratory patterns from a greater diversification of nations has created in Britain a super-diversity:

> Britain can now be characterized by 'super-diversity', a notion intended to underline a level and kind of complexity surpassing anything the country has previously experienced. Such a condition is distinguished by a dynamic interplay of variables among an increased number of new, small and scattered, multiple-origin, transnationally connected, socio-economically differentiated and legally stratified immigrants who have arrived over the last decade. (Vertovec 1024)

Through *Bahok* Khan offers a tiny glimpse of such super-diversification, where competing nationalities, cultural histories, languages and traditions find themselves contained in a singular space. Through this offering the piece also attempts to address the 'coexistence of multiple historical streams and the ways individuals in complex settings relate to each other from different vantage points' (Vertovec 1026). *Bahok* thus provides an important socio-political commentary on how super-diverse communities can generate productive ways of communicating with each other through embodied shared languages that grow out of their circumstantial condition of coexistence.

If *Bahok*'s unspecified transit zone and its multinational occupants are indicative of the super-diversity of contemporary Britain, then by

implication contemporary Britain, particularly London with its dense immigrant population from 179 nations, is an unspecified liminal non-place, a site 'where particular histories and traditions are not (allegedly) relevant' (Cresswell, *On the Move* 44). These particularities are instead replaced by a network of multiple histories that must coexist. *Bahok* therefore contests the cultural anthropologist Marc Augé's notion of non-places as spaces 'which cannot be defined as relational, or historical, or concerned with identity' and therefore are 'not themselves anthropological places' (Augé 63). As a symbolic representation of a super-diverse non-place, *Bahok* extends Augé's postulations on non-places beyond the realms of 'airport terminals, service stations, super-markets, malls, hotelchains' to include in its remit anthropological and relational places like London, where individual histories have had to mutate in order to accommodate the super-diverse histories of its vast immigrant population (Bosteels 119).

At first *Bahok's* location in an unspecified airport transit lounge might seem a direct reference to Augé's notion of non-place. However, through its implicit reference to the super-diversity of places like London, in its large-scale 'capacity to import and export people, products, images and messages' (Augé vii), *Bahok* simultaneously manages to construct these places themselves as global transit zones of 'circulation, consumption and communication' (Augé viii) that are having to renegotiate their relational histories and identities in light of recent trends of mass immigration. This argument is further consolidated by the multinational identity of AKC, which is implicated in the importation, exportation, circulation and consumption of global artists. These artists, like global souls, find a temporary home in London while they work with the company before moving on to other projects in other global cities. Thus *Bahok's* symbolic super-diverse non-place is fuelled by the autobiographical nomadic conditions of the eight multinational global souls who occupy it.

Communication in the diaspora space

The third issue signalled by the opening sequence of *Bahok* points to the challenges of communication experienced by people who share a super-diverse space. The problematic exchange between Lali and her Chinese co-traveller captures the difficulties that will be faced by these eight individuals in trying to communicate with each other, in the absence of a common language or reference points. Even as Lali resorts to English, it is far from the perfect medium of exchange as it is clearly a second language for all of them, apparent from Lali's heavily accented

and grammatically inaccurate utterances. Lali's frantic and anxious chatter about losing sight of her origin emphasises that each traveller in *Bahok* comes from a notional place of origin, and carries in their body idiosyncratic histories and memories of these places. In this, *Bahok* signals cultural studies' recent postulations on the role of the body as an ideological apparatus through which ritualised social customs, shared histories and institutionalised cultural memories are transmitted through generations. Each *bahok*'s body homes culturally specific memories pertaining to their own notional place of origin. However, outside of national borders that lend these bodies identities, having to live alongside bodies with competing cultural memories and unable to find other bodies that share their own particular histories, these *bahoks'* unique cultural memories become destabilised.

In time, in the shared 'diaspora space' of the global transit zone, these notional places of origin and their distinct cultural memories become diluted (Brah, *Cartographies* 16). By painting a picture of a society where dispersion and travel have overtaken 'staying put' such that everyone has become a diasporan, *Bahok* creates a diaspora space whereby it is impossible to ascertain who is indigenous and who is diasporic anymore (Brah, *Cartographies* 16). In this multilayered space individual histories, languages and cultural memories are gradually dismantled to make space for multiple histories and cultural memories to coexist, such that a common language of communication may emerge. As the piece develops it becomes apparent that the eight *bahoks* realise the importance of allowing such a common language of expression to materialise from their shared nomadic existence, in order to effectively communicate with each other. And from their circumstantial meeting and interactions emerges a temporary community.

A hybridised, flexible community of circumstance

In *Bahok* the community created through circumstantial needs evokes social scientist Heather Fraser's notion of communities of circumstance, which emerge from situations otherwise disparate individuals find themselves a part of, as a result of shared circumstances (Fraser 286–7).[5] I would like to further Fraser's notion of communities of circumstance as a flexible condition, always sensitive and responsive to the inclusion and exclusion of members, and through this permanently transient quality remaining a malleable entity. This flexibility is as much a strategic survival tactic for the different members of the community as it is an organically evolving condition.

Dance scholar Anusha Kedhar examines the importance of flexibility as a tactic for British South Asian dancers within the context of globalisation and the arts-commodity market that capitalises on difference. She argues that:

> South Asian dancers have developed an array of flexible practices in order to navigate the tensions between global capital and the nation-state, and that such flexible practices have been important in negotiating the contradictions between race and citizenship, reconfiguring social identities, and re-defining the contours of both South Asianness and Britishness. While I am critical of globalization, in particular its impact on labor flows and its toll on the body, I am also attentive to the power, creativity, strength, and flexibility of the dancing body to adapt to the inequalities and volatility of global capitalism. I suggest that late capitalism has created not just 'flexible citizens' but also flexible bodies. Despite efforts to regulate the transnational movements of racialized labor, South Asian dancers continue to make dance, and make dance work as a career; they continue to perform locally, nationally, and globally; and they continue to move in unruly and unpredictable ways. Thus the South Asian dancing body reveals not only the friction of bodily encounters in globalization but also the flexible corporeal tactics used by transnational dancers to move with, through, and against the often uneven and unequal flows of global capital. (Kedhar vii)

In *Bahok* the community of circumstance created by the eight multinationals similarly negotiates between contradictory and competing identity-politics of race, culture and citizenship. In order to survive the community searches for ways to overcome their differences by deploying a circumstantially emerging flexibility towards each other's othernesses, in order to redefine the contours of their own mobile and flexible identities. Like Kedhar I acknowledge that this flexibility is as troubling as a flattening-out concept as it is empowering in the way it enables communication between disparate individuals within a community of circumstance. But in the context of a productive formation of hybridised communities of circumstance, the efficacy of flexibility is undeniable.

However, it takes time for the eight *bahoks* to realise that in order to communicate with each other and understand their shared nomadic reality, they must acknowledge themselves as a community of circumstance

and begin to function as a collective. Separated from each other by distinct histories, languages, cultural memories and national affiliations, initially these eight people retain their individualities. We witness volatile bodies, agile bodies, grounded bodies, tired bodies, frivolous bodies, playful bodies, fragmented bodies and distorted bodies, all in this one diasporic space that must negotiate with each other in order to successfully generate a common point of reference. Despite their shared sense of uprootedness, the eight *bahoks* find it impossible to communicate with each other as they hold on to their 'archival memories' (Taylor 19). Every attempt at interaction is a failure. As long as they remain confined within their own archival memories and refuse to negotiate a collective understanding of their situation, the *bahoks* remain dysfunctional within the liminal space.

In a particular instance when two Chinese women perform a ballet routine on their own, they only manage to communicate with each other while the others look on in awe of their otherness. A physical interjection into the ballet sequence from the Keralite man with his *kalaripayattu* gestures causes a breakdown of communication and the bodies literally clash as tensions seem to rise within the group.[6] This is heightened further when the Slovakian man expresses his annoyance at the Chinese man's insistence on documenting every fleeting moment of this liminal space on his digital camera, through a beautifully crafted and highly energetic choreography of dodging being photographed. They almost get into a physical fight and are kept apart by the Korean man who attempts to ease the tension in the group. In his anxiety he freezes into an inflexible momentary fragmented gesture which he keeps repeating like a broken record. His spinal column leans slightly forward and then is jerked back into the centre and his head and right arm follow this pattern endlessly. As his friend comforts him he acknowledges his inflexibility by finally blurting out 'I'm stuck'. This physical and verbal proclamation poignantly captures his claustrophobia experienced in a tense, shared space that has not been conducive to enabling communication between its inhabitants. Consequently he finds himself stuck linguistically, physically, spatially, temporally and emotionally, and appears frozen in time between his (and their) collective points of disjuncture.

The travellers acknowledge the growing tension borne of their dysfunctionality in communicating as a group. They gradually come to realise the importance of generating a shared sense of mobility in order to move beyond the condition of dwelling in their individual past cultural memories. Only then will their assimilated growth as a community

of circumstance materialise. Khan reflects on the complex relationship between mobility, carrying and dwelling within the diaspora:

> Concept of carrying means you have to keep moving, you have to shift. You get stopped if you dwell in the past. [...] if you're in the present then you are constantly moving and must keep moving. (Ak. Khan qtd in *Bahok: Lettres sur le Pont*)

His views on the significance of mobility as 'socially produced motion' (Cresswell, *On the Move* 3) that prevents stagnation and assists assimilation emphasises the transgressive and flexible quality latent in creating acts of 'displacement, the moving between in place and out of place' (Cresswell, *On the Move* ix). It also reminds us that in this global cosmopolitan context of travel and multiple settlements, 'culture [...] no longer sits in places, but is hybrid, dynamic – more about routes than roots' (Cresswell, *On the Move* 1). It is therefore generated and transmitted through mobility, which has come to stand for 'an alternative to place, boundedness, foundations, and stability' (Cresswell, *On the Move* 2). This interventionist power in flexible mobility implies that there is more to it than just spatial displacement.

In *Bahok* the eight individuals undergo individual transformations in diluting their own cultural memories to emerge as a community of circumstance that can collectively capture and articulate their shared entrapment in the global transit zone. Through generating a communal 'repertoire' the *bahoks* create an ephemeral, temporary and non-reproducible physicality that is borne of their shared circumstances and temporal and spatial interactions (Taylor 19). This communal language that emerges is a fundamentally syncretic and hybridised language, unique to these eight individuals and their shared reality as a community of circumstance, fuelled by the need to remain on the move.

Two instances exemplify how hybridised mobilities can be instrumental in shaking relocated subjectivities out of the condition of stagnation, into making them flexible. The first is a dream sequence duet between a Chinese woman and a Slovakian man in which the two bodies interact to create an illusion of a new entity altogether. And the second is the penultimate ensemble sequence delivered by all eight travellers where a synchronised sequence ensues that retains individual idiosyncrasies while simultaneously generating a collective language of expression. Permeating both these sequences is the need to achieve and sustain a hybridised mobility as a fundamental feature of globalisation. The relationship between their mobility (their incessant need to move)

nd their hybridity (how they move) is intrinsic to understanding how mobility is embodied differentially' and 'how the act of moving s reflected in and constructed through different bodies' (Cresswell, Embodiment' 176).

The first instance occurs halfway through the piece and demontrates, through a dream sequence, the promise of a hybridised mobility hat could arise in their existence if the travellers were to only move eyond their own cultural reference points and consider entering into roductive dialogue with each other.

A beautiful Chinese woman is so tired of waiting in the departure ounge that she keeps falling asleep on her Slovakian co-traveller's houlder. At first the Slovakian man politely, gently, repeatedly and ffortlessly pushes her back up into a sitting position. However, her pine is completely limp, like that of a rag doll, such that even if he tries o pick her up so that she moves with him, her body weight is entirely eliant upon his support. She clings on to his shirt as he manoeuvres her body weight around him and accidentally places her lips on his in a momentary kiss. He is clearly taken by her beauty which is exacerbated y her vulnerability and her unconscious sharing of intimacy as she ontinues to rely on him for support. He picks her up into an embrace, o her arms and legs are locked around his neck and waist respectively. o cope with his circumstantial embarrassment he fantasises a sensual ncounter between them as the lights dim around the space to focus on he intimate corporeal dialogue that ensues.

Swathed in purple light she slowly releases her upper body from the ug and reaches backwards towards the floor, suspended at his waist, y latching her legs around him in a tight grip. Their limbs move out f their central axis horizontally and their hands meet in mid-air. At irst their bodies create an illusion of a mirror image, moving in perect synchronisation with each other. Their bodies entwine in such erfect synchronicity that it becomes impossible to identify one body s distinct from the other. They are so in-tuned that they each control he other and each give into the other with mutual trust and undertanding. They become extensions of each other's limbs, such that as he holds up her left palm before her face to simulate holding up a miror, he uses his right hand as though it were her own to comb her hair. his image is representative of the *abhinaya* element in *kathak*, where he image of the *nayika*, the female protagonist, adorning herself in the nirror as she waits for her lover, is a popular codified motif and is usully performed as a solo. However, in *Bahok* this motif receives a curious reatment as the adorning and the reflection in the mirror imagery

are carried out by two individual bodies that appear as one. Khan finds an innovative way to recontextualise the classical codification of this motif of *abhinaya* from a singular body and transpose it onto two bodies that share the execution of the motif. What is achieved in this transposition of *abhinaya* is its curious rewriting; whereas in the classical version the male lover exists in the imagination of the solo dancer, in *Bahok* the female and male lovers are fundamentally entwined and an extension of each other, such that the *abhinaya* cannot be executed without the other. This integration of *abhinaya* into an intimate contact improvisation-driven duet deconstructs both the modalities of *abhinaya* and physical theatre simultaneously, and evokes Khan's flexibility in permeating and rewriting both with equal prowess.

As this intimate moment builds to an emotive and musical crescendo the spotlight snaps out, leaving the space in total darkness. When the light returns gradually the Slovakian man is on the floor by himself and the Chinese woman is asleep far away from him on a chair, emphasising that their intimate encounter occurred in his imagination. This dream metaphor insinuates something important about the nature of their itinerant existences, suggesting the potential latent in their bodies but emphasising it is not a part of their current reality yet. The syncretic mobility in this dream sequence also demonstrates that speed and relocation are not all that governs the life of the travellers, that the past and the future are not the only temporal and spatial reference points for global living and that to live and invest in the present locale is just as vital.

Here we see a hybrid entity emerge as a newly forged creation through the bodies of two relocated subjects. This new entity embodies hope, calm, sensuality and presence, but it only exists in the travellers' imaginations, perhaps indicative of the hope and calm that every global soul desires within to home their ever transient bodies. The semantic of their language is entirely specific to their intimate and lyrical bodily encounter. It indicates the serenity and pleasure that lies dormant in these apparently agitated bodies. But most importantly it denotes that just in that moment of exchange between the two bodies home is evoked as a space of familiar intimacy and is traced in the encounter that transpires between them. And in that present moment, their global souls and their bodies are homed and are at home within themselves, with each other and in the world.

If this first instance of hybridised mobility signals a promise of the potential of nomadic existence, the second instance, which is the

penultimate sequence of the piece, embodies a definitive attempt by the travellers to embrace their shared circumstances as yet another home and a collective reference point. In order to move beyond the unspecified global transit zone and permeate the frontiers that seemingly separate them, the individuals gradually assimilate into an ensemble group hug to recognise that 'a frontier is not a wall, but a threshold' (Augé xiv). Their idealistic group hug stands not for 'a world without frontiers, but one where all frontiers are recognized, respected and permeable' (Augé xiv–xv). Lali's character tries to achieve this permeability by being the last person to join the hug. She launches herself into the centre of the mass, clambering over her fellow travellers. As she reaches the centre the light snaps into a bright white wash as the group explodes into a mass movement sequence that starts small and grows bigger, indicating the beginning of their generation as a community. They walk two steps forward and two steps back until they have all embodied a common rhythm. At times they appear stuck to the floor through their left leg, while their right leg and arms strive forward to release themselves from feeling rooted in the past. In considered and carefully crafted ways, they break into a collective and explosive expression of mutation and regrowth.

The ensemble moves as one, taking time to achieve this vision of synchronicity that has grown from their shared liminal condition. Sometimes some individuals fall in and out of place as they break free of the routine while others continue, only to be drawn back into the power of the ensemble again. Their limbs slice through the air and the bodies symbolise transience and dynamism as the rhythm and pace of the section builds to a crescendo. The speed of their movements at times makes it difficult to distinguish between the eight bodies and their individual limbs. It is as though they have become one. However, despite the synchronised nature of their movement, individual traces and idiosyncrasies are retained, suggesting the past is not erased but layered upon the present.

In this penultimate sequence their bodies simultaneously occupy their shared present, look into their distinct futures and carry with them their individual pasts. However, because they occupy the present, their bodies are ephemeral and non-archival. Based on their shared experience of liminality the *bahoks* create their own repertoire and through it a system of knowledge of the present moment as a community of circumstance. As a consequence of only ever belonging to the present moment each of the *bahoks* is forced to reconsider their relationship to their individual notions of home.

The mobile body as a travelling home

If incessant relocations, multiple departures and arrivals and endless resettlements characterise the lives of *bahoks*, then the only moment they can ever claim is the present. Consequently identity formations of such relocated subjectivities enter into highly contested relationships with the notion of home. Avtar Brah describes this complexity beautifully:

> Where is home? On the one hand, 'home' is a mythic place of desire in the diasporic imagination. In this sense it is a place of no return, even if it is possible to visit the geographical territory that is seen as the place of 'origin'. On the other hand, home is also the lived experience of a locality. Its sounds and smells, its heat and dust, balmy summer evenings, or the excitement of the first snowfall [...] all this, as mediated by the historically specific everyday of social relations. In other words, the varying experiences of [...] everyday lived culture [...]. (Brah, *Cartographies* 188–9)

In *Bahok* we witness their initial mourning of the loss and intangibility of home as this 'mythic place of desire' that only exists in their imagination, and their eventual acknowledgment of home as lived experience that is contained and carried within their bodies. It follows then that globalised nomadism challenges rooted notions of home, while simultaneously harbouring in relocated subjects a 'homing desire' (Brah, *Cartographies* 16) in their places of settlement. This enables these *bahoks* to seek the embodied experience of 'feeling at home' in multiple locations, instead of attaching their selves to a single physical place that is home (Brah, *Cartographies* 4). In turn the *bahoks'* relocations dismantle the classical notion of home as a tangible physical place that is 'fixed, rooted, stable – the very antithesis of travel' (George 2).

In *Bahok* home exists in multiple dimensions and is 'simultaneously about roots and routes' (Brah, *Cartographies* 189). Sometimes it is experienced as an imagined 'desire that is fulfilled or denied in varying measure to the subjects' (George 2) and at other times an experience of 'dwelling-in-travel' (Clifford, 'Traveling Cultures' 102), such that the bodies of the mobile subjects become 'traveling homes' (George 2). These multiple evocations of home suggest that it would 'be counter-productive to insist on any one overarching formula for "home"' (George 2). In the piece we experience this pluralistic embodiment of homes as we witness each individual connecting with it in very distinctive ways.

For the Spanish Lali the search for home both as a place of origin and as her place of settlement overrides her ability to settle in the present. She is a near psychotic woman whose highly volatile and restless body represents the extent to which her nomadic existence has permeated her corporeality. While she contemplates and tries to piece together her past through the pieces of paper that she carries around with her, she is incapable of remaining still or contained in one place. The sharp angularity of her movements, her endless agitated floor work that consists of rolls, collapses and sharp rises, her simultaneous forward and upward leaps and her perpetually forward-leaning spine suggest a body that occupies the future and is always relocating in search of a final destination. Lali does not know where she comes from or where she is heading and has truly forgotten everything about herself. In some moments she sits on her knees and rocks herself to procure inner stillness and calm. Unable to do so she falls forward onto her belly and continues to rock back and forth, until the frenzy of her movement takes over yet again. The only time her body manages to achieve some form of superficial stillness is when she returns to imagining her past in the form of the pieces of paper in her hand. However, as soon as she starts to focus on the jigsaw pieces that do not fit, she gets agitated again and moves on. Her identity is enmeshed upon and into her body as she transposes her emotional fragility into a highly volatile physicality that perpetually lacks calm. She is incapable of sharing any memory of the past as her body constantly occupies a temporality ahead of herself, and her present becomes ephemeral as soon it is played out.

As the piece moves on Lali attempts to phone home using her fellow traveller's mobile phone. Even though she is unable to contact her mother, the imagined connection to her place of origin appears to calm her agile body into stillness and slowly makes her realise that her connection to home is carried in her body. Towards the end of the piece Lali asserts control over the text that appears on the digital noticeboard by using the mobile phone as a remote control. Every time she points it at the board and clicks the imagined remote control the text that appears captures what the travellers have collectively come to realise during their time in the unspecified transit zone:

> You sound lost.
> Where are you going?
> Is it in your papers?
> What are you carrying?
> Body.

Memories.
Home.
Hope.
Home. (*Bahok*)⁷

This transformation in Lali's character, from the agitated and lost travel-
ler to the one who matures into revealing to her fellow travellers that
home is embodied in their nomadic existences, is a vital turning point
in *Bahok*. It reminds us that the non-specified global transit zone that
the travellers occupy is at a micro level a 'simulated metropolis [...]
inhabited by a community of modern nomads' (Chambers 57) and a
'collective metaphor of cosmopolitan existence where the pleasure of
travel is not only to arrive, but also not to be in any particular place'
(Chambers 57–8). For these nomadic subjects then dwelling is a condi-
tion that slowly manifests within one's body and not outside it. Lali's
transformation also heightens the catalystic role she plays through
Bahok in searching for and destabilising not only her own self, but
also the selves of the more seemingly grounded of the individuals who
she prompts into expressing distant and often painful memories of
their homes.

One such individual is a South African woman who on the surface
appears calm and collected. Recalling an interrogation scene at UK
immigration where she helps out her South Korean friend as a transla-
tor, she suddenly gets defensive when asked what she carries in her
hand baggage. Clutching onto her bag defensively she takes out a pair
of shoes which are clearly not her own and says 'only my father's shoes'
(*Bahok*). The significance of carrying her father's shoes into her present,
and the act of stepping into the space his feet occupied in the past pain-
fully evokes 'the presence of the past in a present that supersedes it but
still lays claim to it' (Augé 61).

What follows is a sequence where we see her painfully putting on
her father's shoes and with them the weight of her past. She grudgingly
steps into them and relives the memory of home in her father's shoes as
her upper body gently droops forward to evoke the image of an elderly
spine. She tries to walk slowly and painfully, and rests her right arm
across her lower back and holds on to her left elbow. Her upper body
shakes as though with age and tiredness as her right arm and then her
left break out erratically to simulate actions of driving a car. She shifts
gears and combs her hair – all with shaking hands and the imprecision
that accompanies age. Gradually, however, the person behind the steer-
ing wheel becomes less of her father and more of herself, as we witness

her driving away from home and her father. She tries to take her left foot out of her father's shoes, and through a fractured and painful sequence of movements, where her upper body moves in contradiction to her lower body, her right leg remains rooted to her past while her upper torso and left leg attempt to move forward and beyond through jolted fragmented gestures. This separation of the upper and lower body into different modes of movement is reminiscent of a very similar routine that simultaneously captures stagnation and growth, resistance and malleability, in Khan's first solo of *Loose in Flight* as already discussed in Chapter 3.

In *Bahok* this similar choreographic strategy at once captures disjuncture and movement away from home and a simultaneous and painful connection to home which she carries deep in her sinews. The very act of putting on her father's shoes both homes and destabilises her at the same time. Rosemary Marangoly George suggests that the 'word "home" immediately connotes the private sphere of patriarchal hierarchy, gendered self-identity, shelter, comfort, nurture and protection' (George 1). This is evoked in the body of the South African woman, who expresses a need for the comfort and shelter of home while trying to escape from its patriarchal clasps. The South African woman realises through her painful interaction with her father's shoes that she is just as fiercely rooted in and by them, as she is committed to seeking her routes to escape from home. In this moment she acknowledges that although it is central to her socialisation into the world, home for her is thus 'a place to escape to and a place to escape from' (George 9).

Home is evoked as less of a painful past and more of a technologically enhanced present in the interdependency between an Indian man and his mobile phone, through which he is in constant contact with his *amma* (mother) back in Kerala. His need to speak in Malayalam suggests that home for him is partially a memory that can be recalled through linguistic affiliations. Therefore while on the one hand speaking in his mother tongue to his mother roots him to a particular place and culture, the mobile phone becomes a signifier of his globally mobile status through which he can maintain his transnational ties with ease due to advancement in technology and reduced telecommunication costs (Vertovec 1043). The endless mobile phone calls eventually stop connecting as the performance continues, suggesting that holding on to his cultural memory will not move him forward in his transient state. His grounded physicality of *kalaripayattu* may trick us into perceiving him as secure and rooted, but the act of calling home endlessly reveals a clear sense of uprootedness, and a constant attempt to secure his roots

through clinging on to the past. Salman Rushdie writes on the human need to secure connection to our birthplace:

> we pretend that we are trees and speak of roots. Look under your feet. You will not find gnarled growths sprouting through the soles. Roots, I sometimes think, are a conservative myth, designed to keep us in our places. (Rushdie qtd in George 199)

The three *bahoks* discussed above embody Rushdie's words in completely different ways. Some are so uprooted that they are unable to occupy the present moment in favour of always dwelling in the future. Others root themselves to the past and the present simultaneously through painful negotiations and this makes their future difficult to negotiate. And still others are so linked to their pasts that they have no awareness of their present, let alone their future. In each instance, however, home becomes a politicised entity that the individual must negotiate as part of their relocated subjectivities. Rosemary Marangoly George suggests that beyond the geographical location that it evokes, home is a political concept that relies on patterns of inclusion and exclusion of different groups:

> Homes are manifest on geographical, psychological and material levels. They are places that are recognized as such by those within and those without. They are places of violence and nurturing, A place that is flexible, that manifests itself in various forms and yet whose every reinvention seems to follow the basic pattern of inclusions/ exclusions. Home is a place to escape to and a place to escape from. Its importance lies in the fact that it is not equally available to all. Home is the desired place that is fought for and established as the exclusive domain of a few. It is not a neutral place. It is community. (George 9)

Home then is an isolationist trope that engenders difference by creating affiliations of belonging for its subjects. In *Bahok* this becomes apparent in the linguistic trope of the Keralite man who excludes his fellow travellers from sharing his experience. George suggests that home is a community that is never neutral and a politically charged space where ideological control is exercised. The South African woman's fractured body suggests its urgency to break away from the ideological control of her home's patriarchal environment, while simultaneously being

controlled by it. Spanish Lali embodies a nomadic existence in her inability to be homed at any given point, because her volatile and fragile body *is* her home.

These multiple physical narratives are carried in individual bodies that are not contained within the borders of singular nations and homes. Travelling through multiple borders and setting up multiple homes calls upon the individual's body to become a flexible vehicle through which an individual is homed at any given point. Thus the political act of imagining home is enmeshed with and shifted onto the corporeality of the individual's physical existence. Khan comments on the need to disassociate a singular physical location with the notion of home and to acknowledge the body's ability to home and become homed at any given point:

> When I started my own place, the first thing I did was [...] to throw away, simplify, no memory. We start new and never collect anything. The memory's in the body. It doesn't have to be in material things. (Ak. Khan qtd in *Bahok: Lettres sur le Pont*)

Home then becomes a multiple register and embodiment of unique experiences exclusive to 'individual systems of DNA' (Chaudhry, '*Bahok* Query').

In *Bahok* we thus encounter eight different evocations of home to counter eight different experiences of homelessness. The need to find communal belonging through the act of collective imagination by communities is thrown into question. Instead the body of the *bahok* becomes home as this conceptually intangible notion finds a bodily reality. And since each individual's lived experience is unique, the concept of home as a singular, geographical and homogeneous entity becomes redundant and is replaced by pluralistic corporeal expressions. Thus, as Chaudhry's words vividly capture, a generalised and flattened concept of home, despite the common uprootedness which we witness in our *bahoks*, is a myth in itself. It needs dismantling to acknowledge the significance of subjectivity in relocated identity formations, and its relationship to mobility and flexibility in transnational contexts.

Through these poignantly crafted sequences *Bahok* redefines the concept of home by examining it through the interconnected conditions of dwelling-in-travel, mobility, and the flexibility generated by nomadic existences of incessantly relocating subjects. As an artistic

commentary *Bahok* brings about an important shift in the ideological debates on home:

> From the study of bounded and rooted cultures [...] to the study of routes – the way in which identities are produced and performed through mobility or, more precisely, travel. As this travel increases, so cultures can no longer be said to be located. (Cresswell, *On the Move* 44)

The piece therefore questions the 'organic, naturalizing bias of the term culture – seen as a rooted body that grows, lives, dies etc' and emphasises the importance of mobility to rewrite homes as multiple 'sites of displacement, interference, and interaction' (Clifford, 'Traveling Cultures' 101). In this *Bahok* also reinforces the idea of identities as fluid, processual and flexible conditions that subjects *choose* to embody through selecting the routes they take through life, rather than inheriting given and permanent roots.

Khan's embodied approach to new interculturalism thus rests on an innate experience of mobility that is enabled by choice and privilege. This generates a flexibility which enables him and others like him to meet, interact with and grow from otherness on a permanent basis. Through *Bahok* Khan further extrapolates his own condition of embodying competing cultural memories and traditions within his own body, through a depiction of a global context where competing cultural memories embodied within individuals are gradually dismantled and replaced by a flexible and shared language that binds those who occupy the space temporarily as a community of circumstance. This shared language of the *bahoks* is also reminiscent of Khan's own unique aesthetic, generated out of the need to find an alternative mode of communication that most suitably reflects his own multistitial condition. But perhaps most importantly, *Bahok* provides a powerful insight into the significance of mobility as a cosmopolitan licence for dwelling-in-travel. It exemplifies mobility as both an economic condition of privilege and choice and a sociological condition that complicates the relationship between place and identity-politics. This privileged condition lends mobile subjects the ability to be and 'see everywhere with a flexible eye' (Iyer 24). Consequently to them the very notion of home as a fixed place of settlement becomes unfamiliar, and the state of flexibility, instability and unfamiliarity that accompanies mobility becomes the only home they will ever know. In this *Bahok* hints at Khan's approach to new interculturalism as an inherently flexible, privileged and privileging condition and lens through which his own increasingly malleable lived experiences can be played out.

6
Queering Normativity in
iTMOi (2013)

If *Bahok* explores the condition of flexibility through evoking global flows of mobility and relocations, *iTMOi* (2013) places it at the heart of the aestheticisation process through which Khan's new interculturalism queers normativity. An acronym for *In the Mind of Igor*, and inspired by Igor Stravinsky's seminal composition of *The Rite of Spring*, Khan choreographed *iTMOi* for the centenary celebrations of its premiere on 29 May 1913 at Théâtre des Champs-Elysées in Paris. Critics have received Khan's homage in divergent ways.

Judith Mackrell concludes that although Khan's cacophonous metaphoric visual and violent imagery 'rarely cohere, [...] they jolt and assault us viscerally as *The Rite of Spring* did its original audience' (Mackrell, '*iTMOi*'). Concurring with Mackrell but more perturbed by the unfamiliarity of Khan's aesthetic, Patricia Boccadoro suggests that '*iTMOi* is not to be recommended for the faint-hearted, least of all those accustomed to the charm, poetry and harmony inherent in Akram Khan's previous works' (Boccadoro). Ismene Brown's agitation is palpable at Khan's refusal to use the original score in favour of three original compositions by musicians Nitin Sawhney, Ben Frost and Jocelyn Pook. This is coupled with her critique of the vague acronymic title and, by implication, Khan's obscuring of the themes. Brown writes, 'So, as he strains in vain to see into Stravinsky's mind, one strains in vain to see inside Akram's' (Is. Brown). And finally Mark Monahan expresses similar discontent as he describes it as a piece that is 'full of Khanian inquisitiveness into how Stravinsky's imagination might have been fired; but also obscure, disjointed and, compared to Khan's best work, unsatisfying' (Monahan). While the critics are themselves divided about the efficacy of *iTMOi*, through inevitable but unhelpful references to Khan's past works Boccadoro and Monahan both correctly surmise in

their own ways that *iTMOi* is a departure point for Khan, both in thematic and aesthetic terms.

This chapter suggests that *iTMOi*'s visceral, disruptive, surreal and powerful aesthetic is a deliberate artistic intervention that jolts white middle-class audiences into encountering Khan's new interculturalism as a process of queering normativity. The piece's provocative use of violent, grotesque, obscure, and disjointed imagery embodies and emphasises its most significant theme of androgyny, signalled in the 'iT' of the title *iTMOi*, and its relationship to ambivalent sexualities. In this it marks a seminal departure point in Khan's artistic trajectory which, until *iTMOi*, had stayed clear of explicitly broaching and evoking human sexualities. The chapter further argues that through a deliberately obscuring and jarring aesthetic, Khan's evocations of androgyny and ambivalent sexualities become another process through which he can destabilise the centre, by emphasising his non-normative position as a British-Bangladeshi artist within white mainstream culture and arts. I theorise this destabilising aesthetic as a queering of normativity and frame it as Khan's mechanism for evoking his alterity within the mainstream. My use of the term queering is strategic, and my intention is to shift the term queer from its historic associations as a noun and an identification category for non-heteronormative sexualities, to becoming a verb that encapsulates anti-normative and disruptive actions against dominant ideologies. I am therefore more interested in theorising queering as an aestheticisation process through which any anti-normative and alternative position can be articulated.

Theorising queering

Sandra Chatterjee and Cynthia Ling Lee remind us that the word queer carried anti-gay and homophobic connotations before it was reclaimed as a positive identity categorisation by Queer Nation and ACT UP! AIDS activists in New York in the nineties (Chatterjee and Lee 130). This reclamation has created over the years the noun queer as an inclusive and generic label to categorise people who identify with anti-heteronormative sexualities and embody anti-heteronormative gender traits. David V. Ruffalo helpfully critiques the limitations of this identitarian label:

> Queer has reached a political peak. Its theoretical movements have become limited by its incessant investment in identity politics and its political outlook has in many ways attained dormant status due to its narrowed interest in heteronormativity. This is, of course, not

to suggest *the* end of queer but instead *a* potential deterritorialization of queer as we know it today. (Ruffalo 1)

Shifting emphasis onto queering as actions that destabilise heteronormative culture, Ruffalo suggests a re-examination of the term by considering it instead as an action, a queering, that 'disturbs, disrupts, and centers – what is considered "normal" in order to explore possibilities outside of patriarchal, hierarchical, and heteronormative discursive practices' (Ruffalo 2). While David Halperin retains the term queer as a noun, he too shifts it from its identity-politics-driven discourse to suggest that 'queer is by definition *whatever* is at odds with the normal, the legitimate, the dominant' (Halperin qtd in D. Hall 67). Similarly Judith Halberstam calls for the need to 'detach queerness from sexual identity' (Halberstam 1) by conceptualising the term as a 'way of life', with its embodiment of anti-normative temporalities and spatialities (Halberstam 6).

In the context of Khan's new interculturalism, these much-needed post-identitarian conceptualisations of the term queering, as doing rather than being, frame my use of queering as an aestheticisation process that enables artists like Khan to represent alterities in order to disrupt dominant ideologies (Ruffalo 4). In this process the discourse of androgyny and its relationship to ambivalent sexualities becomes a metaphor through which anti-normative realities are evoked on stage. We must remember of course that in representing alterities in his art, Khan mobilises his own complex anti-normative and minority positions as not only a British-Bangladeshi choreographer in a field that is mostly dominated by white choreographers, but also a male dancer in a field that is mostly dominated by South Asian women. As a Muslim South Asian man working in the fields of British and global contemporary dance, Khan has therefore publically queered the normative expectations associated with contemporary dance through his influential presence in the field.

Queering contemporary dance as a South Asian man

Historically the status of the male South Asian dancer within the traditional *guru-shishya* (teacher-student) system has been one of authority, such that male *gurus* have imparted knowledge and skill to female students, ensuring that 'the domain of the teachers, managers, patrons remained male bastions' (Dutt and Sarkar Munsi 165). This hierarchical male dominance was, however, called into question during the Indian

nationalist project when postcolonial values of a Victorian sensibility codified gender roles in strict heteronormative terms and problematised the association of men with the profession of dance, even in positions of authority. Bishnupriya Dutt and Urmimala Sarkar Munsi explain that in the wake of the classicisation of dance forms during the Indian nationalist project, the practice and development of 'the classical dances essentially became a female domain as soon as they were formalized into the revitalized and restructured shape in the modern times' (Dutt and Sarkar Munsi 165). Thus, while female dancers gradually took centre stage and acquired authority as choreographers and subjects of their art, male dancers found themselves pushed to the margins. In the British South Asian context, the same heteronormative gendering of dance practice has been perpetuated, and preserving home culture through dance has been largely perceived as a female project. In the influential South Asian Dance in Britain (SADIB) report, Andrée Grau confirms that most South Asian dancers in Britain are female (Grau 8), even though the rare male dancer does exist in the field.

It was therefore not only unusual for Khan as a South Asian man to train in a feminised art form, but it was further unusual for him to be training under a male *guru*, Sri Pratap Pawar.[1] Khan's *kathak* training in the UK was therefore in itself a queering of normativity at multiple levels. This queering was further nuanced in Khan's case by his Islamic identity, which condemns bodily expressions through dance and music. In my interview with his mother, Anwara Khan is honest in revealing the anxiety and distress Khan's career choice caused to the family, as pressures from the diasporic community made them question the appropriateness of allowing a Muslim man to pursue a feminised and condemned profession (An. Khan, Interview). As a South Asian man Khan therefore not only had to negotiate the perception of entering a profession that was deemed as feminised, but as a Muslim man he also had the additional burden of negotiating his community's disapproval. While there are other male South Asian dancers like Mavin Khoo, Darshan Singh Bhuller and most recently Aakash Odedra who have also developed significant reputations in British dance, Khan's success and visibility have so far surpassed the contributions of his other male South Asian peers in unprecedented ways.

Khan's queering of the contemporary dance field is further enabled by a specific aspect of his *kathak* training whose *abhinaya* modality embodies an inherent transgenderism. Purnima Shah observes that *kathak* performers who mostly dance solo, regardless of their sex, are able to shift seamlessly between corporeal depictions of masculinity and femininity

by virtue of embodying strictly codified signifiers of gendered movement. They do not rely on 'extraneous use of costumes, makeup, props, or technical effects' (P. Shah 3):

> Gender difference is expressed through the manipulation of body movements, expressions and gestures. For instance, broad shoulders and chest, uplifted face, straight spine, and a direct look in the eyes are some of the male physical characteristics; the female may be depicted with relaxed shoulders, slightly drawn inwards, thigh closed together, eyes lowered within a slightly bent head [...]. (P. Shah 6)

Shah further notes that a *kathak* performer 'emotes the feelings of a female character with the same intensity and depths as he would a male', through an embodiment of the codes of femininity and masculinity as required (P. Shah 6). As a highly skilled *kathak* performer Khan can therefore shift seamlessly between embodied depictions of masculine and feminine energies through an aesthetic that foregrounds transgenderism. These qualities inherent in his *kathak* training have enabled Khan to queer white middle-class audience experience of the contemporary dance field at multifarious levels. However, it is important to note that while Khan's *abhinaya* training does indeed enable him to present a queering of gender roles in his performances, it is clearly a mimetic aesthetic, where audiences witness a temporary transgendering that does not necessarily compromise his own lived normative masculine gender traits.

Khan's anti-normative status as a South Asian male dancer has been further catalysed by the rising status of the male choreographer in contemporary Britain. This is a fairly recent phenomenon which in itself has had to historically struggle arduously against patriarchal perceptions of dance as a feminised profession, in order to shake off societal prejudices born from the 'association between male dancers and homosexuality' (Burt, *Male Dancer* 11). The male dancer as a site of codified gender discourse is a long-contested zone in Western theatre dance. According to Ramsay Burt, patriarchal control and monitoring of male behaviour have historically denied men 'a secure autonomy', requiring them to continually 'adjust and redefine the meanings attributed to sexual difference in order to maintain dominance in the face of changing social circumstances' (Burt, *Male Dancer* 12). Furthermore prejudices pertaining to homophobia towards male dancers still persist in contemporary society. Therefore the recent visibility of male choreographers in mainstream dance has in itself queered a once female-dominated field

and is testimony to the progress made by the profession in going some distance to dismantle such limiting perceptions of masculinity. Writing for the *Guardian*, Judith Mackrell identifies this unprecedented visibility of male choreographers in her aptly titled article 'Vanishing Pointe: Where Are All the Great Female Choreographers?'. She observes that 'while the dance scene has never appeared healthier, it is also one that looks distinctly alpha male' (Mackrell, 'Vanishing Pointe'). Postulating over why male choreographers are so much more visible at the moment Mackrell concludes that 'paradoxically, the fact that fewer men enter the profession than women may be one of the reasons why such a large proportion rise to the top' because 'once a man has embarked on dance training, he quickly knows he is a precious commodity' (Mackrell, 'Vanishing Pointe').

Despite these circumstances that all point to Khan's anti-normative queering of the contemporary dance field, themes explored by his performance trajectory have so far not explicitly addressed heteronormativity, let alone challenged it. As a performer in his duet with the French actress Juliette Binoche in *In-I* (2008) Khan hinted at the somewhat trite challenges of the dating game and attempted to expose the nuances that permeate heterosexual interactions in ways that feel forced and dishonest. As a choreographer and performance-maker in *Bahok* (2008) Khan choreographed a brief, sensual dream sequence between a heterosexual pairing of a Slovakian man and a Chinese woman. In *Vertical Road* (2010) Khan's choreographic vision depicted the breakdown and transformation of a heterosexual relationship that was once full of sexual desire, intimacy and trust into a connection that laments its past while fully knowing it needs to move on. There appeared time and again the presence of a third man in this equation who was not necessarily intimated as the cause of the breakdown, but perhaps its effect. This man's presence was made further ambiguous by his ambivalent sexuality, as it was not clear whether he connected to the man or the woman of the heterosexual pairing, or both.

Three years later, in his most recent choreographic project *iTMOi*, Khan centralises ambivalent sexualities as a theme and explores in depth its relationship to androgyny in his homage to Stravinsky's *The Rite of Spring*. It therefore becomes clear that while as a performer Khan has so far stayed clear of explicitly handling anti-heteronormative themes, as a performance-maker his vision has become more politicised, and his desire to insightfully explore such themes more potent, albeit from a perspective of critical distance and removed from his own embodied position. He explains that his own subconscious decision

1ot to perform in pieces that explicitly address themes of human sexu-
1lities is a mark of respect towards his parents and their South Asian
,ensibilities. However, he admits that by engaging with these issues in
he capacity of a choreographer, his parents can disassociate him from
he artwork and are therefore potentially not as destabilised by it (Ak.
<han, Interview 2). It is therefore Khan's aesthetic as realised through
1is increasingly politicised vision as a performance-maker that I wish to
heorise as a queering of normativity, through an analysis of how this
nanifests in *iTMOi.* To understand how queering operates in *iTMOi,* a
brief contextualisation of its relationship to the original performance of
The Rite of Spring is vital here.

;travinsky and Nijinsky's 'queering' of *The Rite of Spring* (1913)

The scandal that has become synonymous with the premiere of *The Rite
of Spring* in 1913 rests upon a marriage of the progressive genius of the
nusical score composed by Igor Stravinsky (1882–1971) and the radical
1nti-ballet choreography of Vaslav Nijinsky (1890–1950) that accom-
banied it. It is impossible to disassociate the two. Yet as an homage to
The Rite of Spring, the acronymic title *iTMOi* expanded to *In the Mind of
Igor* seems to explicitly distance itself from the embodied choreographic
1alf of this radical art-event that represented 'the shattering birth pangs
of modern art' (Mackrell, '*iTMOi*'). Khan's disassociation seems in line
with Stephanie Jordan's observation that Nijinsky's choreography for
The Rite of Spring is a 'lost original' (Jordan 68) which was sacrificed in
'avour of the reputation of Stravinsky's musical score, and has since
been 'misunderstood and abandoned' (Jordan 67). It would seem that
while Stravinsky's iconic composition is deemed responsible for cata-
ysing all future twentieth-century music experimentations, Nijinsky's
provocative choreography is not considered as seminal to the trajectory
of dance innovations that followed. Yet the score and the choreogra-
phy both embody radical innovations within the fields of music and
dance respectively, and were responsible for destabilising the normative
aesthetic of both classical music and ballet. British composer George
Benjamin writes that Stravinsky's 'score did intend to shock' with its
'savage violence', such that 'musical materials slice into one another,
interact and superimpose with the most brutal edges' (Benjamin). In a
similar vein dance critic Joan Acocella describes Nijinsky's choreogra-
phy as nothing like what had been called ballet before – 'the approach
was analytic, the look "ugly", the emotions discomforting' (Acocella).

Nijinsky had 'engineered a thoroughly novel mode of bodily display' where 'audiences were confronted with the spectacle of the body in and of itself, rather than the spectacle of physical virtuosity to which they were accustomed' (Horowitz 2). And where Stravinsky's 'rhythms pound and batter', Nijinsky's 'provocative choreography elicited such a volume of abuse that the music itself was frequently inaudible' (Benjamin).

It is of course impossible to retrospectively speculate as to whether the score on its own would have created the same scandal had it not been accompanied by Nijinsky's choreography. However, according to Jordan, the failure of the 1913 ballet followed by the success of the score's first concert performance in 1914 led Stravinsky to reject 'the score as a vehicle for choreography' and blame Nijinsky as 'the prime cause of the original debacle' (Jordan 65–6). It is easy to understand how the radicalisation of music can become more accessible and eventually acceptable when totally disassociated from an equally radical and disruptive bodily aesthetic. The body as a prime site of sociological control takes a lot longer to be accepted as a catalyst for radical change, because it has the potential to threaten normativity in more immediate, tangible and permanent ways. This might be one possible explanation as to why Khan disassociated himself from that half of the scandal that has been long abandoned by public memory anyway.

Despite this, Khan's homage to *The Rite of Spring* is utterly visceral and embodied, and in this is haunted by the spectre of Nijinsky and his radical and disruptive movement aesthetic which, abandoned or not, fundamentally dispensed with traditional ballet vocabulary and did away with virtuosic spectacle via a return to the body in all its animalistic and primal magnificence (Horowitz 2). In this Khan silently acknowledges the commonality in the radical visions shared by Stravinsky and Nijinsky vis-à-vis their individual desires to radically transform their respective art forms. Their shared radical vision manifested in the early twentieth century as a queering of the normative standards of classical dance and classical ballet respectively. And it is this queering of the two arts forms when experienced in union that created an explosive charge that resulted in the scandalous premiere of *The Rite of Spring*.

Furthermore an identitarian analysis of Stravinsky's score and Nijinsky's choreography through the anti-heteronormative lens of queering points us to their ambisexual lifestyles. Nijinsky was openly homosexual in real life and, through his art, he critiqued the heteronormativity of ballet, such that his body became a 'metaphor for ambiguous sexuality, mobilized and moulded for various creative ends

by queer observers' (Horowitz 1). He did, however, get married to a Hungarian woman, Romola de Pulszky, soon after his relationship with Sergei Pavlovich Diaghilev, the ballet entrepreneur and patron, started to break down.

The ambisexuality of Stravinsky's life is a little more debated however, as despite working with artists who were openly homosexual, Stravinsky led his public life as a heterosexual man. It only became public knowledge when his co-conductor, companion and confidant Robert Craft controversially claimed in his book *Stravinsky: Discoveries and Memories* that, during the making of *The Rite of Spring*, Stravinsky was in an ambisexual phase and had relationships with both men and women (Craft 163). While these claims have been contested and there is no evidence, except for the apparent letters that Craft bases his book on, to suggest that Stravinsky was indeed an ambisexual man, this perspective lends greater depth to the idea of queering as an anti-normative aestheticisation process that both Stravinsky and Nijinsky deployed in their radical revisionisms of classical music and classical dance respectively.

For Nijinsky this may have been driven by an identitarian position of his own ambisexuality, while for Stravinsky it may have been driven by the ambisexuality he witnessed around him, whether or not he was ambisexual himself. Therefore, for both Stravinsky and Nijinsky their artistic experimentations became the medium through which they could represent anti-normative alterities, sexual or not. And I propose that it is at *this* level that Khan accessed the potency of *The Rite of Spring*. So while Ismene Brown is quick to dismiss Khan's ability to provide audiences with a glimpse into the mind of Stravinsky, she, along with other critics, fails to read *iTMOi* beyond its immediate and imposed relationship to the original score. Unlike the innumerable choreographic ventures since the 1913 event that have used the original score to revive *The Rite of Spring*, Khan's conscious 'rejection of the western canon in favour of wanting to work with living artists' is a clear signal that for him the myth of *The Rite of Spring* persists at a more aesthetic and primal level beyond the score itself (Ak. Khan, Interview 2).

Khan explores in *iTMOi* the queering aesthetic that Stravinsky and Nijinsky had both deployed in the fields of classical music and ballet respectively, and uses this queering to create an aesthetic that is as far from his past works as possible and fundamentally anti-normative in both form and themes. In his own words, *iTMOi* is a reinvestigation on his own terms of the forces that created *The Rite of Spring* with a view to exploring the human condition through a 'fundamental dismantling

of his past aesthetic in order to rebuild it all over again' (Ak. Khan, Interview 2):

> In this work, I am interested in the dynamics of how Stravinsky transformed the classical world of music by evoking emotions through patterns, rather than through expression, and these patterns were rooted in the concept of a woman dancing herself to death. This approach is a huge inspiration to me. But in a sense I hope to reinvestigate it, not just through patterns, as Stravinsky did, but also through exploring the human condition. (Ak. Khan, AKC Website)

So for Khan, Stravinsky and Nijinsky's creation becomes a portal through which he journeys towards his own anti-normative explorations.

iTMOi, androgyny and ambisexualities

iTMOi begins abruptly with the violent, powerful and loud roar of a voice that calls the audience to attention while the house lights are still on, making us jump out of our seats. This disruption of the audience-performer dynamic, whereby the codes of a theatre event are broken, instantly signals a journey into the unexpected and the unknown. As the auditorium lights darken, a loud and ominous soundscape of tolling bells filters through the space. A tall black man dressed in a long and voluminous black coat appears through the dark and foggy gloom, and in a raspy voice and breathy accent he bellows out words that are partly inaudible, but partly evoke the myth of Abraham's dutiful offering of his son Isaac as a sacrifice to God. In this swift moment of intertextuality Khan connects the story of Isaac's sacrifice from the Old Testament to the theme of sacrifice in the original narrative of *The Rite of Spring* where, amidst communal rituals celebrating the arrival of spring, a young girl is chosen as a sacrificial victim, and dances herself to death. This link is an evocative one as it demonstrates how, even within secular environments, religious myths circulate and are perpetuated as social rituals. This dark scene builds to a crescendo as other dancers appear in and out of the mist, until they all become visible. They go on to dance a powerful and ritualistic ensemble sequence to a guttural rhythm that echoes the same mathematical pattern as in the original score of *The Rite of Spring*, punching their fists into the air towards the ground, and pounding their feet into it in a tribal and earthy choreography that pulsates with agitation, while violence simmers away beneath the

movements. The group appear almost possessed, their gestures full of anger and passion.

And then out of nowhere appears a figure centre stage, dressed in an austere white gown. The upper body is corseted but reveals a bare, near-flat-chested left breast with an erect nipple. The face is initially invisible as it is covered by a spectacularly big white hat. When the hat is removed it reveals a stark white-painted face and chest, with dramatically emphasised and exaggerated black eyes and a tight knot at the nape of the neck. The lower body is encased in a full-length, billowing, stiff, hooped white skirt that commands the entire space. This elaborate and domineering costume is fundamental to our perception of this figure as someone in a position of dictatorial authority. Its presence is made powerful through a distillation of slight, precise and powerful hand gestures with extreme attention to detail. With a flick of the wrist or a turn of the neck, the figure controls the community, making them dance to its tune. It is impossible to ascertain the sexed-identity of the figure as, despite being dressed in a corset and skirt, the body appears androgynous. There are some fleeting moments when the corset shifts to reveal both of the erect nipples and a faint swelling of the breasts underneath, but the upper body is mostly flat-chested enough to complicate our perception of the figure's sex. This ambiguity is heightened through the figure's authoritarian, controlling and masculinised presence, as it delivers feminised, graceful and slight gestures through its highly muscular arms. The visual surface signs of the corset, the skirt, the tiny swelling of the breast and these slight feminised gestures make us want to read the figure as a woman as per our normative expectations. However, it is in this normative fixing of the figure's sexed-identity that we are in danger of ignoring the significance of its androgyny.

Khan's deployment of androgyny in this figure resonates with the use of androgyny in contemporary Japanese theatre as argued by Erica Stevens Abbitt:

> In theatre, the representation of androgyny has provided a tool with which to explore the gaps between supposedly fixed points. Whether linked to sex (which has to do with orientation, action, and desire) or to gender (which has to do with social and physical attributes), androgyny has proved useful as a means to navigate unknown space in performance – not only the unmapped territory between male and female, or gay and straight, but also the juncture between expectation and reality, history and fiction, other and self. (Abbitt 251)

The androgyny of this authoritative figure becomes a crucial tool with which Khan navigates unknown spaces and challenges audience expectations vis-à-vis the sanitised aesthetic they have become comfortable with in his past works. Through its androgyny this central character in *iTMOi* 'crosses boundaries of gender and geography', in order to represent alterities that cannot be easily categorised, and whose seamless slippages between various normative positions make us question normativity in fundamental ways (Abbitt 250). The figure appears asexual, as though its sexuality has been replaced by celibacy in favour of its transgendered identity and position of authority. This becomes even more potent when we examine the asexual androgyny of this older white authoritative figure in relation to the half-sexual/half-child androgyny of the other white figure in the piece, the Chosen One.

The older white figure of authority controls the ritual and it becomes apparent that it is responsible for choosing the one to anoint for the sacrifice. The person who is selected is another androgynous figure, much younger in age and smaller in frame, and wearing a knee-length semi-translucent white flowing tunic that once again obscures the sexed-identity of the body beneath it, while heightening its vulnerability. The body bares the contours of breasts which are nearly flat, but swollen enough to create an ambiguity over its sexed-identity. The anointing takes the form of a white, powder-like substance that is thrown onto the younger figure's face and hair, such that it takes on the colouring of the white-painted face of the older white figure. This androgynous body embodies another threshold between childhood and youth, innocence and maturity, playfulness and sexual desire. Our normative tendency as an audience is to perceive this figure as a young girl because we are aware that in the original *Rite of Spring* it was a girl who was sacrificed. Yet, once again, this would be a simplistic reading of Khan's deliberate queering of the Chosen One.

While the figure looks androgynous and half-sexual and half-child-like, it also moves in equally ambivalent ways, which makes it difficult for us to ascertain its gender traits through a heteronormative lens. Its movements are violent, jerky and turbulent, and pulsate with an animalistic urge – qualities that are not associated with the feminine. This figure's relationship to other men in the community is equally ambiguous. It is not clear if the man dressed in purple who tries to protect the Chosen One, offering himself to be sacrificed instead, is a father or a lover. Their interactions are ambivalent as the man appears equally to protect and violate the Chosen One, just as the Chosen One starts off by accepting his protection before violating him through cruel

and tortuous manipulation of his physicality, trapping his neck under her feet. These interactions also hint at a disturbingly paedophiliac homoeroticism because the sex of the Chosen One is ambivalent, conjuring up moments of ambisexual charge between an older man and an androgynous younger figure.

As if it isn't destabilising enough to not be able to fix the sexed-identities and sexualities of the human characters in *iTMOi*, Khan layers these androgynous and ambivalent interactions with the presence of an animal figure, a human in the permanent guise of a horned beast. Wearing nothing but a loincloth and a headdress of long and pronounced horns, the beast lurks in the background through the first half of the piece and then acquires a more central intimidating role once the Chosen One is selected. It appears as an animal companion to the older androgynous figure, bowing to its authority and channelling its power by threatening the others in the community. Perpetually on all fours, and depicted through the graceful, precise and lithe walk of a leopard, the beast preys on the next sacrifice and circles the Chosen One surreptitiously once it has been anointed. So, just as it is impossible to fix the human characters in the piece, this horned beast is as ambiguous in its representation, shifting between a bull and a leopard. It is also both predatory and sexual in its presence and conjures up the insatiable animalistic nature of human sexualities as both a creative and a destructive force.

In the penultimate scene, through the most impeccably choreographed violence, delivered via a savage use of ropes used by the community to tie up the man in purple to sacrifice him, a significant transformation occurs in the physicality of the Chosen One. As the community's violence escalates in the background, the two white figures walk towards each other along the front axis, from opposite ends of the stage. It would seem that the younger white figure has been chosen not so much as the 'sacrificial lamb,' as intimated earlier, but to inherit the power of the older character. Their walk is slow, deliberate, tense and sinister as they meet in the centre. The younger white figure steps assertively on the edge of the hoop skirt of the older white figure and towers over, causing the older figure to bend backwards in fearful deference. The older androgynous figure takes off the spectacular white hat and places it on the younger androgynous figure's head. This transfer of costume triggers a metaphoric transfer of power onto and into the younger figure, whose physicality changes from the turbulent and the half-sexual, to the distilled, the austere and the asexual. It's as though in that moment of the transference of power the younger figure takes on the burden of celibacy. And the circle begins again as the stage grows dark.

As the bells toll ominously and the ceremonies of spring-awakening draw to a close, the lights shine on centre stage where, beneath a dangerously swinging large golden ball, two semi-naked figures writhe on the floor very close to each other, as though simulating an explicitly erotic and sexual ritual. They create an illusion of being entwined in each other's arms but never actually touch. They appear interlocked as they weave in and out of each other and simulate the most extreme sexual intimacy, such that their bodies often appear to be entwined as one. But they are not. Their organic and earthy state is punctuated by the menacing presence of the horned beast that lurks dangerously in the background, as though channelling its insatiable sexual energies into the human couple. Above them a swinging golden pendulous ball appears to scrape over their bodies as a warning that the act they are engaged in is perhaps best obliterated. Wearing nothing but flesh-coloured loincloths that make invisible their genitalia and hence obscure our normative tendency to fix their sexed-identities, these two bodies are highly androgynous as they are both equally flat-chested, muscular and lithe. Occasional glimpses of erect nipples on one body and not the other makes us want to visualise the pair as heterosexual. But such a reading is reductive of the otherwise strong suggestions of homoeroticism. Together these readings point to a strong evocation of their ambisexuality.

As their sexual ritual draws to an end, oblivious of the swinging golden ball, the figures stand up and stare intensely into each other's eyes and then appear to nearly kiss as a resolution of their erotic ritual of non-touch. But this too is non-permissible as in this very instant they are separated by the ball that swings dangerously between them. As the two figures get consumed by the darkness, the horned beast continues to lurk in a predatory manner in the space where animalistic sexual desire and human intellect mated in an unresolved ritual only moments before. And it is on this strong imagery that *iTMOi* draws to its painful and powerful close.

Khan is strategic in his use of non-touch to choreograph these final depictions of human sexual desire as contained, unresolved and unsatisfied, distinct from its animalistic counterpart. He does not want to offer a resolution to either his performers or his audience. Exploring the latent power of non-touch, Khan exercises his belief that 'being withheld sexually in art and life is far more interesting than being sexually liberated' (Ak. Khan, Interview 2).[2] This withheld depiction of human sexualities creates an overwhelming tension in the aesthetic and refuses to give the audience the release we absolutely crave at the end of *iTMOi*.

Instead it continues the aesthetic of queering by never giving in to our expectations at any point. Khan reveals that this final duet epilogue in his mind is what marks the 'beginning of the end, the birth of the creation of the *Rite of Spring*' and the clash it embodied between the atavistic and animalistic nature of humanity and its intellectual progress (Ak. Khan, Interview 2).

Queering as aestheticisation and costuming

Central to Khan's aestheticisation process of queering normativity is his deployment of androgynous bodies in order to create 'an aesthetic of turbulence that inscribes abrupt shifts in time and space', and helps destabilise audience perceptions of his past aesthetic as sanitised and familiar, even in its otherness (Halberstam 107). This turbulence reconstructs these androgynous bodies as sites of 'critical reinvention', vis-à-vis representations of their anti-normative alterities (Halberstam 107). Judith Halberstam theorises the turbulent aesthetic that accompanies transgenderism further:

> Within this turbulence we can locate a transgender look, a mode of seeing and being seen that is not simply at odds with binary gender but that is part of a reorientation of the body in space and time. (Halberstam 107)

While transgenderism and androgyny are not interchangeable concepts or conditions, Halberstam's argument still holds true for Khan's depiction of androgyny as a fundamental aesthetic tool through which he queers normativity, by choreographing androgyny as a blurring of masculine strength and feminine sensuousness.

One of the significant means through which Khan conjures androgyny on stage is through strategic and well-intellectualised processes of costuming by the costume designer Kimie Nakano. This lends *iTMOi* an operatic scale and aesthetic and shifts it from the realm of contemporary dance to the realm of visual arts (Ak. Khan, Interview 2). Theatre scholar Aoife Monks raises a critical distinction between 'costume' as the attire a performer puts on to become a character, and the act of 'costuming', which is instead about the 'uses, perception and effects' of these costumes 'in the relations between the actor, the costume and the audience' such that it is 'an act or event that is centred on the ways in which audiences look at an actor on stage' (Monks). This critical approach to understanding the role and effect of costumes on audiences

permeates Khan's approach to costuming in *iTMOi* and distinguishes it from his use of costumes in his previous works.

This approach to costuming is at odds with Khan's *kathak* training, where performing strictly codified gender roles relies not on costumes and external paraphernalia, but on embodied gestures of masculinity and femininity. What is further at odds, perhaps, is that *kathak* performers do not embody androgyny in order to hint at ambivalences surrounding their sexed-identity in relation to the gender-identity of their characters. Instead the sexed-identity of the dancer either coincides with or remains distinct from the performed gender-identity of the character they are embodying. Costumes play little or no role in these processes. In *iTMOi*, however, a deliberate obscuring and ambivalence is generated in the androgyny of both the dancers and the characters they embody. This is enabled through costuming that obscures the sexed-identity of the dancers. This obscuring is heightened by the nature of the movements which blur the boundaries between femininity and masculinity. Costuming as an aestheticisation process towards queering normativity is enhanced further by the simultaneously flat-chested, lithe and muscular bodies of the dancers themselves. It is deployed to both layer these bodies with strategically designed clothes, as in the case of the two white figures, and to reduce them to a vulnerable semi-nakedness, as in the case of the two figures in the erotic final duet. The ambivalence in the style and design of the costumes themselves makes it impossible to place them in specific times and spaces, thereby queering normative expectations that seek clarity surrounding the geographical and/or cultural contexts within which *iTMOi* unfolds. Costuming therefore operates in *iTMOi* in ways that are unprecedented in Khan's previous pieces, because it is a fundamental part of the aestheticisation process through which Khan queers all kinds of normativity, in order to deliberately jolt, jar and disorientate his audiences into acknowledging all kinds of anti-normative alterities on stage. And the explicit reference to ambivalent sexualities becomes a metaphor for such myriad realities.

The evocation in the title of the French word 'moi', meaning 'me', is not an incidental detail in a title that reveals nothing about the themes of the piece. It is instead an obscure and an obscuring nod at the intricate and evocative ways in which, using *The Rite of Spring* as a departure point, *iTMOi* becomes Khan's personal and self-referential exploration of what it might mean to queer normativity around audience expectations vis-à-vis *his* reputation and aesthetic in the twenty-first century contemporary dance world, in the same way Stravinsky and Nijinsky queered the normative expectations that governed the worlds of classical music

and ballet respectively a hundred years ago. Khan's decision not to use the original score is a reminder of the way he approached his explorations of the Hindu epic of the *Mahabharata* in *Gnosis*. By deliberately not engaging with the score, which holds an archival status in Western classical music, Khan distanced himself as much as possible from potential criticisms of misappropriating Stravinsky's intentions. Khan wanted *iTMOi* to stand as its own entity and as his own creation. The obscure nature of Khan's title is a further postcolonial strategy to deliberately not explain himself and his ideas to white middle-class audiences who want to categorise him as a safe and sanitised other, and who are therefore frustrated by the distance Khan generates through such obscurity. It embodies in choreographic terms David Huddat's defence of Homi Bhabha's convoluted and dense writings on the conditions of postcoloniality. Huddat argues that Bhabha's often impenetrable writings can be read as a postcolonial strategy to both capture *and* deliberately obscure for his white Western readership the confused and confusing reality of postcolonial subjects, without feeling the need to explain himself to them (Huddat 15). In these terms *iTMOi* becomes Khan's new interculturalism's most powerful postcolonial intervention yet through an unapologetic queering of his own and others' anti-normative alterities vis-à-vis the white middle-class environment in which he has gained unprecedented visibility and success.

Conclusion
New Interculturalism and the Rewriting of *Abhinaya* and *Rasa*

As demonstrated through the previous five chapters, Khan's new inter-culturalism manifests in his art as both a political and philosophical stance and a performance aesthetic. Although I have deployed one characteristic per case study in each of the preceding chapters, Khan's trajectory as a whole engages with all of the following features that nuance his embodied approach to this position. As a dancer and choreographer, working with his own lived reality and that of others, Khan ultimately interrogates his own multiple and fragmented selves through his art.

Firstly then Khan's new interculturalism is embodied in a series of relentless and multiple critical self-portraits characterised by a fundamental spirit of *auto-ethnography*, where his field of enquiry is both informed by and takes shape in his and others' lived corporealities. Secondly, it thus follows that its aesthetic manifestation prioritises the *bodily language* over other means of communication. The unfixed and transient nature of the corporeal language provides far more flexibility in exploring multiple forms of otherness which play out in and through bodies as impermanent repertoires, subject to change, just like the selves that are fundamentally connected to them. Thirdly, the innumerable reference points that the selves are moulded by lends Khan's new interculturalism an innate *multistitiality*, oscillating between different and changing affiliations and thereby remaining dynamic and permanently unfixed. This unstable and evolving nature of Khan's lived reality is reflected appropriately in a performance aesthetic that is in and of itself equally unstable, multilayered and multidisciplinary, looking for modes of critical enunciation at multistitial points between the disciplines of dance, theatre, visual arts, music, literature, digital media and animation. Fourthly, this multistitiality is nurtured further through a privileged *mobility* that lends Khan's new interculturalism a spirit of

itinerancy, forever mutating through contacts and interactions with different places, people and cultures on a global scale. The fifth aspect of Khan's new interculturalism makes it an aesthetic that is unpredictable, resting on a constant *queering of normativity*, to the point where everyone and everything, including himself, appears unfamiliar and othered. The sixth and final feature of Khan's new interculturalism deploys othering as an aestheticisation process that dismantles the simplistic and mutually exclusive nature of the us-them binary. Lulling his primarily white audiences into a familiar and comfortable space, Khan draws on complex and multifarious visual and aural codes of otherness to simultaneously destabilise them. But he applies this othering process to himself with equal prowess. In *Torobaka* the predominant use of Spanish in the piece distances and defamiliarises not only non-Spanish-speaking audiences, but also Khan himself. The use of multilingual soundscapes and multicultural reference points which are not translated for those who are not privy to their meanings range from dialogues in Bengali (*Desh*), song lyrics in Hindi (*Zero Degrees* and *Gnosis*), Hebrew (*Zero Degrees*), French (*iTMOi*) and Japanese (*Gnosis*), and costumes and props that are a mix of South Asian and other cultural resources. But perhaps most prominently, his deconstructive use of the South Asian dramaturgical principles of *abhinaya* and *rasa* deserve special scrutiny here as a vital mechanism of the othering process through which Khan's new interculturalism simultaneously rewrites both Western and South Asian dramaturgies.

Khan's inflection of *abhinaya*, the codified and mimetic storytelling feature acquired from his *kathak* training, characterises Khan's new interculturalism in two different ways, and finds two distinct forms of manifestation within his art.[1] In the first instance, as witnessed in *Gnosis* and *Zero Degrees*, Khan integrates *abhinaya* in its pure form accompanied by Hindi lyrics, acting out each word of the song through *kathak's* codified mimetic language. Khan does not translate either the aural Hindi soundscape or the strictly codified *abhinaya* gestures in these moments, but allows the audience to access signification at whatever level they are privy to. This becomes a postcolonial strategy to inject into his movement aesthetic a layer of signification that a large proportion of his white and non-South Asian audiences cannot access. The Hindi lyrics are incredibly pertinent to the point in the narrative that Khan has set up beforehand, be it Khan's *abhinaya* rendition of the desperate emotional wreck that is Duryodhana as he appeals to his mother, Gandhari, to understand his political motives in setting himself up against his cousins in *Gnosis*, or the widow's mourning of her

husband's passing on the train as Khan's *abhinaya* enacts her predicament in *Zero Degrees*. In *Gnosis* Khan's *abhinaya* rendition is a significant turning point for the piece as it demonstrates, to those who can access the language, Duryodhana's last appeal to his mother to support his desire for success at the cost of his cousins' lives. In *Zero Degrees*, having just used the synchronised choreography of everyday gestures to recall the moment when Khan witnessed the dead body of a man next to his helpless, wailing wife, he transforms before us from himself into the traumatised woman through *abhinaya*, enacting her distress as she screams for help in vain. It is through calling upon the mimetic codes of *abhinaya* that Khan convincingly makes the shift between his masculine self and the feminine, vulnerable woman he depicts. Khan's storytelling takes on a heightened codified form in these instances. In both these examples, the departure from the quotidian modalities of signification in Western contemporary dance, particularly the genre of physical theatre, and the embrace of the South Asian aesthetic of *abhinaya*, not only retains the role of the *kathakar* (storyteller), but also creates a complex connotative layer that communicates to different members of the audience at different levels. But this departure does not jar with the physical theatre aesthetic; instead it enhances it, extending its ability to make meaning beyond hitherto largely Western dramaturgical conventions of significations. Also in both these examples, the nature of the *abhinaya* does not stray from its classical codifications as Khan transforms before our eyes into the *kathakar* he trained to be, before embarking on his eclectic Western dance training.

In the second instance Khan reconsiders the parameters of the language of *abhinaya* and begins to transform its codes to suit his performance aesthetic that embodies contemporary conditions. He questions the need to abide by the strict stylisations of the *abhinaya* language while still retaining its philosophical principles, as he searches for new ways to engage his audiences. Thus, while the codified *kathak* hand gestures and facial expressions are removed from the language, the mimetic nature of *abhinaya* and its quality of enacting every word through hand gestures are retained. By replacing *kathak*'s codified gestural language and stylised facial expressions with detailed hand gestures and naturalistic facial expressions from our everyday world, Khan translates and mutates *abhinaya* for his eclectic audiences. In Khan's loosening of the moorings of *abhinaya* from its Sanskritised associations, and in his deconstruction of its strict codified language, a new deployment of this South Asian dramaturgical principle emerges. Retaining its principle of representing the basic human emotions as recognisable in everyday contexts, Khan

turns to the expressions of these basic emotions through pedestrian gestures that are grounded in his contemporary reality, and heightens their impact through stylisation.

Such a deconstructive staging of *abhinaya* is witnessed in the opening sequence of *Loose in Flight* where Khan's face is pressed against the window looking out on Docklands, as he cups his hand to shield his vision and moves his gaze slowly and introspectively across the derelict landscape outside. This slow, contained and heightened gesture, mediated through the camera, adds intense theatricality to this moment, where through hardly any movement he communicates a great deal. In *Gnosis* the simple act of repeatedly dodging Sunahata's stick in order to evade being caught by her in an embrace becomes a stylised dance that dramatises Khan's desire to operate without any form of jurisdiction or accountability. This deconstructed manifestation of *abhinaya* is perhaps most sophisticated in *Zero Degrees'* delivery of the synchronised verbal and physical language, where every hand gesture literally enacts every word spoken by Khan and Cherkaoui, including those left unsaid. Uttara Coorlawala also notes the innovative deployment of *abhinaya* from a solo mimetic form to a duet performed in synchronicity in this sequence:

> In Khan's *Zero Degrees* he and Cherkaoui simultaneously perform abhinaya, except, we notice that their supposedly independent spontaneous narratives are in fact perfectly synchronised! The spontaneous 'natural' is exposed as artifice, as carefully memorised and planned! (Coorlawala 10)

Khan exposes the artificiality in the mimetic and codified nature of *abhinaya*, by delivering the everyday spontaneous gestures in rehearsed, planned and immaculate synchronicity with Cherkaoui. The dream sequence in *Bahok* transfers the traditional solo *abhinaya* modality onto two bodies but in a different way to *Zero Degrees*. Here they intertwine to create a hybridised and composite image of a woman holding a mirror while applying make-up and adorning herself with jewels. But it is impossible to distinguish whose hand holds the imaginary mirror, and whose hands puts on the jewellery.

These two distinct but linked treatments of *abhinaya* permeate Khan's aesthetic of new interculturalism as othering interventions in different permutations through his pieces. Through Khan's use of pure *abhinaya* sequences in *Zero Degrees* and *Gnosis*, his audiences are split between those who understand the lyrics and codes of classical *kathak*

abhinaya, and those who do not. Here two kinds of critical distances are generated simultaneously. On the one hand, those who understand the aesthetic are momentarily distanced from the everyday embodied realism that physical theatre conventionally depicts. In this moment of recognising two cultural dramaturgies at the same time, these audience members have to intellectualise Khan's layering of *abhinaya* onto his more quotidian modalities of signification, in order to weave their way through the multilayered nexus this generates. This removes the danger of merely creating empathy within the audience. On the other hand, those who do not understand the aesthetic of *abhinaya* must look harder beyond the form of Khan's *kathak* language, to find in it kinaesthetic resonances with the storytelling that has preceded it. This too creates a distance that removes the possibility of purely empathising with the action.

In the second instance, as in the opening scene to *Zero Degrees* that deconstructs *abhinaya* to suit a contemporary aesthetic, Khan's audiences are aurally and visually bombarded with information that they must receive and process simultaneously in order to make sense of the narrative being relayed to them. This is made more difficult for the audience as the textual delivery is interspersed with swear words like 'fuck' or 'screw that', whose use jars the audience out of the impeccably stylised world of Khan and Cherkaoui's magical synchronised storytelling, suddenly reminding them of the reality of the memory. The blurring of fiction and reality as achieved through Khan's deconstructed use of *abhinaya* also generates a critical distance through which the reception of his aesthetic is complicated. It is not clear whose story they are narrating and whose fiction is whose reality. Khan's performance aesthetic therefore does not just extend the landscape of Western contemporary dance by injecting into its remit the codified modality of *abhinaya* that he also rewrites in the process, it also necessitates a discussion of the complex ways in which his aesthetic can be received and engaged with. In generating an aesthetic and critical distance, the *rasa* theory as embodied in his training as a *kathakar* becomes a useful lens through which to theorise the reception of Khan's complex, syncretic aesthetic of new interculturalism.

Khan's othering strategies, of splitting his audience members into those who are privy to the codes of *abhinaya* (and other forms of otherness) and those who cannot access them, generate different kinds of critical distance in different members of his audience. And since every member in the audience is distinct in terms of their own embodied histories, lived realities and cultural reference points, they

ccess *rasa* in distinct ways. By constantly providing multiple layers of intercultural information which are not broken down, translated or sewn together for the audience, Khan relies on his audience to complete the signification process by bringing to his art their own culturally embodied subjectivities, which become lenses through which Khan communicates with their interiorities. Khan's aesthetic of new interculturalism therefore seeks more objective and abstracted ways to communicate socio-political themes. It thus echoes *rasa* theory's call for a need to present abstracted emotions that audiences can identify and empathise with at different levels, without completely losing themselves in them.

Therefore Khan not only injects the principle and practice of *abhinaya* into his aesthetic of new interculturalism, he simultaneously rewrites *abhinaya* and mutates it into a more productive and less limiting dramaturgical framework. Equally Khan opens up the remit of the *rasa* philosophy from its ancient Sanskritised context, and transforms it through his subjective interpretation of what it might mean to generate aesthetic distance through his own performance aesthetic. In his negotiation of *rasa* through deconstructing and finding innovative ways to use *abhinaya*, he embodies Avanthi Meduri's observation about the status of *rasa* in the practice of the contemporary secular South Asian dancer who is seeking ways for 'the power of manipulation to rest with her, and she is willing to take this responsibility' (Meduri 17). However, he still manages to sustain the fundamental principle of *rasa* as 'an intersubjective experience between spectator and artist', despite rewriting it for secular and contemporaneous contexts (Meduri 17).

His innovative experimentations with *abhinaya* and his intercultural channelling of *rasa* are thus important reminders that the *Natyashastra* is by no means a static and permanent dictate, but one that needs constant reconsideration in light of our current social milieu, in its call to create art that mirrors and comments upon today's society. They are also strategically considered and implemented postcolonial interventions through which Khan encounters, interacts with and represents othernesses as complex and rich conditions in his art, from his own perspective as an other. By mastering the art of unapologetically deploying codes of alterities, Khan's new interculturalism has evolved into a brand that thrives on being both familiar to and distant from his audiences. And if whiteness is just as much an other to him as other forms of alterities, then an analysis of *Dust* (2014), Khan's most recent performance and a choreographic commission by the English National Ballet,

is an appropriate note on which to conclude this monograph, vis-à-vis
Khan's attempt to rewrite the codes of ballet, a classical form that is as
white, elitist and other as it gets from his own lived reality.

Khan, the English National Ballet and *Dust*

The English National Ballet (ENB) describes itself as 'a bold company of
ambitious dancers, choreographers, costumiers, musicians and design-
ers' that 'performs ballet anywhere' (ENB Website). Citing its artistic
director, the internationally renowned ballerina Tamara Rojo, as pivotal
to its dynamic and contemporary vision, the company claims to 'reach
for innovative collaborations, creative excellence and bold ways of
honouring, but adding to, traditional ballet' (ENB Website). Rojo herself
emphasises her vision for ENB by focusing on innovation in order to
enrich the vocabulary of ballet, so that it does not stagnate as preserved
and frozen, but evolves as a living and contemporaneous art form. To
achieve this she wishes to commission choreographers who are not
necessarily associated with the classical ballet world, in order to create
choreographies for classically trained ballet dancers. Rojo is curious to
witness and nurture the results of such experimentations, despite being
aware of classicist criticism towards such innovations. She cites the
company's recent production of *Lest We Forget* (2014), a centenary com-
memoration of the First World War, as integral to achieving this vision.
Lest We Forget is the result of Rojo commissioning three new pieces
by choreographers Liam Scott, Russell Maliphant and Khan, who she
believes represent the cutting edge in their respective fields, despite –
and indeed because of – covering such a range of choreographic styles.[2]
It is significant that Rojo herself performs with Khan in *Dust*, thereby
being an intrinsic and embodied part of the company's innovations and
'leading from the front as its big-draw dancer' (Winship). Rojo notes
further that, of these pieces, the impact of Khan's *Dust* is by far the most
potent in terms of its repercussions on both ballet audiences and the
ballet vocabulary itself (Rojo, Interview). On being asked why she chose
Khan for one of the commissions, Rojo responds:

> I knew that Akram is a very dramatic artist, even though he does not
> always present a narrative [...] yet his work is incredibly theatrical.
> And I thought that for this epic First World War Memorial, I wanted
> one of the pieces to have that theatrical weight. I also really admire
> him and wanted to work with him. Sometimes it is as simple as that.
> (Rojo, Interview)

In recognising what Khan's aesthetic brought to ENB, Rojo reflects on his complex choreographic vision, which oscillates between the extreme precision and discipline of his classical *kathak* training and an innate desire to rebel against it:

> His own training as a classical *kathak* dancer underlies everything he does. From the way he approaches work, which is extremely disciplined, hard-working and always striving for excellence, for absolute precision, which is something that we don't achieve even in ballet as far as he does [...]. As well as his intrinsic necessity to rebel against it. So he is quite a complex choreographer. On one hand he wants that level of precision, on the other hand he wants you as an interpreter to come through it [...]. He doesn't settle for easy. (Rojo, Interview)

Rojo's instinctive and strategic decision to commission Khan's theatrical aesthetic for this heavy-themed centenary memorial event resonates in reviews by British dance critics. Zoe Anderson from the *Independent* claims, '*Dust* is superb, using weighted dance to evoke wartime experience and the changes it brings [...] It's dancing full of pain and power' (Anderson, 'Lest'). Judith Mackrell from the *Guardian* commends *Dust*'s simultaneous 'experiment and accessibility' and values its socio-political commentary on the role of women during the First World War, recognising that for Khan the 'chorus of women are warriors of the home front' (Mackrell, 'English'). Lyndsey Winship from the *Evening Standard* comments on the repercussions of this experiment on the ballet bodies of the company:

> The movement created by Khan [...] is worlds away from classical ballet and might come as a shock to audiences used to the princess and tutus of something like *Swan Lake*. It's also a new world for the dancers. There's not a pointe shoe in sight and lots of kneepads in action. As one dancer tells me, 'It's knocked everyone out of their comfort zones.' (Winship)

Rojo and Khan both acknowledge that there were tensions generated by this collaboration. Rojo admits that, through *Dust*, she came to realise that not all ballet dancers in ENB want to be challenged to reach within themselves to access deep and inner truths in the way she had assumed they would. And it is with these dancers that the tension arose:

> So what do you do when a creator is pulling you very far and very fast and some dancers just don't want to go there? (Rojo, Interview)

Khan admits that his choreographic vocabulary and vision are deemed by some from within and outside of ENB to 'poison the ballet world' (Khan, Interview 2). This poisoning is generated by introducing new information to ballet bodies, and artistically counselling them to process the newness and countering their instinct to reject it. Rojo echoes Khan's thoughts and admits that some of the ENB dancers failed to process this newness, while others thrived in Khan's vision.

Those ballet dancers who thrive in *Dust* and who take on 'Khan's contemporary style with devoted care' have to renegotiate their relationship with gravity (Anderson, 'Lest'). No longer in pointe shoes, they have to embrace a grounded relationship with the floor in a way that is fundamentally alien to their own training. Whilst a ballet dancer's centre is located in the solar plexus, and they must make a relentless effort to appear to defy gravity, Khan's vocabulary lowers their centre of gravity into their pelvis, placing high-density pressure on their thighs and gluteal muscles. Instead of the straightened and lengthened ballet spine, Khan requires his dancers to round their backs into long periods of Grahamesque contractions without corresponding releases. These fundamental kinaesthetic changes in the bodies of the ballet dancers create a very different relationship to feeling and communicating emotions.

No longer reliant on mimetic codes of enacting emotional content in relation to ballet narratives, Khan's aesthetic enables the dancers to feel an emotional charge through both weighted thematic content and the actual kinaesthetic sensation of performing powerful movements. Moreover *Dust*'s rejection of a classical ballet narrative in favour of 'the first world war [...] a narrative that runs as deep in [...] audience's folk memory as any classic fairytale' is instrumental in making ballet speak of and to social issues that continue to resonate (Mackrell, 'English'). But most importantly, Khan's othering of the ballet world brings about a fundamental shift from perceiving ballet bodies as virtuosic choreographic tools to valuing them as emotive interpreters of choreographic vision. This shift grounds ballet dancers in reality and makes them more accessible and tangible within the contemporary populist milieu, enabling Mark Savage's unlikely proclamation in the *Guardian* – 'ballet makes Glastonbury debut' – a reality (Savage).[3] Thus Khan, enabled by Rojo's vision, not only contemporises ballet by releasing it from the realms of a frozen art form, but also dismantles its elitist associations by taking the ENB to the infamous Pyramid Stage at Glastonbury Music Festival 2014, and thus into the heart of what has become Britain's most popular and mainstream music festival.[4]

Dust[5]

Dust is the fourth and final piece in *Lest We Forget*'s quadruple bill. It follows renowned contemporary choreographer Russell Maliphant's formalist experimentations in *Second Breath*, which also rejects pointe shoes and enters his dancers into a relationship with gravity that oscillates between defiance and compliance. But if Maliphant hints at the dancers' groundedness, Khan roots them in a profound weightedness that is at once tangible and epic.

The piece begins in darkness that seems to last forever, until very gradually a dim spotlight illuminates a hunched over inhuman figure centre stage. The figure faces backstage and its bare back twitches erratically as though its movements are involuntary, unpredictable and beyond the control of the body they emanate from. The twitching back develops into a writhing body which hits the ground with a painful thud, emphasised by the stark silence that engulfs the space. The body is permanently contracted with no sense of release, alienated in and by its own embodied trauma.

As we continue to focus on this body, like an illusion that plays tricks with our mind a line of bodies appear right behind the figure on the floor and step into the light. They are dressed in identical, dull and dust-coloured full-length robes with the same fabric covering their heads. They appear to be simulations of each other; a mass of people sharing a common cause and experiencing a common trauma. They stare resolutely and powerfully into the dark and appear to leave a gap for the writhing body, to indicate perhaps it once belonged to the community who mourns its absence. Suddenly their stillness, punctuated by the silence, is broken, as they clap their hands and release from their fists a cloud of dust that colours their hands grey. Khan emphasises the significance of dust in this piece as a metaphor for the shedding of old skin to evoke new beginnings:

> One of the things I noticed in many of the images of war was people covered in dust. It's something like a skin, a snake that needs to be released in order for new life to start. (Ak. Khan, Interview 2)

This is not the first time Khan has used dust to evoke the boundaries between life and death. In *Abide with Me*, his choreography for London's Olympic Opening Ceremony, the ensemble similarly released dust into the air from their fists as a poetic reminder of what remains of human bodies in death. The writhing body of the figure on the floor is very

much reminiscent of such a process of self-renewal, painfully trying to release itself from within the dust of its old skin to allow a new life to emerge. Juxtaposed against this, the community stand in a military-like straight line, straining their dust-ridden grey palms open and raising them into the shaft of light as though in resignation to their fates. This simple and evocative gesture of the open palms will return to haunt the piece later, carrying the intrinsically opposite signification of power and resistance. The writhing body is suddenly encapsulated by the community from two ends as they face him in order to manipulate him into a machine-like existence, their joint limbs rippling through the air. We realise this figure is a man, broken from the repercussions of war and the changes it has brought into his life and community.

The community peels away seamlessly to leave a woman, Rojo, facing the man, Khan. They stare resiliently at each other wanting to touch, but resisting their urges. They know full well the painful parting that lies ahead when Khan has to leave Rojo to serve his nation in the war. A percussive rhythm accompanies Rojo and Khan's confrontational, passionate and angry duet through which they push each other away as much as they hold each other tight, caught up in the tension between togetherness and the isolation that is to follow. Khan gradually disappears along with the other men of the community beyond the trenches, leaving Rojo behind to fend for herself and the nation.

Khan's emancipatory vision of the women left behind is refreshing as he recognises that in creating a commemorative piece about the First World War he 'didn't want to show the men dying in the trenches [...] but [...] wanted to reflect that even though people are dying, the women working in the factories have to build weapons for the war' (Ak. Khan, Interview 2). This harsh and ironic reality, of being complicit in producing the resources that fuel the very atrocities that take the lives of lovers, fathers and sons, is captured by Khan in depicting the women as possessed and powerful entities, who carry out their duties towards the nation with chilling precision and resilience. Their movements are bold, powerful and in unison, and slice through the air with as much hatred as efficiency, keeping the war resourced and functioning. Khan emphasises their arms in a way similar to *kathak*'s use of punctuated limbs, but replaces its delicacy and subtlety with a tremendous weightedness and punch. The most gripping moment of this ensemble section is when the women rise on their bare toes as if to defy gravity and as though on pointe shoes. Khan exposes the impossibility of such a task by emphasising the precariousness of these women as they teeter on their toes fighting hard to retain their balance. This image emphasises

their surface strength and superhuman resilience that is really a veneer for the utter fragility beneath.

At the end of this shockingly powerful and hard-hitting unison sequence where, unlike the principal dancer in a ballet ensemble, Rojo is in no way singled out and very much appears to be one of the female community, Khan returns broken from war and stands before her. He looks imploringly at her for support and acceptance despite everything that has passed in the time they were apart. Rojo walks slowly towards Khan and holds out her palms in the same outstretched manner we have seen before. Khan's fingers meet hers, but there is no charge left in the contact. To the haunting and evocative lyrics of 'Should Auld Acquaintance Be Forgot' what follows is a painful and traumatic exchange between a couple whose once charged intimacy has been tainted and changed forever by the traumatic experiences of war, and who as a result have nothing left in common except for a nostalgic longing for their past. This, they realise, is just not enough. Rojo and Khan's unconventional *pas de deux* is danced for the sake of their past, and rewrites the rules of this romanticised convention in several ways. Whereas in ballet conventions, the female ballerina is exhibited as a virtuosic object of desire by her male partner, Rojo and Khan's exchange is an internalised embodiment of extreme angst at the unattainable nature of their past relationship, degenerating through circumstances completely beyond their control. And while they share each other's weight with equal prowess and emotional charge, making their duet anything but romantic, Rojo remains resilient and offers strength to Khan's vulnerability. Their movements oscillate violently between the comforting, the confrontational, the edgy and the unfamiliar as they desperately try to process how their complicité has lost its past charge. They share one final intimate encounter of both anger and passion, which fails to provide a sense of resolution for either of them. Using the same strained open palms, Rojo finally pushes Khan violently away from her and turns her back to him, making a conscious choice to move forward on her own, without him by her side. As Rojo self-sufficiently dances a formal waltz without the need for a partner, Khan processes her rejection as he painfully withdraws from their past and retreats back into the trenches, into the lap of the war that has reaped devastation in his life. By foregrounding *Dust*'s narrative in the strength of womanhood as a self-sufficient entity, Khan's othering of ballet can also be read as a feminist intervention to an art form that has historically objectified women as submissive objects of male desire.[6]

Through *Dust* Khan thus confronts the otherness of ballet through the otherness of his aesthetic of new interculturalism. On one hand he manages to destabilise classicist ballet audiences by taking them out of their comfort zones. On the other he simultaneously creates new audiences for ballet by making the art form speak to and of the contemporary milieu. He treats the ballet vocabulary with reverence in valuing its inherent discipline and rigour. However, he simultaneously strips it of its intrinsic conventions such as corsets, pointe shoes and the heteronormatively gendered *pas de deux*. In encountering and working through Khan's new interculturalism the art of ballet has the potential to lay to rest its reputation as static, frozen and elite, and fundamentally transform into an intercultural form. Rojo and ENB have registered the impact of *Dust* on the ballet world and its potential to make ballet speak to contemporary and once alienated audiences. Consequently they have decided to appoint Khan an associate artist of the company with a view to not only commissioning him to make new work with ENB dancers, but also entrusting him with the responsibility of reviving renowned classical ballets such as *Giselle* through his unique lens and practice of new interculturalism. ENB's partnership with Sadler's Wells from 2015 further signals this important blurring of the classical and contemporary dance worlds. As the first ballet company to become a Sadler's Wells associate company, ENB's vision of making ballet reach out to wider audiences is clear and crystallised in the formalisation of the relationship between the company and Khan. But the collaboration between Khan and ENB signifies much more than bringing ballet to contemporary and uninitiated audiences. It suggests that Khan's new interculturalism has arrived full circle as he layers the codified principles of one classical dance world (*kathak*) onto the unfamiliar and othered landscape of another codified classical dance world (ballet). *Dust* thus represents a mere glimpse of not only the interventionist potential that lies in the encounter between Khan's new interculturalism and classical ballet, but also what this exchange might mean for the contemporary dance world at large. Furthermore, by starting to straddle multiple art worlds, the most recent venture being his first attempt as a curator for a visual arts exhibition, *Akram Khan – One Side to the Other* (2014), at the Lowry in Manchester, Khan's new interculturalism is starting to find multidisciplinary manifestations. Whether this dilutes its charge or intensifies it remains to be seen. But what is already evident is the significant widening of the body of people who are encountering and interacting with his new interculturalism.

New interculturalism and the emancipated spectator

As a first-generation diasporic Indian living in Britain but straddling national and cultural spaces between India, Britain and America, critical theory-driven spaces between postcolonial studies, cultural studies and dance studies, disciplinary spaces between theatre and dance, and articulative spaces between scholarship and education, I share with Khan the same experience of multiple reference points that inform my own identity positions and my ways of seeing the world. I now understand why watching Khan negotiate his multiple affiliations in *Polaroid Feet* had such an impact on me over a decade ago. Empowered by the French philosopher Jacques Rancière's seminal framework of the 'emancipated spectator' I realise that I am as implicit in theorising Khan's new interculturalism as he is in embodying and practising it in his art. I am that spectator:

> The spectator also acts [...]. She observes, selects, compares, interprets. She links what she sees to a host of other things that she has seen on other stages, in other kinds of places. She composes her own poem with the elements of the poem before her. (Rancière 13)

Watching *Polaroid Feet* through my embodied, complex, diasporic reality as a former *kathak* dancer, I was able to compose a poem of my own existence through the poem that Khan painted so eloquently and poignantly of his own lived realities. This emancipated me. Khan's reliance on his audience to function as the final pieces of the jigsaw, concluding the signification process of his art, has allowed me to reassess my own embodied interactions with alterities in the world we both inhabit. This echoes Marsha Meskimmon's crucial observation about the role of intercultural artists like Khan in engendering through their art an important shift from perceiving artworks as objects that reveal critical issues about the world they inhabit, to enabling audiences to consider ways in which they can participate in and potentially transform the boundaries through which they interact with and negotiate this world (Meskimmon 6).

Over the years, as my own points of reference have multiplied and my own lived realities developed more and more complexities, I have continued to experience Khan's art through these multifarious access points. I came to recognise that I am amongst the very few members of Khan's audiences who are privy to some of the othered layers of significations in comparison to his largely white and Western audiences,

because of the number of commonalities I share with his lived reality. These shared reference points enable me to access, interpret and read Khan's aesthetic of new interculturalism at multiple dimensions. In the spirit of *rasa* theory, Khan never instructs his spectators but simply produces in them 'a form of consciousness, an intensity of feeling, an energy for action' that energises and brings into consciousness our own embodied realities (Rancière 14). The more complex and aligned our realities are to Khan's, the closer we can come to his art. This book is thus the result of the ideological transactions that have transpired between Khan's art and my own embodied realities, and 'is the third thing that is owned by no one, whose meaning is owned by no one, but which subsists' between Khan's knowledge, inspirations, lived realities, multiple affiliations and my own (Rancière 15).

That Khan's presence in British and global contemporary culture has significantly challenged pre-existent frameworks, ideologies and perceptions of both whiteness and diasporic South Asianness, and has irrevocably altered the landscape of global contemporary dance, is now an undeniable reality. What is less considered is the emancipation his art can offer to both contemporaneous and future generations of artists, in their individual quests to articulate their own complex, syncretic, volatile and transient embodied realities. For them I offer my conceptualisation of Khan's new interculturalism.

Appendix: List of Performances by Akram Khan Company

1999 *Loose in Flight.* Directed by Akram Khan and Rachel Davies. Performed by Akram Khan. Broadcast by Channel 4 Television in September 1999.

1999 *Duet.* Directed by Akram Khan and Jonathan Burrows. Performed by Akram Khan and Jonathan Burrows. Premiered on 14 July 1999 at Queen Elizabeth Hall, London.

2000 *Loose in Flight.* Directed by Akram Khan. Performed by Akram Khan. Premiered on 11 March 2000 at Tron Theatre, Glasgow.

2000 *Fix.* Directed by Akram Khan. Performed by Akram Khan. Premiered on 11 March 2000 at Tron Theatre, Glasgow.

2000 *Rush.* Directed by Akram Khan. Performed by Akram Khan, Moya Michael, Gwyn Emberton/Inn Pang Ooi. Premiered on 5 October 2000 at Midlands Arts Centre, Birmingham.

2001 *Polaroid Feet.* Directed by Akram Khan. Performed by Akram Khan. Premiered on 8 April 2001 at Purcell Room, London.

2001 *Related Rocks.* Directed by Akram Khan. Performed by Akram Khan, Rachel Krische, Moya Michael, Inn Pang Ooi, Shanell Winlock. Premiered on 9 December 2001 at Queen Elizabeth Hall, London.

2002 *Kaash.* Directed by Akram Khan. Performed by Akram Khan, Rachel Krische, Moya Michael, Inn Pang Ooi, Shanell Winlock. Premiered on 28 March 2002 at Creteil, France.

2003 *Ronin.* Directed by Akram Khan and Gauri Sharma Tripathi. Performed by Akram Khan. Premiered on 11 April 2003 at Purcell Room, London.

2004 *ma.* Directed by Akram Khan. Performed by Akram Khan, Eulalia Ayguade Farro, Anton Lachky, Nikoleta Rafaelisova, Shanell Winlock. Premiered on 28 May 2004 at Singapore Arts Festival, Singapore.

2005 *Zero Degrees.* Directed by Akram Khan and Sidi Larbi Cherkaoui. Performed by Akram Khan and Sidi Larbi Cherkaoui. Premiered on 8 July 2005 at Sadler's Wells, London.

2006 *Sacred Monsters.* Directed by Akram Khan. Performed by Akram Khan and Sylvie Guillem. Premiered on 19 September 2006 at Sadler's Wells, London.

2008 *In-I.* Directed by Akram Khan and Juliette Binoche. Performed by Akram Khan and Juliette Binoche. Premiered on 18 September 2008 at Lyttleton, National Theatre, London.

2008 *Bahok.* Directed by Akram Khan. Performed by Eulalia Ayguade Farro, Young Jin Kim, Meng Ning Ning, Andrej Petrovic, Saju, Shanell Winlock,

Wang Yitong, Zhang Zhenxin. Premiered on 25 January 2008 at Tianqiao Theatre, Beijing, China.

2009 *Confluence*. Directed by Akram Khan and Nitin Sawhney. Performed by Akram Khan, Nitin Sawhney, Eulalia Ayguade Farro, Konstandina Efthymiadou, Young Jin Kim, Yen Ching Lin, Andrej Petrovic. Premiered on 27 November 2009 at Sadler's Wells, London.

2010 *Gnosis*. Directed by Akram Khan. Performed by Akram Khan and Yoshie Sunahata/ Fang-Yi Sheu. Premiered on 26 April 2010 at Sadler's Wells, London.

2010 *Vertical Road*. Directed by Akram Khan. Performed by Salah El Brogy, Konstandina Efthymiadou, Eulalia Ayguade Farro, Ahmed Khemis, Young Jin Kim, Yen Ching Lin, Andrej Petrovic and Paul Zvkovich. Premiered on 16 September 2010 at Curve Theatre, Leicester.

2011 *Desh*. Directed by Akram Khan. Performed by Akram Khan. Premiered on 15 September 2011 at Curve Theatre, Leicester.

2013 *iTMOi*. Directed by Akram Khan. Performed by Kristina Alleyne, Sadé Alleyne, Ching Ying Chien, Denis 'Kooné' Kuhnert, Yen Ching Lin, TJ Lowe, Christine Joy Ritter, Catherine Schaub Abkarian, Nicola Monaco, Blenard Azizaj, Cheng-An Wu. Premiered on 14 May 2013 at MC2, Grenoble, France.

2014 *Dust*. Directed by Akram Khan. Performed by Akram Khan, Tamara Rojo and English National Ballet. Premiered on 2 April 2014 at Barbican Theatre, London.

2014 *Torobaka*. Directed by Akram Khan and Israel Galván. Performed by Akram Khan and Israel Galván. Premiered on 2 June 2014, at MC2, Grenoble, France.

Notes

Preface

1. In 2005 Khan was appointed associate artist at Sadler's Wells, London's premiere contemporary dance venue. In 2006, already a lecturer at the University of Wolverhampton for five years, I started my doctoral research at Royal Holloway, University of London.
2. It is worth noting that while at university my own performance training began to encounter nearly as eclectic a range of movement languages as Khan's training at the Northern School of Contemporary Dance, as discussed in detail in Chapter 1.
3. Nearly a decade later *Polaroid Feet* became the basis of the classical half of *Gnosis* (2010), which I examine in detail in Chapter 2.

Introduction

1. I note here that my analysis of *Abide with Me* rests on the live television relay of the Opening Ceremony on the evening of Friday 27 July 2012.
2. This is not the first time that a host nation has referenced the threat of global terrorism and its impact upon their national identity in their Opening Ceremony for the Olympics. Analysing the staging of national identity in Olympic Opening Ceremonies, sociologist Jackie Hogan argues that the USA's hosting of the Games in Salt Lake City (2002) clearly referenced potent nationalist symbols that were deployed to signal the nation's position on the 'War on Terror' in the wake of 9/11. These included the battered flag that flew on the World Trade Centre, the national anthem alongside a ubiquitous presence of the US military and police forces as a warning to future perpetrators. Britain's tribute to the victims of 7/7, however, was a celebration of the value and humility of life. This difference in approach between the USA and Britain to very similar national tragedies may well explain why NBC, the American television network exclusively responsible for broadcasting the Olympics, chose not to include Khan's section of the Opening Ceremony. This segment was replaced with an interview with the American Olympic champion Michael Phelps by the *American Idol* host Ryan Seacrest. Defending NBC's decision to edit Khan's performance out of their broadcast, Greg Hughes, NBC's sports spokesman claimed that the Olympics programme had not given any clear indication that Khan's segment was a tribute to the 7/7 victims and that editorial decisions had been driven by the need to tailor the broadcast for the US television audience.
3. The role of the Boy was performed by Reiss Jeram, a nine-year-old British-Asian boy of Indian descent who auditioned for the part and was selected by Khan himself.

4. In an email exchange between Reiss Jeram and myself, as mediated by his mother, Sonal Jeram, Reiss recognised the intergenerational nature of his relationship with Khan in the *Abide with Me* section as that of a father and son. He went on to say that the piece was driven by the fear of letting go of loved ones as demonstrated in his need to hold on to Khan.

5. In the *Mahabharata* Ekalavya is a young, low-caste prince who is denied the tutelage of the great sage Drona to train as a warrior. Ekalavya tutors himself in the presence of a clay-statue of Drona and believes he is still guided by Drona's blessings. Years later, when Drona encounters Ekalavya's superior skills at warfare, he demands *gurudakshina* (a tutor's fee) by asking Ekalavya to cut off his right thumb. Ekalavya promptly does so, demonstrating his loyalty and respect for the devious Drona, whose intention is to taint Ekalavya's skill and destroy his future chances of becoming a superior archer.

6. It is interesting to note that Sonal and Dinesh Jeram, the parents of Reiss Jeram who plays the Boy, recognise that Reiss's role in *Abide with Me* can be read as a younger Khan. And that the interactions between Khan and Reiss symbolise Khan's own tensions and struggles while growing up as a diasporic subject caught between multiple identity-positions and negotiating for himself what to hold on to and what to let go of, to shape his own destiny.

7. Over the years the term diaspora has shifted from being associated with a group of people who are dispersed from their homelands to, firstly, a condition that permeates the experience of migrancy in a host culture; secondly a cultural and (maybe) artistic identification process through which these experiences are articulated; and finally to the field of study that enquires into this immigrant experience and its articulations. For an excellent overview of these multiple associations of the term, please see the article 'Theorising Diaspora: Perspectives on "Classical" and "Contemporary" Diaspora' by Michele Reis.

8. For scholarship on *kathak* please see *Bells of Change* by Pallabi Chakravorty, 'Courtesans and Choreographers: The (Re)Placement of Women in the History of Kathak Dance' by Margaret Walker, 'Transcending Gender in the Performance of Kathak' by Purnima Shah, and *India's Kathak Dance – Past, Present, Future* by Reginald Massey.

9. The *Natyashastra* is believed to have been written over a long period of time between the sixth century BC and the second century AD. While its authorship is popularly attributed to Bharata, scholars have suggested that the name of Bharata has come to stand for an oral tradition generated over several centuries and by several authors (Vatsyayan, *Bharata* 5–6), in keeping with a long tradition of anonymity of authors as evidenced by historical Indian texts, and a 'self-conscious transcendence of self-identity' (Vatsyayan, *Bharata* 2).

10. While Burt aims these views at his analysis of *Kaash* (2002), I believe they are just as applicable to Khan's oeuvre as a whole.

11. It is important to note here that while examples of intercultural theatre do exist where non-Western practices have been influenced by Western performance principles and traditions, giving rise to forms that are born out of such dialogues, like Japanese Butoh or Indian *kathakali* production of Shakespeare plays, somehow, historically, these examples have not been considered as part of the discourse on intercultural theatre in quite the same way as Western experimentations with non-Western cultures and traditions.

12. Such celebratory reviews continue into more recent times. Even in 2006, Milly S. Barranger wrote that '[Brook's] efforts to transform a Hindu myth into universalized art, accessible to any and all cultures, are triumphant' (Barranger 234). Barranger uses problematic and long-challenged terminology like 'Eastern' theatre and 'Eastern' martial arts to commend Brook's use of traditional art forms to depict a sense of universalism within *The Mahabharata*.

13. In claiming that the *Mahabharata* is a primarily Indian text Bharucha seems to not fully acknowledge those other South Asian and South East Asian countries like Sri Lanka, Thailand and Indonesia whose cultural histories have not just borrowed the Indian epic, but are just as intrinsically informed by it, and whose performance traditions continue to narrate stories from the epic in locally specific ways. Thus, to regard the epic as primarily belonging to India, as a lot of scholars do when critiquing Brook's *The Mahabharata*, is an idea that needs loosening. I clarify here therefore that while I continue to use India and Indian culture in my terminology when discussing the epic because of referencing scholars whose analysis is located from within India, I acknowledge through these terms a wider reach of the epic and its impact on other South and South East Asian cultures.

14. Anthony Giddens distinguishes between pre-modern and late-modern relationships to the role of tradition in shaping social interactions and identity constructions (Giddens, 'Living'). He proposes that while, in the pre-modern era, a lack of choice meant conforming to tradition, leading to a dominance of collective identity, in late modernity the focus shifted to individual identity construction through challenge to norms and traditions. Giddens refers to the latter form of sociality as a 'post-traditional society' where the individual is free to construct oneself as desired, without subscribing to formulaic norms and specificities. The breakdown of tradition has generated for individuals an abundance of choice and the relative free will to decide how they wish to construct their sense of self 'amid a puzzling diversity of options and possibilities' (Giddens, *Modernity* 3). Giddens suggests that such choice leads to a self-reflexivity in identity constructions in the post-traditional society.

15. Alongside bringing world dance companies to London, Sadler's Wells is also patron to sixteen Associate Artists and Companies including Ballet Boyz, Matthew Bourne, Sidi Larbi Cherkaoui, Jonzi D, Sylvie Guillem, Russell Maliphant, Wayne McGregor, Nitin Sawhney, Jasmin Vardimon, Hofesh Schechter and Akram Khan, who it supports by commissioning new work and providing resources, technical expertise and office spaces.

16. While this book examines seven pieces from Khan's extensive repertoire, I have included a list of his entire trajectory so far in the appendix to provide chronological context to my choices. For a fuller summary of Khan's oeuvre please see Stacey Prickett's entry, 'Akram Khan', in *Fifty Contemporary Choreographers* (2nd Edition).

1 Khan's Body-of-Action

1. Khan's biographical details are collated from the following key sources: 'An Artistic Journey' by Lorna Sanders, available on the Akram Khan Company website, and from interviews conducted by myself with Akram Khan and

his mother Anwara Khan in July 2009. These are referenced in the text as (Sanders, 'Akram'), (Ak. Khan, Interview) and (An. Khan, Interview) respectively. Interviews with Khan available in the public domain in newspapers and video clips also inform this biographical narrative and have been specifically referenced as such.

2. For a detailed history of Bangladesh please see William van Schendel's *A History of Bangladesh*.
3. The British genre of physical theatre has a long-contested genealogy. Franc Chamberlain suggests that there are two lineages to the genre: first is the mime tradition as developed in the practice of Copeau, Decroux and Lecoq, and the second is the aesthetic embodied in the practice of the British company DV8 Physical Theatre's challenge to contemporary dance (Chamberlain 119). Simon Murray and John Keefe situate its multi-lineaged history in the experimental theatre practice of Grotowski in the late 1960s, in Steven Berkoff and his Lecoq-inspired aesthetic in the 1970s, and finally in DV8 Physical Theatre, signalled in their endorsement of the label in its company name in 1986 (Murray and Keefe 14). To deliberately not emphasise one of these lineages over others, Murray and Keefe champion a pluralistic approach to the genre by claiming for physical theatres or the physical in theatres (Murray and Keefe 1). Such a broad remit for engaging with the genre is inherently problematic as it fails to consider the genre as a hybridised aesthetic that has emerged at the interstices between the disciplines of dance and theatre. Instead of seeing the experimentations in these disciplines as parallel and co-existing practices, Ana Sánchez-Colberg's approach identifies a commonality between them. This enables her to frame the genre of physical theatre as an interdisciplinary and hybrid entity between dance and theatre.
4. I acknowledge here that Janet O'Shea notes that Jeyasingh's work does generate a certain kind of signification through a newly negotiated nexus of signs and their interplay through the use of body, space and technology. However, I would contend that this level of signification is not narrative-driven as in the case of Khan's aesthetic.
5. In a publication entitled 'Performing Cultural Heritage in "Weaving Paths" by Sonia Sabri Dance Company', I have examined what Sabri means by taking *kathak* to new spaces, contexts and audiences by analysing her site-specific project 'Weaving Paths', which was created in response to and performed within Bantock House, an Edwardian manor house in Wolverhampton, UK.

2 Corporeal Gestures in *Gnosis* (2010)

1. *The Mahabharata* was created originally in French, premiering at the Avignon Festival in 1985. However, this chapter will focus primarily on the English version.
2. I must emphasise here that by pointing out Bharucha's Indian-centric discussions of the epic, I am not aligning him with the Hindutva philosophy.
3. While Margaret Jolly writes about motherhood in colonial and postcolonial contexts in South Asia itself, a lot of her material is equally applicable to the conditions that governed motherhood amongst the South Asian diaspora.

4. In the first tour of *Gnosis*, Gandhari's role was performed by the Japanese taiko drummer and dancer Yoshie Sunahata. In the subsequent tour, Sunahata was replaced by the Taiwanese dancer Fang-Yi Sheu. However, my analysis of *Gnosis* rests on the first version, which I saw live, and therefore refers to Sunahata throughout as Gandhari.
5. In frustration Gandhari is believed to have beaten her womb with a rod, from which emerged a hardened mass of grey-coloured flesh. To console her from devastation, Vyasa, the sage and author of the epic, divided the ball of flesh into one hundred equal pieces, and put them in pots which were sealed and buried in the earth for one year. At the end of the year, the first pot was opened and Duryodhana emerged.
6. I note here that while Margaret Trawick's ethnographic study focuses on the different displays of love in a Tamil family from the south of India, it is also relevant in most South Asian contexts because the significance and valued status of a mother's love for her son is shared across most South Asian cultures (Mandelbaum, Haddad, Zaman, Bhopal and others).
7. Yvonne Yazbeck Haddad has written on the relationship between mother and son in Islamic South Asian contexts.
8. In Hindu philosophy the related concepts of *dharma* and *karma* refer, respectively, to every human being's duty-bound path in their present life to determine their fate in the next. It is through observing a righteous life of good morals, led by observing *dharma*, the cosmic laws that govern our actions, that our actions, our *karma*, are judged and evaluated to determine our fate in our next incarnated form.

3 Auto-ethnography and *Loose in Flight* (1999)

1. I acknowledge here that, as discussed in Chapter 1, Khan and his family do not represent the deprived Bangladeshi migrant population who are residents of East London, and whose lives were arguably marginalised by the regeneration of the Docklands region. I propose instead that Khan's relationship to and reclamation of this landscape becomes symbolic of an alternative kind of migrant reality that may not be deprived, but none-the-less seeks articulation and representation in mainstream culture.
2. It is important to note also that Rachel Davies, who created the film in collaboration with Khan, also made another dance-film for the *Per4mance* series called *Khooyile* in collaboration with another male South Asian dancer, Mavin Khoo. This further emphasises the proactive promotion of contemporary South Asian culture within the public domain by the Labour government supported by its policies on multiculturalism.
3. This information on the making, broadcasting and exhibition contexts for the dance-film *Loose in Flight* has been obtained from the website of Rachel Davies and also the British Film Institute (BFI) website.
4. This segregation of the upper and lower body is reminiscent of some sections of *abhinaya* in *kathak* recitals where, while the feet and the lower body remain mostly static, the upper body, arms, hands and facial expressions deliver meaning through mobile and codified gestures.

4 Third Space Politics in *Zero Degrees* (2005) and *Desh* (2011)

1. A *dhoti* is a traditional garment worn by men in some parts of South Asia, particularly in West Bengal in India and in Bangladesh. It is a long, rectangular piece of unstitched fabric that is worn in different ways on the bottom half of the body, depending on which part of South Asia one is from. In *Desh* Khan's *dhoti*-like trousers are reminiscent of the way a traditional *dhoti* is worn in both West Bengal and Bangladesh. This is an important visual reminder that despite distinct national narratives Bengalis from both India and Bangladesh share a common cultural heritage and social practices.
2. Kantor was inspired by Edward Gordon Craig's call for the replacement of the live actor with the 'über marionette'. However, he believed that the solution was not to replace the live actor but to enhance his presence and inject 'life' into him by juxtaposing him against an inanimate and 'dead' replica of him in the form of a mannequin. His piece *Dead Class*, created in 1975, made use of live actors alongside mannequins in interaction with each other. The latter represented dead manifestations of students and through them the live students confronted their dead selves.

5 Mobility and Flexibility in *Bahok* (2008)

1. I conceptualise this idea of flexibility in dialectic with dance scholar Anusha Kedhar's doctoral thesis entitled 'On the Move: Transnational South Asian Dancers and the "Flexible" Dancing Body'. In her thesis Kedhar deploys the term flexible to evoke a need for British South Asian dancers to be adaptable in their skill sets and practices in order to 'negotiate the effects of globalization on their dance practices, work, careers, and bodies' to reconcile the different tensions between 'the global, the national, and the local in and through dance' (Kedhar vi). She further argues that global late capitalism has not just created 'flexible citizens' but also 'flexible bodies' (Kedhar vii). I concur with Kedhar's position and propose that late capitalism and globalisation has triggered flexibility as both a conscious and strategically discerning set of artistic choices (as argued by Kedhar), and an organic and embodied living condition amongst artists like Khan, triggered by their multistitial embodied realities.
2. In a DVD on the making of *Bahok* entitled *Bahok: Lettres sur le Pont*, Khan reveals that the piece went through several working titles before settling on *Bahok*, which was suggested to him by his mother. He listed them chronologically as *Built to Destroy*, *Bridges* and *Nomads*.
3. NBC was founded in 1959 and prides itself on being 'the only Chinese national ballet' (NBC website). Its artistic mission is twofold. Firstly it wants to promote Western classical and contemporary ballet to Chinese audiences. And secondly it wants to explore the 'unique fusion possible between classical ballet and Chinese culture' (NBC website). *Bahok* is proclaimed as NBC's first ever dialogue with the language of contemporary dance.

4. I use the adjectival term nomadic to conjure lives that are shaped by itinerancy and relentless relocations driven by choice and finances, and delineate it from the richly theorised condition of nomadism as pertinent to the lives of nomads whose reasons for travelling and settling over and over again do not stem from either privilege or choice . While I acknowledge that apart from the actual reality of endless travel and resettlements there is perhaps little in common between the lives of Khan's nomadic subjects in *Bahok* and nomads themselves, I am drawn to their subversive potential vis-à-vis the social spaces and structures that they infiltrate and transform as a result of their temporary presence. My considered choice to deploy the term nomadic therefore signals this subversive quality in both groups, without suggesting that Khan's nomadic subjects in *Bahok* are indeed the same as nomads.
5. Fraser cites Graham Marsh's formulation of the *community of circumstance* in her study of communities.
6. *Kalaripayattu* is a martial art form originating in the southern Indian state of Kerala which has received recent attention in Western performance studies scholarship in the study by Phillip Zarrilli entitled *When the Body Becomes All Eyes: Paradigms, Discourses and Practices of Power in Kalarippayattu, a South Indian Martial Art Form*. Zarrilli writes about the value of employing this somatic art form as the foundation of Western actor training and uses this as the basis of his own practice. Characterised by athleticism, flexibility, clean straight lines, impossibly high leaps and deep centred lunges, *kalaripayattu* is energising and meditative, engendering a body that is both supple and compliant while being simultaneously grounded and focused. It is often used as part of the training regime for other south Indian classical dance forms such as *kathakali*.
7. During the course of the piece the digital noticeboard shifts from displaying clinical instructions such as 'PLEASE WAIT', 'DELAYED' and 'RESCHEDULED' to being used as a translation medium for the story that the South Korean man recalls of home. In this final scene, the noticeboard takes on the role of a commentator that communicates directly with the travellers.

6 Queering Normativity in *iTMOi* (2013)

1. I acknowledge here that the presence of male *gurus* in *kathak* is only unusual in the diasporic context where the majority of *gurus* tend to be women. In India, however, *kathak* still continues to be taught by male *gurus*.
2. I have analysed the choreographic strategy of non-touch in the work of the late Indian choreographer Chandralekha as an empowering quality that operates beyond narratives of human sexualities by rejecting the titillation and objectification encoded by touch and moving towards constructing non-touch as an active sexual choice. Please see 'The Parting Pelvis: Temporality, Sexuality and Indian Womanhood in Chandralekha's *Sharira* (2001)' in the *Dance Research Journal* (2014). It is not a coincidence that Khan mentions Chandralekha as a choreographer who he is inspired by, and whose aesthetic stands apart from other South Asian dance artists as an embodied form of lived reality.

Conclusion

1. See Uttara Coorlawala's insightful article entitled 'Writing Out Otherness' and its examination of Khan's innovative movement vocabulary vis-à-vis its decontextualisation of *abhinaya* within his art, through an analysis of *Zero Degrees* and *Bahok*.
2. *Lest We Forget* comprised an evening of four pieces of which Liam Scott's *No Man's Land*, Russell Maliphant's *Second Breath* and Akram Khan's *Dust* were new commissions. The fourth piece was a revival of ENB associate George Williamson's award-winning production of *Firebird*.
3. Khan and Rojo do not perform in the Glastonbury version of *Dust*. Instead, ENB dancers and husband and wife duo James Streeter and Erina Takahashi perform the *pas de deux* at the end.
4. It is vital to note here that this is not the first time Khan has collaborated with the popular and mainstream. The first instance was Khan's choreography of 'Samsara' for the Australian popular singer Kylie Minogue in the 'homecoming' version of the Showgirl (2006) concert that marked her return to her illustrious career after her brief hiatus due to breast cancer treatment. I have written about this project in an article entitled 'Akram Khan Re-writes *Radha*: The "Hypervisible" Cultural Identity in Kylie Minogue's "Showgirl"'. The second was Khan's choreography for the televised advertisement of Yves Saint Laurent's (YSL) classic perfume Belle D'Opium (2010).
5. My analysis of *Dust* rests on the performance of the solo male dancer's role at the beginning by Khan himself and the *pas de deux* being performed by Rojo and Khan. However, in other versions, the principal solo male role is performed by Fabian Reimair and the *pas de deux* is danced by husband and wife duo James Streeter and Erina Takahashi.
6. See Susan Foster's 'Ballerina's Phallic Pointe' for a detailed discussion of the objectification of the female ballerina by the male dancer and for male desire.

Bibliography

Abbitt, Erica Stevens. 'Androgyny and Otherness: Exploring the West through the Japanese Performative Body'. *Asian Theatre Journal* 18.2 (2001): 249–256. Print.

Acocella, Joan. 'Secrets of Nijinsky'. *New York Review of Books*, 1999. Web. Accessed: 5 June 2014. <http://www.nybooks.com/articles/archives/1999/jan/14/secrets-of-nijinsky/>.

Akram Khan Company. 'Akram: A Short Biography'. Akram Khan Company Website, 2010. Web. Accessed: 5 April 2010. <http://www.akramkhancompany.net/html/akram_akram.htm>.

Alam, Jayanti. 'Gandhari, the Rebel'. *Economic and Political Weekly* 29.25 (1994): 1517–1519. Print.

Albright, Ann Cooper. *Choreographing Difference: The Body and Identity in Contemporary Dance*. Middletown: Wesleyan University Press, 1997. Print.

Anderson, Zoë. 'Akram Khan, Sadler's Wells, London'. *Independent*, 2010. Web. Accessed: 1 July 2010. <http://www.independent.co.uk/arts-entertainment/theatredance/reviews/akramkhan-Sadler's-wells-london-1957195.html>.

———. '*Lest We Forget*, Barbican, Dance Review'. *Independent*, 2014. Web. Accessed: 4 July 2014. <http://www.independent.co.uk/arts-entertainment/theatre-dance/reviews/lest-we-forget-barbican-dance-review-9235153.html>.

Anthias, Floya. 'New Hybridities, Old Concepts: The Limits of "Culture"'. *Ethnic and Racial Studies* 24.4 (2001): 619–641. Print.

Augé, Marc. *Non-Places: An Introduction to Supermodernity*. 2nd ed. London: Verso, 2008. Print.

Bagchi, Indrani, and Kounteya Sinha. 'We Want To Attract Brightest and Best to Britain: David Cameron'. *Times of India*, 2013. Web. Accessed: 10 March 2014. <http://timesofindia.indiatimes.com/world/uk/We-want-to-attract-brightest-and-best-to-Britain-David-Cameron/articleshow/25718406.cms>.

Ballard, Roger. 'The Emergence of Desh Pardesh'. Introduction. *Desh Pardesh: The South Asian Presence in Britain*. Ed. Roger Ballard. London: C. Hurst & Company, 1994. 1–34. Print.

Balme, Christopher. *Decolonizing the Stage: Theatrical Syncretism and Post-Colonial Drama*. Oxford: Oxford University Press, 1999. Print.

Banes, Sally. *Dancing Women: Female Bodies on Stage*. London: Routledge, 1998. Print.

Barranger, Milly S. *Theatre: A Way of Seeing*. 6th ed. Belmont: Thomson Higher Education, 2006. Print.

Barry, Peter. *Beginning Theory: An Introduction to Literary and Cultural Theory*. Manchester: Manchester University Press, 1995. Print.

Barthes, Roland. *S/Z*. Trans. Richard Miller. London: Jonathan Cape, 1975. Print.

———. 'The Death of the Author'. *Modern Criticism and Theory: A Reader*. 2nd ed. Ed. David Lodge and Nigel Wood. Harlow: Pearson Education Limited, 2000. 146–150. Print.

Beck, Ulrich. *Cosmopolitan Vision*. Cambridge: Polity Press, 2006. Print.

Benjamin, George. 'How Stravinsky's *Rite of Spring* Has Shaped 100 Years of Music'. *Guardian*, 2013. Web. Accessed: 5 June 2014. <http://www.theguardian.com/music/2013/may/29/stravinsky-rite-of-spring>.

Belle D'Opium by Yves Saint Laurent. 'The Artists'. *Belle D'Opium* Website, 2011. Web. Accessed: 7 March 2011. <http://belledopium.com/en_GB/artistes.html>.

Bhabha, Homi K. 'The Commitment to Theory'. *New Formation* 5 (1988): 5–23. Print.

———. *The Location of Culture*. London: Routledge, 1994. Print.

Bharucha, Rustom. 'Peter Brook's "Mahabharata": A View from India'. *Economic and Political Weekly* 23.32 (1988): 1642–1647. Print.

———. *Theatre and the World: Performance and the Politics of Culture*. London: Routledge, 1993. Print.

———. 'Dialogue: Erika Fischer-Lichte and Rustom Bharucha'. *Textures*, 2011. Web. Accessed: 10 March 2014. <http://www.textures-platform.com/?p=1667>.

Bhopal, Kalwant. 'South Asian Women in East London: Motherhood and Social Support'. *Women's Studies International Forum* 21.5 (1998): 485–492. Print.

Billman, Larry. 'Music Video as Short Form Dance Film'. *Envisioning Dance on Film and Video*. Ed. Judy Mitoma. New York: Routledge, 2002. 12–20. Print.

Black, Les, Michael Keith, Azra Khan, Kalbir Shukra and John Solomos. 'Return of Assimilationism: Ralopezce, Multiculturalism and New Labour'. *Sociological Research Online* 7.2 (2002): n.p. Web. Accessed: 5 April 2010. <http://www.socresonline.org.uk/7/2/back.html>.

Boccadoro, Patricia. 'Review: Akram Khan's *iTMOi*'. *Culturekiosque*, 2014. Web. Accessed: 5 June 2014. <http://www.culturekiosque.com/dance/reviews/akram_khan_itmoi863.html>.

Bosteels, Bruno. 'Nonplaces: An Anecdoted Topography of Contemporary French Theory'. *Diacritics* 33.3/4 (2003): 117–139. Print.

Bourdieu, Pierre. *Practical Reason: On the Theory of Action*. Stanford: Stanford University Press, 1998. Print.

Brah, Avtar. *Cartographies of Diaspora: Contesting Identities*. London: Routledge, 1996. Print.

———. 'The "Asian" in Britain'. *A Postcolonial People: South Asians in Britain*. Ed. N. Ali, V.S. Kalra and S. Sayyid. London: Hurst & Co, 2006. 35–61. Print.

Brennan, Richard. *The Alexander Technique Manual*. London: Connections, 2004. Print.

Briginshaw, Valerie A. *Dance, Space and Subjectivity*. 2nd ed. Basingstoke: Palgrave Macmillan, 2009. Print.

British Film Institute. *Per4mance*. British Film Institute Website, 2011. Accessed: 18 July 2011. <http://ftvdb.bfi.org.uk/sift/series/32115>.

Brown, Carol. 'Making Space, Speaking Spaces'. *The Routledge Dance Studies Reader*. 2nd ed. Ed. Alexandra Carter and Janet O'Shea. Abingdon: Routledge, 2010. 58–72. Print.

Brown, Ismene. '*Gnosis*, Akram Khan, Sadler's Wells Theatre'. *Arts Desk*, 2010. Web. Accessed: 1 July 2010. <http://www.theartsdesk.com/index.php?option=com_k2&view=item&id=1403:gnosis-dance-review&Itemid=22>.

———. '*iTMOi*, Akram Khan Company, Sadler's Wells Theatre'. *Arts Desk*, 2013. Web. Accessed: 5 June 2014. <http://www.theartsdesk.com/dance/itmoi-akram-khan-company-sadlers-wells-theatre>.

Brubaker, Rogers. 'The "Diaspora" Diaspora'. *Ethnics and Racial Studies* 28.1 (2005): 1–19. Print.

Buckland, Theresa Jill. 'Shifting Perspectives on Dance Ethnography'. *The Routledge Dance Studies Reader*. 2nd ed. Ed. Alexandra Carter and Janet O'Shea. Abingdon: Routledge, 2010. 335–343. Print.

Burt, Ramsay. '*Kaash*: Dance, Sculpture and the Visual'. *Visual Culture in Britain* 5.2 (2004): 93–108. Print.

———. *The Male Dancer*. 2nd ed. London: Routledge, 2007. Print.

Cantle, Ted. *Interculturalism: The New Era of Cohesion and Diversity*. Basingstoke: Palgrave Macmillan, 2012. Print.

———. *About Interculturalism*. Ted Cantle Website, 2014. Web. Accessed: 13 June 2014. <http://tedcantle.co.uk/resources-and-publications/about-interculturalism/>.

Carlson, Marvin. 'Peter Brook's "The Mahabharata" and Ariane Mnouchkine's "L'Indiade" as Examples of Contemporary Cross-Cultural Theatre'. *The Dramatic Touch of Difference: Theatre, Own and Foreign*. Ed. Erika Fischer-Lichte, Josephine Riley and Michael Gissenwehrer. Tubingen: Gunter Narr Verlag Tubingen, 1990. 49–56. Print.

Catley, Michael. *Reading Body Language – Watching Eyes*. Suite 101, 2009. Web. Accessed: 22 October 2010. <http://www.suite101.com/content/reading-body-language-watching-eyes-a146002>.

Chakravorty, Pallabi. *Bells of Change: Kathak Dance, Women and Modernity in India*. Calcutta: Seagull Books, 2008. Print.

—. 'Clarification on Kathak'. Message to author. 6 November 2014. E-mail.

Chambers, Iain. *Border Dialogues: Journeys in Postmodernity*. London: Routledge, 1990. Print.

Chamberlain, Franc. 'Gesturing Towards Post-Physical Performance'. *Physical Theatres: A Critical Reader*. Ed. John Keefe and Simon Murray. Abingdon: Routledge, 2007. 117–122. Print.

Chatterjee, Sandra, and Cynthia Ling Lee. 'Solidarity – *Rasa*/Autobiography – *Abhinaya*: South Asian Tactics for Performing Queerness.' *Studies in South Asian Film & Media* 4.2 (2012): 129–140. Print.

Chaudhuri, Una. 'Beyond a "Taxonomic Theater": Interculturalism after Postcolonialism and Globalization'. *Theatre* 32.1 (2002): 33–47. Print.

Chaudhry, Farooq. '*Bahok* Query'. Message to author. 15 November 2008. E-mail.

———. 'Keynote Speech by Farooq Chaudhry'. *Commotie*, 2009. Web. Accessed: 18 August 2010. 1–5. <www.commotie.nu/media/keynote-farooq-chaudhry.pdf>.

Claid, Emilyn. 'Still Curious'. *The Routledge Dance Studies Reader*. 2nd ed. Ed. Alexandra Carter and Janet O'Shea. Abingdon: Routledge, 2010. 133–143. Print.

Clayton, Martin. '"You Can't Fuse Yourself": Contemporary British Asian Music and the Musical Expression of Identity'. *East European Meetings in Ethnomusicology* 5 (1998): 73–87. Print.

Clifford, James. 'Traveling Cultures'. *Cultural Studies*. Ed. Lawrence Grossberg, Cary Nelson and Paula Treichler. New York: Routledge, 1992. 96–116. Print.

———. *Routes: Travel and Translation in the Late Twentieth Century*. Cambridge: Harvard University Press, 1997. Print.

Coombes, Annie E., and Avtar Brah. 'Introduction: The Conundrum of Mixing'. *Hybridity and Its Discontents: Politics, Science, Culture*. Ed. Avtar Brah and Annie E. Coombes. London: Routledge, 2000. 1–16. Print.

Coorlawala, Uttara. 'Writing Out Otherness'. *Scholar Space*, 2013. Web. Accessed: 4 July 2014. <http://scholarspace.manoa.hawaii.edu/handle/10125/30709>.

Crabb, Michael. 'Tracking a Cultural Tug-of-War in Dance'. *Toronto Star*, 2013. Web. Accessed: 5 June 2014. <http://torontostar.newspaperdirect.com/epaper/viewer.aspx>.

Craft, Robert. *Stravinsky: Discoveries and Memories*. UK: Naxos Books, 2013. Print.

Cresswell, Tim. 'Embodiment, Power and the Politics of Mobility: The Case of Female Tramps and Hobos'. *Transactions of the Institute of British Geographers* 24.2 (1999): 175–192. Print.

———. *On the Move: Mobility in the Modern Western World*. Routledge: Abingdon, 2006. Print.

Crompton, Sarah. 'Akram Khan's *Gnosis* at Sadler's Wells, Review'. *Telegraph*, 2010. Web. Accessed: 1 July 2010. <http://www.telegraph.co.uk/culture/theatre/dance/7657058/Akram-Khans-Gnosis-at-Sadlers-Wells-review.html>.

———. 'History'. Sadler's Wells Website, 2014. Web. Accessed: 4 July 2014. <http://www.sadlerswells.com/about-us/history/>.

Csordas, Thomas J. Preface. *Embodiment and Experience: The Existential Ground of Culture and Self*. Ed. Thomas J. Csordas. Cambridge: Cambridge University Press, 2003. xi. Print.

Dantas, Marcello. 'Conversation Between Curator Marcello Dantas and Anish Kapoor'. Anish Kapoor Website, 2006. Web. Accessed: 1 July 2010. <http://www.anishkapoor.com/writing/brazilinterview.htm>.

Dasgupta, Chidananda. 'Cultural Nationalism and the Cross-Cultural Product'. *Blesok* 29 (2002): 1–2. Accessed: 1 July 2010. <http://www.blesok.com.mk/tekst.asp?lang=eng&tekst=483>.

Dasgupta, Gautam. '*The Mahabharata*: Peter Brook's "Orientalism"'. *Performing Arts Journal* 10.3 (1987): 9–16. Print.

Davies, Rachel. *Loose in Flight*. Rachel Davies Website, 2011. Web. Accessed: 18 July 2011. <http://www.racheldavies.com/tv/looseinflight.html>.

Dutt, Bishnupriya, and Urmimala Sarkar Munsi. *Engendering Performance: Indian Women Performers in Search of an Identity*. New Delhi: Sage Publications, 2010. Print.

Ellis, Samantha. 'Dance Was About Breaking All the Rules That Were Set in My Body'. *Guardian*, 2004. Web. Accessed: 9 March 2011. <http://www.guardian.co.uk/culture/2004/apr/22/samanthaellis.guesteditors>.

English National Ballet (ENB). 'The Company'. English National Ballet Website, 2014. Web. Accessed: 4 July 2014. <http://www.ballet.org.uk/the-company/>.

Etchells, Tim. 'Both Sitting or Brecht Might Have Liked It'. Tim Etchells Website, 2007. Web. Accessed: 28 July 2010. <http://www.timetchells.com/notebook/may-2007/both-sitting-or-brecht-might-have-liked-it/>.

Fensham, Rachel, and Odette Kelada. 'Introduction: Dancing the Transcultural across the South'. *Journal of Intercultural Studies*, 33.4 (2012): 363–373. Print.

Fischer-Lichte, Erika. 'Dialogue: Erika Fischer-Lichte and Rustom Bharucha'. *Textures*, 2011. Web. Accessed: 10 March 2014. <http://www.textures-platform.com/?p=1667>.

Fomina, Joanna. 'The Failure of British Multiculturalism: Lessons for Europe'. *Polish Sociological Review* 4.156 (2006): 409–424. Print.

Foster, Susan Leigh. 'Introduction'. *Corporealities: Dancing Knowledge Culture and Power*. Ed. Susan Leigh Foster. London: Routledge, 1996. ix–xvii. Print.

———. 'The Ballerina's Phallic Pointe'. *Corporealities: Dancing Knowledge Culture and Power*. Ed. Susan Leigh Foster. London: Routledge, 1996. 1–26. Print.

Foulkes, Julia L. *Modern Bodies: Dance and American Modernism from Martha Graham to Alvin Ailey*. Chapel Hill: University of North Carolina Press, 2002. Print.

Fraleigh, Sondra Horton. *Dance and the Lived Body: A Descriptive Aesthetics*. Pittsburgh: University of Pittsburgh Press, 1987. Print.

Fraser, Heather. 'Four Different Approaches to Community Participation'. *Community Development Journal* (2005): 286–300. Web. Accessed: 20 March 2011. <http://cdj.oxfordjournals.org/content/40/3/286.short>.

Garnham, Nicholas. 'From Cultural to Creative Industries: An Analysis of the Implications of the "Creative Industries" Approach to Arts and Media Policy Making in the United Kingdom'. *International Journal of Cultural Policy* 11.1 (2005): 15–29. Print.

George, Rosemary Marangoly. *The Politics of Home: Postcolonial Relocations and Twentieth Century Fiction*. Berkeley: University of California Press, 1996. Print.

Giddens, Anthony. *Modernity and Self-Identity: Self and Society in the Late Modern Age*. Cambridge: Polity Press, 1991. Print.

———. 'Living in a Post-Traditional Society'. *Reflexive Modernization: Politics, Tradition and Aesthetics in the Modern Social Order*. Ed. Ulrich Beck, Anthony Giddens and Scott Lash. Cambridge: Polity Press, 1994. 56–109. Print.

Gilbert, Helen, and Joanne Tompkins. *Post-colonial Drama: Theory, Practice, Politics*. Abingdon: Routledge, 1996. Print.

Gillespie, Marie. 'From Comic Asians to Asian Comics: *Goodness Gracious Me*, British Television Comedy and Representations of Ethnicity'. *Group Identities on French and British Television*. Ed. Michael Scriven and Emily Roberts. New York: Berghahn Books, 2003. 93–107. Print.

Gilroy, Paul. *The Black Atlantic: Modernity and Double Consciousness* London: Verso Books, 1993. Print.

Gnostic Instructor. 'What is Gnosis?' Gnostic Teachings Website, Date Unknown. Web. Accessed: 15 June 2014. <http://gnosticteachings.org/courses/alphabet-of-kabbalah/12-lames>.

Goffman, Erving. *Interaction Ritual: Essays in Face-to-Face Behaviour*. New Brunswick: Transaction Publishers, 2005. Print.

Gordon, Robert. *The Purpose of Playing: Modern Acting Theories in Perspective*. Michigan: University of Michigan Press, 2006. Print.

Gradinger, Malve. 'Pina Bausch'. *Fifty Contemporary Choreographers*. Ed. Martha Bremser. London: Routledge, 1999. 25–29. Print.

Grau, Andrée. 'South Asian Dance in Britain: Negotiating Cultural Identity through Dance (SADiB)'. *Leverhulme Trust Report (1999–2001)*, 2002. 1–85. Print.

Grehan, Helena. 'Rakini Devi: Diasporic Subject and Agent Provocateur'. *Theatre Research International* 28.3 (2003): 229–244. Print.

Greskovic, Robert. 'Merce Cunningham'. *Fifty Contemporary Choreographers*. Ed. Martha Bremser. London: Routledge, 1999. 72–77. Print.

Grosz, Elizabeth. 'Inscriptions and Body-Maps: Representation and the Corporeal'. *Feminine/Masculine and Representation*. Ed. Terry Threadgold and Anne Cranny-Francis. Sydney: Allen and Unwin, 1990. 62–74. Print.

Grotowski, Jerzy. 'Towards a Poor Theatre'. *Towards a Poor Theatre*. Ed. Euginio Barba. London: Methuen, 1969. 15–25. Print.

Gupta, Akhil, and James Ferguson. 'Beyond Culture: Space, Identity and the Politics of Difference'. *Cultural Anthropology* 7.1 (1992): 6–23. Print.

Haddad, Yvonne Yazbeck. *Contemporary Islam and the Challenge of History*. Albany: State University of New York Press, 1982. Print.

Halberstam, Judith. *In a Queer Time and Place: Transgender Bodies, Subcultural Lives*. New York: New York University Press, 2005. Print.

Hale, Catherine. 'Akram Khan: "Loose in Flight", "Rush", "Related Rocks"'. *Ballet*, 2002. Web. Accessed: 15 March 2009. <http://www.ballet.co.uk/magazines/yr_02/nov02/ch_rev_akram_khan_1002.htm>.

Hall, Donald E. *Queer Theories*. New York: Palgrave Macmillan, 2003. Print.

Hall, Stuart. 'New Ethnicities'. *Black British Cultural Studies: A Reader*. Ed. Houston A. Baker, Jr, Manthia Diawara and Ruth H. Lindeborg. Chicago: University of Chicago Press, 1996. 163–172. Print.

———. 'Minimal Selves'. *Black British Cultural Studies: A Reader*. Ed. Houston A. Baker, Jr, Manthia Diawara and Ruth H. Lindeborg. Chicago: University of Chicago Press, 1996. 114–119. Print.

———. 'Cultural Identity and Diaspora'. *Identity: Community, Culture, Difference*. 2nd ed. Ed. Jonathan Rutherford. London: Lawrence and Wishart, 1998. 222–237. Print.

———. 'Political Belonging in a World of Multiple Identities'. *Conceiving Cosmopolitanism: Theory, Context, and Practice*. Ed. Steven Vertovec and Robin Cohen. Oxford: Oxford University Press, 2002. 25–31. Print.

Hargreaves, Kelly. 'Europeans Filming New Narrative Dance'. *Envisioning Dance on Film and Video*. Ed. Judy Mitoma. London: Routledge, 2002. 163–167. Print.

Hawksley, Sue. 'Re-membering(s): Being There and Then, and Here and Now'. *Fandangodesign*, Date Unknown. Web. Accessed: 8 August 2010. <http://www.fandangodesign.com/grs/remembering.pdf>.

Hines, Thomas Jenson. *Collaborative Form: Studies in the Relations of the Arts*. Kent: Kent State University Press, 1991. Print.

Hirsch, Marianne. 'The Generation of Postmemory'. *Poetics Today* 29.1 (2008): 103–128. Print.

Hogan, Jackie. 'Staging the Nation: Gendered and Ethnicized Discourses of National Identity in Olympic Opening Ceremonies'. *Journal of Sports and Social Issues* 27.2 (2003): 100–123. Print.

Holledge, Julie, and Joanne Tompkins. *Women's Intercultural Performance*. London: Routledge, 2000. Print.

Holt, Nicholas L. 'Representation, Legitimation and Autoethnography: An Autoethnographic Writing Story'. *International Journal of Qualitative Methods* 2.1 (2003): 18–28. Print.

Horowitz, Katie R. *Satyriasis: The Pornographic Afterlife of Vaslav Nijinsky*. UCLA Center for the Study of Women, 2008. Web. Accessed: 5 June 2014. <http://escholarship.org/uc/item/2xx4f4vc>.

Huddat, David. *Homi K. Bhabha*. London: Routledge, 2005. Print.

Huggan, Graham. *The Postcolonial Exotic: Marketing the Margins*. Abingdon: Routledge, 2001. Print.

Iser, Wolfgang. 'The Reading Process: A Phenomenological Approach'. *Modern Criticism and Theory: A Reader*. 2nd ed. Ed. David Lodge and Nigel Wood. Harlow: Pearson Education Limited, 2000. 189–205. Print.

Iyer, Pico. *Global Souls: Jetlag, Supermarkets and the Search for Home*. London: Bloomsbury, 2000. Print.

Jaggi, Maya. 'The Transformation of Kathak'. Akram Khan *Gnosis* Programme Notes. 2010. Print.

Jazeel, Tariq. 'The World is Sound?: Geography, Musicology and British-Asian Soundscapes'. *Area* 37.3 (2005): 233–241. Print.

Jennings, Luke. *'Gnosis'. Guardian*, 2010. Web. Accessed: 1 July 2010. <http://www.guardian.co.uk/stage/2010/may/02/gnosis-akram-khan-Sadler's-wells>.

Jeram, Sonal. 'Olympics Query'. Message to author. 8 November 2013. E-mail.

Jeyasingh, Shobana. 'Text Context Dance'. *Choreography and Dance: An International Journal* (*South Asian Dance: The British Experience*) 4.2 (1997): 31–34. Print.

Jolly, Margaret. 'Introduction: Colonial and Postcolonial Plots in Histories of Maternities and Modernities'. *Maternities and Modernities: Colonial and Postcolonial Experiences in Asia and the Pacific.* Ed. Kalpana Ram and Margaret Jolly. Cambridge: Cambridge University Press, 1998. 1–25. Print.

Jordan, Stephanie. 'The Demons in a Database: Interrogating "Stravinsky the Global Dancer"'. *Dance Research: The Journal of the Society for Dance Research* 22.1 (2004): 57–83. Print.

Kabeer, Naila. 'The Quest for National Identity: Women, Islam and the State in Bangladesh'. *Feminist Review* 37 (1991): 38–58. Print.

Kane, Jean M., and Salman Rushdie. 'The Migrant Intellectual and the Body of History: Salman Rushdie's "Midnight's Children"'. *Contemporary Literature* 37.1 (1996): 94–118. Print.

Kantor, Tadeusz. *A Journey through Other Spaces: Essays and Manifestos, 1944–1990.* Trans. Michal Kobialka. Berkeley: University of California Press, 1993. Print.

Keith, Michael, and Steve Pile. 'Introduction Part 1: The Politics of Place'. *Place and the Politics of Identity.* Ed. Michael Keith and Steve Pile. London: Routledge, 1993. 1–21. Print.

Kedhar, Anusha. 'On the Move: Transnational South Asian Dancers and the "Flexible" Dancing Body'. Diss. University of California, Riverside, 2011. Print.

Kennedy, Philippa. 'The Art of Movement'. The National, 2010. Web. Accessed: 10 July 2010. <http://www.thenational.ae/featured-content/work-in-progress/to-publish/the-art-of-movement>.

Khalil, Shezad. 'Contemporary Kathak and "Loosening the Bolts" of Performance'. 2008. Unpublished Paper.

———. 'The British Space: An Examination of Sonia Sabri's Artistic Endeavours'. Sonia Sabri Dance Company Website, 2009. Web. Accessed: 27 July 2010. <http://www.ssco.org.uk/news/shezad2.html>.

———. 'Sonia Sabri – in Discussion with Shezad Khalil'. Sonia Sabri Dance Company Website, 2009. Web. Accessed: 27 July 2010. <http://www.ssco.org.uk/news/articles.html>.

Khan, Akram. 'Akram Khan: "Gnosis"'. Akram Khan *Gnosis* Programme Notes. 2010. Print.

———. 'Dancer Akram Khan Reckons He Can Never Top Role in London Olympics Opening Ceremony'. *Telegraph*, 2013. Web. Accessed: 10 March 2014. <http://www.telegraph.co.uk/sport/10203546/Dancer-Akram-Khan-reckons-he-can-never-top-role-in-London-Olympics-opening-ceremony.html>.

———. *'iTMOi'*. Akram Khan Company Website, 2013. Web. Accessed: 5 June 2014. <http://www.akramkhancompany.net/html/akram_production.php?productionid=47>.

Khan, Akram, and Rachel Davies. 'Cutting Loose'. *Pulse*, Spring 2002. Web. Accessed: 15 March 2009. <http://www.pulseconnects.com/archives?film&dance02.pdf>.

Knowles, Ric. *Theatre and Interculturalism.* Basingstoke: Palgrave Macmillan, 2010. Print.

Liu, Wei-Chen Roger. 'Global Universalism or Diasporic Particularism?' *Beyond Imagined Uniqueness: Nationalisms in Contemporary Perspectives.* Ed. Joan Burbick and William Glass. Newcastle Upon Tyne: Cambridge Scholars Publishing, 2010. 305–320. Print.

Lo, Jacqueline, and Helen Gilbert. 'Toward a Topography of Cross-Cultural Theatre Praxis'. *The Drama Review: TDR,* 46.3 (2002): 31–53. Print.

Lopez y Royo, Alessandra. 'South Asian Dances in Museums: Culture, Education and Patronage in the Diaspora'. Roehampton University Public Repository, 2002. Web. Accessed: 15 March 2009. 1–11. <http://rrp.roehampton.ac.uk/artspapers/2>.

———. 'Dance in the British South Asian Diaspora: Redefining Classicism'. *Postcolonial Text* 1.1 (2004). Web. <http://pkp.ubc.ca/pocol/viewarticle.php?id=138>.

Luckett, Moya. 'Postnational Television? *Goodness Gracious Me* and Britasian Diaspora'. *Planet TV: A Global Television Reader.* Ed. Lisa Parks and Shanti Kumar. New York: New York University Press, 2003. 402–422. Print.

MacCabe, Colin. 'Hanif Kureishi on London'. *Critical Quarterly* 41.3 (1999): 37–56. Print.

Mackrell, Judith. 'Vanishing Pointe: Where Are All the Great Female Choreographers?' *Guardian,* 2009. Web. Accessed: 22 December 2010. <http://www.guardian.co.uk/stage/2009/oct/27/where-are-the-female-choreographers>.

———. 'MoveTube: Why Akram Khan Will Command the Olympic Stadium'. *Guardian,* 2012. Web. Accessed: 10 March 2014. <http://www.theguardian.com/stage/2012/jul/27/movetube-akram-khan-olympic-dance>.

———. 'Akram Khan Company: *iTMOi* – Review'. *Guardian,* 2013. Web. Accessed: 5 June 2014. <http://www.theguardian.com/stage/2013/may/30/akram-khan-itmoi-review>.

———. 'English National Ballet: *Lest We Forget* Review – Compelling Quartet on War. *Guardian,* 2014. Web. Accessed: 4 July 2014. <http://www.theguardian.com/stage/2014/apr/03/enb-lest-we-forget-review>.

Majumdar, Sanjoy. 'From Ritual Drama to National Prime Time: *Mahabharata,* India's Televisual Obsession'. *Between the Lines: South Asians and Postcoloniality.* Ed. Deepika Bahri and Mary Vasudeva. Philadelphia: Temple University Press, 1996. 204–215. Print.

Mandelbaum, David G. *Society in India: Volume 2: Change and Continuity.* Berkeley: University of California Press, 1970. Print.

Martin, Randy. *Critical Moves: Dance Studies in Theory and Politics.* Durham: Duke University Press, 1998. Print.

Mason, David. '*Rasa*, "Rasaesthetics" and Dramatic Theory as Performance Packaging'. *Theatre Research International* 31.1 (2006): 69–83. Print.

Massey, Reginald. *India's Kathak Dance – Past, Present, Future.* New Delhi: Abhinav Publications, 1999. Print.

Meisner, Nadine. 'From First Class to Economy'. *Independent,* 2001. Web. Accessed: 15 March 2009. <http://www.independent.co.uk/arts-entertainment/theatre-dance/reviews/from-first-class-to-economy-683585.html>.

Meduri, Avanthi. 'Bharatha Natyam – What Are You?' *Asian Theatre Journal* 5.1 (1988): 1–22. Print.

Menski, Werner F. 'Immigration and Multiculturalism in Britain: New Issues in Research and Policy'. *KIAPS: Bulletin of Asia-Pacific Studies*, 2002. Web. Accessed: 5 April 2010 1–20. <http://www.casas.org.uk/papers/pdfpapers/osakalecture.pdf>.

Mercer, Kobena. 'Ethnicity and Internationality: New British Art and Diaspora-Based Blackness'. *The Visual Culture Reader*. 2nd ed. Ed. Nicholas Mirzoeff. London: Routledge, 2002. 190–203. Print.

———. Introduction. *Exiles, Diasporas & Strangers*. Ed. Kobena Mercer. London: Iniva & The MIT Press, 2008. 6–27. Print.

Meskimmon, Marsha. *Contemporary Art and the Cosmopolitan Imagination*. Abingdon: Routledge, 2011. Print.

Mitoma, Judy. Introduction. *Envisioning Dance on Film and Video*. Ed. Judy Mitoma. London: Routledge, 2002. xxxi–xxxii. Print.

Mitra, Royona. 'Cerebrality: Rewriting the Corporeality of a Transcultural Dancer'. *Dance and Cognition*. Ed. Johannes Birringer and Josephine Fenger. Munster: Lit Verlag, 2005. 167–183. Print.

———. 'Akram Khan Re-writes Radha: The "Hypervisible" Cultural Identity in Kylie Minogue's "Showgirl"'. *Women & Performance: A Journal of Feminist Theory* 19.1 (2009): 23–34. Print.

———. 'Embodiment of Memory and the Diasporic Agent in Akram Khan's *Bahok*'. *Performance Embodiment and Cultural Memory*. Ed. Colin Counsel and Roberta Mock. Newcastle Upon Tyne: Cambridge Scholars Press, 2009. 41–48. Print.

———. 'Dancing Embodiment, Theorising Space: Exploring the "Third Space" in Akram Khan's *zero degrees*'. *Planes of Composition: Dance, Theory and the Global*. Ed. André Lepecki and Jenn Joy. London: Seagull Books, 2010. 40–63. Print.

———. 'Performing Cultural Heritage in "Weaving Paths" by Sonia Sabri Dance Company'. *Performing Heritage: Research, Practice and Innovation in Museum and Live Interpretation*. Ed. Anthony Jackson and Jennifer Kidd. Manchester: Manchester University Press, 2010. 144–157. Print.

———. 'The Parting Pelvis: Temporality, Sexuality, and Indian Womanhood in Chandralekha's *Sharira* (2001)'. *Dance Research Journal* 46.2 (2014): 4–19. Print.

Monahan. Mark. 'Akram Khan's *iTMOi*, Sadler's Wells, Review'. *Telegraph*, 2013. Web. Accessed: 5 June 2014. <http://www.telegraph.co.uk/culture/theatre/dance/10089494/Akram-Khans-iTMOi-Sadlers-Wells-review.html>.

Monks, Aoife. *The Actor in Costume*. Basingstoke: Palgrave Macmillan, 2009. Kindle.

Moreiras, Alberto. 'Hybridity and Double Consciousness'. *Cultural Studies* 13.3 (1999): 373–407. Print.

Morris, Gay. 'Bourdieu, the Body, and Graham's Post-War Dance'. *Dance Research* 19.2 (2001): 52–82. Print.

Murray, Simon, and John Keefe. *Physical Theatres: A Critical Introduction*. Abingdon: Routledge, 2007. Print.

National Ballet of China (NBC). 'The National Ballet of China'. National Ballet of China Website, 2010. Web. Accessed: 5 April 2010. <http://www.ballet.org.cn/en/jutuanjieshao.htm>.

Nasar, Anita Dawood. 'Filming into the Mainstream'. *Pulse*, Spring 2002. Web. Accessed: 15 March 2009. <http://www.pulseconnects.com/archives?film&dance02.pdf>.

Netto, Gina. 'Multiculturalism in the Devolved Context: Minority Ethnic Negotiation of Identity through Engagement in the Arts in Scotland'. *Sociology* 42.1 (2008): 47–64. Print.

Norridge, Zoe. 'Dancing the Multicultural Conversation?: Critical Responses to Akram Khan's Work in the Context of Pluralist Poetics'. *Forum for Modern Language Studies* 10.1 (2010): 1–16. Print.

Novack, Cynthia J. *Sharing the Dance: Contact Improvisation and American Culture.* Madison: University of Wisconsin, 1990. Print.

On the Verge. *Observer,* 2003. Web. Accessed: 10 July 2010. <http://www.guardian.co.uk/stage/2003/nov/30/dance>.

O'Shea, Janet. 'Unbalancing the Authentic/Partnering Classicism: Shobana Jeyasingh's Choreography and the *Bharata Natyam* "Tradition"'. *Decentring Dancing Texts: The Challenge of Interpreting Dance.* Ed. Janet Lansdale. Basingstoke: Palgrave Macmillan, 2008. 38–54. Print.

Papastergiadis, Nikos. 'Hybridity and Ambivalence: Places and Flows in Contemporary Art and Culture'. *Theory, Culture & Society* 22.4 (2005): 39–64. Print.

Parkinson: Masterclass. 'Akram Khan'. 21 April 2014.

P.A.R.T.S. 'Presentation of the School'. P.A.R.T.S. Website, 2011. Web. Accessed: 18 July 2011. <http://parts.rosas.foreach.be/en/presentation>.

Patterson, Christina. 'Akram Khan: "You Have To Become a Warrior"'. *Independent,* 2009. Web. Accessed: 10 July 2010. <http://www.independent.co.uk/artsentertainment/interviews/akram-khan-you-have-to-become-a-warrior-1815314.html>.

Pavis, Patrice. 'Problems of Translation for the Stage: Interculturalism and Postmodern Theatre'. Trans. Loren Kruger. *The Play Out of Context: Transferring Plays from Culture to Culture.* Ed. Hanna Scolnicov and Peter Holland. Cambridge: Cambridge University Press, 1989. 25–44. Print.

———. *Theatre at the Crossroads of Culture.* London: Routledge, 1992. Print.

Perron, Wendy. 'East and West Meet in the Body of Akram Khan'. *Dance Magazine,* 2008. Web. Accessed: 10 July 2010. <http://findarticles.com/p/articles/mi_m1083/is_11_82/ai_n31021927/>.

Piccirillo, Annalisa. 'Hybrid Bodies in Transit: The "Third Language" of Contemporary *Kathak*'. *Anglistica* 12.2 (2008): 27–41. Print.

Poulton, Lindsay, and Michael Tait. 'Dancer Akram Khan: My Body Is My Voice'. *Guardian,* 2009. Web. Accessed: 10 July 2010. <http://www.guardian.co.uk/stage/video/2009/dec/09/akram-khan-dance>.

Preston-Dunlop, Valerie. *Dance Words.* Amsterdam: Harwood Academic Publishers, 1995. Print.

Preston-Dunlop, Valerie, and Ana Sánchez-Colberg. 'Core Concepts of a Choreological Perspective'. *Dance and the Performative: A Choreological Perspective – Laban and Beyond.* Ed. Valerie Preston-Dunlop and Ana Sánchez-Colberg. London: Verve Publishing, 2002. 7–37. Print.

Prickett, Stacey. 'Akram Khan'. *Fifty Contemporary Choreographers.* 2nd ed. Ed. Martha Bremser and Lorna Sanders. London: Routledge, 2011. 194–202. Print.

Purkayastha, Prarthana. 'Bodies Beyond Borders: Modern Dance in Colonial and Postcolonial India'. Diss. University of Roehampton, 2008. Print.

Ranasinha, Rurani. *South Asian Writers in Twentieth-Century Britain: Culture in Translation.* Oxford: Oxford University Press, 2007. Print.

Rancière, Jacques. *The Emancipated Spectator.* Trans. Gregory Elliott. London: Verso, 2009. Print.

Reis, Michele. 'Theorising Diaspora: Perspectives on "Classical" and "Contemporary" Diaspora'. *International Migration* 42.2 (2004): 41–60. Print.

Routledge, Paul. 'The Third Space as Critical Engagement'. *Antipode* 28.4 (1996): 399–419. Print.

Roy, Sanjoy. 'Dirt, Noise, Traffic: Contemporary Indian Dance in the Western City: Modernity, Ethnicity and Hybridity'. *Dance in the City*. Ed. Helen Thomas. Basingstoke: Palgrave Macmillan, 1997. 68–85. Print.

Ruffalo, David R. *Post-Queer Politics*. Farnham: Ashgate, 2009. Print.

Runnymede Trust. *The Report: Part One – A Vision for Britain*. Runnymede Trust, 2010. Web. Accessed: 5 April 2010. <http://www.runnymedetrust.org/report-PartOne.html>.

Rushdie, Salman. *The Ground Beneath Her Feet*. London: Picador, 2000. Print.

Rutherford, Jonathan. 'A Place Called Home: Identity and the Cultural Politics of Difference'. *Identity: Community, Culture, Difference*. 2nd ed. Ed. Jonathan Rutherford. London: Lawrence and Wishart, 1998. 9–27. Print.

———. 'The Third Space: Interview with Homi Bhabha'. *Identity: Community, Culture, Difference*. 2nd ed. Ed. Jonathan Rutherford. London: Lawrence and Wishart, 1998. 207–221. Print.

Sabri, Sonia. 'Sonia Sabri Company: Company'. Sonia Sabri Company Website, 2010. Web. Accessed: 4 August 2010. <http://www.ssco.org.uk/news/articles.html>.

Sadler's Wells. 'About Us'. Sadler's Wells Theatre Website, 2014. Web. Accessed: 4 July 2014. <http://www.sadlerswells.com/about-us/>.

Savage, Mark. 'Ballet Makes Glastonbury Debut'. BBC Website, 2014. Web. Accessed: 4 July 2014. <http://www.bbc.co.uk/news/entertainment-arts-28078730>.

Saner, Emine. 'My Thriller Routine Beat the Bullies'. *Guardian*, 2009. Web. Accessed: 10 July 2010. <http://www.guardian.co.uk/music/2009/jun/26/akram-khan-michael-jackson-thriller>.

Sánchez-Colberg, Ana. 'An(n)a Annotated: A Critical Journey'. *Theatre enCorps*, 2004. Web. Accessed: 5 March 2011. <www.theatreencorps.com/resources/Anna%20Annotated.pdf>.

———. 'Altered States and Subliminal Spaces: Charting the Road Towards a Physical Theatre'. *Physical Theatres: A Critical Reader*. Ed. John Keefe and Simon Murray. Abingdon: Routledge, 2007. Print.

Sanders, Lorna. 'Akram Khan'. Akram Khan Company Website, 2003. Web. Accessed: 10 March 2014. <http://www.akramkhancompany.net/ckfinder/userfiles/files/Akram%20Khan%20by%20Lorna%20Sanders,%20May%202003.pdf>.

———. *Akram Khan's Rush: Creative Insights*. Alton: Dance Books, 2004. Print.

———. '"I Just Can't Wait to Get to the Hotel": zero degrees (2005)'. Akram Khan Company Website, 2007. Web. Accessed: 10 March 2014. <http://www.akramkhancompany.net/ckfinder/userfiles/files/AKCT%20zerodegrees-1%20by%20Lorna.pdf>.

———. 'Akram Khan's *ma* (2004): An Essay in Hybridisation and Productive Ambiguity'. *Decentring Dancing Texts: The Challenge of Interpreting Dance*. Ed. Janet Lansdale. Basingstoke: Palgrave Macmillan, 2008. 55–72. Print.

Schechner, Richard. 'Interculturalism and the Culture of Choice: Richard Schechner Interviewed by Patrice Pavis'. *The Intercultural Performance Reader*. Ed. Patrice Pavis. London: Routledge, 1996. 41–50. Print.

——. *Performance Studies: An Introduction*. 2nd ed. Abingdon: Routledge, 2013. Print.

Schechner, Richard, and Willa Appel (eds). *By Means of Performance: Intercultural Studies of Theatre and Ritual*. Cambridge: Cambridge University Press, 1990. Print

Schendel, William van. *A History of Bangladesh*. Cambridge: Cambridge University Press, 2009. Print.

Shah, Asma. 'Working Internationally: An Interview with Farooq Chaudhry'. Akram Khan Company Website, 2014. Web. Accessed: 20 November 2014. <http://www.akramkhancompany.net/ckfinder/userfiles/files/Working%20 Internationally%20%20An%20interview%20with%20Farooq%20Chaudhry. pdf>.

Shah, Purnima. 'Transcending Gender in the Performance of Kathak'. *Dance Research Journal* 30.2 (1998): 2–17. Print.

Sharma, Sanjay, John Hutnyk and Ashwani Sharma. Introduction. *Dis-Orienting Rhythms: The Politics of the New Asian Dance Music*. Ed. Sanjay Sharma, John Hutnyk and Ashwani Sharma. London: Zed Books, 1996. 1–14. Print.

Sharma, Shailja. 'Salman Rushdie: The Ambivalence of Migrancy'. *Twentieth Century Literature* 47.4 (2001): 596–618. Print.

Shevtsova, Maria. 'Interculturalism, Aestheticism, Orientalism: Starting from Peter Brook's *Mahabharata*'. *Theatre Research International* 22.2 (1997): 98–104. Print.

Silk, Michael. 'Towards a Sociological Analysis of London 2012'. *Sociology* 45.5 (2011): 733–748. Print.

Smith, Lucy. 'In-between Spaces: An Investigation into the Embodiment of Culture in Contemporary Dance'. *Research in Dance Education* 9.1 (2008): 79–86. Print.

Smith, Michael Peter. 'Postmodernism, Urban Ethnography and the New Social Space of Ethnic Identity'. *Theatre and Society* 21.4 (1992): 493–531. Print.

Spry, Tami. 'Performing Autoethnography: An Embodied Methodological Praxis'. *Qualitative Enquiry* 7.6 (2001): 706–732. Print.

Stoneley, Peter. *A Queer History of the Ballet*. Abingdon: Routledge, 2007.

Sunahata, Yoshie. '*Gnosis*'. Message to author. 26 October 2010. E-mail.

Szerszynski, Bronislaw, and John Urry. 'Cultures of Cosmopolitanism'. *Sociological Review* 50 (2002): 461–481. Print.

Taylor, Diana. *The Archive and the Repertoire: Performing Cultural Memory in the Americas*. Durham: Duke University Press, 2003. Print.

Thakur, Rakesh. 'Looking Glass Self: *Mahabharata* as a "Significant Other"'. *Text and Inter-Textuality in the Mahabharata: Myth, Meaning and Metamorphoses*. Ed. Pradeep Trikha. New Delhi: Sarup and Sons, 2006. 58–67. Print.

Thornley, Andy. 'The 2012 London Olympics. What legacy?' *Journal of Policy Research in Tourism, Leisure and Events* 4.2 (2012): 206–210. Print.

Trawick, Margaret. 'The Ideology of Love in a Tamil Family'. *Divine Passions: The Social Construction of Emotion in India*. Ed. Owen M. Lynch. Berkeley: University of California Press, 1990. 37–63. Print.

Tyndall, Kate. 'Farooq Chaudhry'. The Producers: Alchemists of the Impossible, 2006. Web. Accessed: 18 August 2010. <http://www.the-producers.org/ FarooqChaudhry>.

Uytterhoeven, Lise. 'A Cosmopolite's Utopia: Limitations to the Generational Flemish Dance History Model'. *Platform* 4.2 (2009): 1–14. Print.

'atsyayan, Kapila. *Bharata: The Natyashastra*. New Delhi: Sahitya Academy, 1996. Print.

'ertovec, Steven. 'Super-diversity and Its Implications'. *Ethnic and Racial Studies* 30.6 (2007): 1024–1054. Print.

Walker, Margaret. 'Courtesans and Choreographers: The (Re)Placement of Women in the History of *Kathak* Dance'. *Dance Matters: Performing India on Local and Global Stages*. Ed. Pallabi Chakravorty and Nilanjana Gupta. New Delhi: Routledge, 2010. 279–300. Print.

Werbner, Pnina. 'Theorising Complex Diasporas: Purity and Hybridity in the South Asian Public Sphere in Britain'. *Journal of Ethnic and Migration Studies* 30.5 (2004): 895–911. Print.

Winship, Lyndsey. 'Tamara Rojo on English National Ballet's New First World War Show, *Lest We Forget'*. *Evening Standard*, 2014. Web. Accessed: 4 July 2014. <http://www.standard.co.uk/goingout/theatre/tamara-rojo-on-english-national-ballets-new-first-world-war-show-lest-we-forget-9198909.html>.

Williams, Ann. 'Jonathan Burrows and Matteo Fargion: "Both Sitting Duet"'. *Ballet Magazine*, 2003. Web. Accessed: 28 July 2010. <http://www.ballet.co.uk/magazines/yr_03/nov03/aw_rev_jonathan_burrows_fargion_1003.htm>.

Williams, David. 'Theatre of Innocence and of Experience: Peter Brook's International Centre – An Introduction'. *Peter Brook and the Mahabharata: Critical Perspectives*. Ed. David Williams. London: Routledge, 1991. 3–28. Print.

———. 'Assembling Our Differences: Bridging Identities-in-Motion in Intercultural Performances'. *Physical Theatres: A Critical Reader*. Ed. John Keefe and Simon Murray. Abingdon: Routledge, 2007. 239–248. Print.

Young, Robert J.C. *Colonial Desire: Hybridity in Theory, Culture and Race*. Abingdon: Routledge, 1995. Print.

Zaman, Shahaduz. *Broken Limbs, Broken Lives: Ethnography of a Hospital Ward in Bangladesh*. Amsterdam: Het Spinhuris, 2005. Print.

Zarrilli, Phillip. 'The Aftermath: When Peter Brook Came to India'. *The Drama Review: TDR* 30.1 (1986): 92–99. Print.

Interviews

Khan, Akram. Personal Interview 1. 7 August 2009.

———. Personal Interview 2. 9 June 2014.

Khan, Anwara. Personal Interview. 25 August 2009.

Rojo, Tamara. Personal Interview. 12 June 2014.

Live Performances

Bahok. By Akram Khan Company. Dir. Akram Khan. Perf. Eulalia Ayguade Farro, Young Jin Kim, Meng Ning Ning, Andrej Petrovic, Saju, Shanell Winlock, Wang Yitong and Zhang Zhenxin. Birmingham Repertory Theatre, Birmingham. 13–14 May. 2008. Performance.

Gnosis. By Akram Khan Company. Dir. Akram Khan. Perf. Akram Khan and Yoshie Sunahata. Sadler's Wells Theatre, London. 26–27 April. 2010. Performance.

Polaroid Feet. By Akram Khan Company. Dir. Akram Khan. Perf. Akram Khan. Royal Festival Hall, London. 8–10 April. 2001. Performance.

Vertical Road. By Akram Khan Company. Dir. Akram Khan. Perf. Salah El Brogy, Konstandina Efthymiadou, Eulalia Ayguade Farro, Ahmed Khemis, Young Jin Kim, Yen Ching Lin, Andrej Petrovic and Paul Zvkovich. Sadler's Wells Theatre, London. 5–9 October. 2010. Performance.

zero degrees. By Akram Khan Company. Dir. Akram Khan and Sidi Larbi Cherkaoui. Perf. Akram Khan and Sidi Larbi Cherkaoui. Sadler's Wells Theatre, London. 8–16 July. 2005. Performance.

Multimedia Sources

Bahok: Lettres sur le Pont. Dir. Gilles Delmas. Perf. Akram Khan Company and National Ballet of China. Lardux Films, 2008. DVD.

Belle d'Opium. By Akram Khan. Dir. Romain Gavras. Perf. Mélanie Thierry. 2010. Web. <http://belledopium.com/en_GB/home.html#/film/>.

Loose in Flight. By Akram Khan. Dir. Rachel Davies. Perf. Akram Khan. 1999. Web. <http://www.akramkhancompany.net/html/akram_production. php?productionid=17>.

Samsara: Showgirl Homecoming. By Kylie Minogue. Dir. Akram Khan. Perf. Kylie Minogue, Akram Khan and Ensemble. EMI, 2007. DVD.

zero degrees. Dir. Akram Khan and Sidi Larbi Cherkaoui. Perf. Akram Khan and Sidi Larbi Cherkaoui. Axiom Films, 2008. DVD.

Index

Printed and bound by CPI Group (UK) Ltd, Croydon, CR0 4YY